Graphis is committed to presenting exceptional work in international Design, Advertising, Illustration & Photography.

LogoDesign7

Published by **Graphis** ׀ CEO&Creative Director: B. Martin Pedersen ׀ Publishers: B. Martin Pedersen, Danielle B. Baker Editor: Anna Carnick ׀ Designer: Yon Joo Choi ׀ Production Manager: Eno Park ׀ Assistant Editors: Ellen Fure, Christine Mauritzen ׀ Editorial Assistant: Melanie Madden ׀ Support Staff: Rita Jones, Carla Miller ׀ Interns: Celine Bouchez, Malia Ferguson, Patrick Himmer, Jiyeon Kim, Nikeisha Antonette Nelson, Ryan Quigley, Monica Sanga, Corey Sharp

Remarks: We extend our heartfelt thanks to contributors throughout the world who have made it possible to publish a wide and international spectrum of the best work in this field. Entry instructions for all Graphis Books may be requested from: Graphis Inc., 307 Fifth Avenue, Tenth Floor, New York, New York 10016, or visit our web site at www.graphis.com.

Anmerkungen: Unser Dank gilt den Einsendern aus aller Welt, die es uns ermöglicht haben, ein breites, internationales. Spektrum der besten Arbeiten zu veröffentlichen.Teilnahmebedingungen für die Graphis-Bücher sind erhältlich bei: Graphis, Inc., 307 Fifth Avenue, Tenth Floor, New York, New York 10016. Besuchen Sie uns im World Wide Web, www.graphis.com.

Remerciements: Nous remercions les participants du monde entier qui ont rendu possible la publication de cet ouvrage offrant un panorama complet des meilleurs travaux. Les modalités d'inscription peuvent être obtenues auprès de: Graphis, Inc., 307 Fifth Avenue, Tenth Floor, New York, New York 10016. Rendez-nous visite sur notre site web: www.graphis.com.

Contents

Previous Spread: Concrete Design Communications Inc. | *Opposite Page:* Dfraile – Brand for project supporting little clinics and the reuse of hospital goods in Mauritania.

01

"If I had a dream assignment, it would be to design a cultural icon — although I must admit, I have no idea how to do that. I'm sure it must involve voodoo, a billion-dollar marketing budget or kittens."

 Well, here it is, late Monday night, and Graphis has asked me to provide information about Catapult, myself, and logo design. Of course, it's due tomorrow. Writing. I hated writing papers in school. The only thing I hated more in school was calculus, so I pursued a career in art because: 1) my parents named me Art, 2) I dislike writing, and 3) I really dislike math. But if Graphis wants to do a piece about you and your company, you can't be an idiot and ignore the opportunity. So, here I sit at the computer instead of watching "How It's Made" on the Discovery Channel.

First, some background and a description of our firm. Catapult is the product of two design firms that merged in 1984 — SGL Design, owned by Brad Ghormley and me, and Duke Marketing Communications (DMC), owned by Dave Duke. The three of us decided to drop the initials and names on the door and adopt a name that describes what it is we do for our clients.

Since the merger, Catapult has focused its efforts on being really good at one thing — helping clients build successful brands. We employ a process we call Visual Intelligence to move our clients' businesses forward in ways not otherwise possible.

Our expertise lies in strategic branding and positioning, followed by the design and execution of everything that contributes to building the brand: identities, graphic standards, stationery, websites, brochure & collateral materials, advertising, environmental graphics, packaging, and annual reports. We currently employ 14 people, 9 of whom are designers and production artists.

Now…a brief statement (is that possible?) on logo design and a short history of my obsession with it. I've had an interest in logos and cultural icons since I was a kid. I remember forming a club with friends in the 4th grade. I don't remember the purpose of the club — only that I wanted to be the president, so I could design its logo. If I recall, the design somehow involved a surfer cross. They were the cool thing then.

Then came junior high school in the late 1960s. I remember being fascinated with cultural icons like Gerald Holtom's peace sign, the ubiquitous Ankh — the Egyptian symbol of life, with its oval-topped T — and of course Harvey Ball's — love it or loathe it — smiley face. I found it interesting that these simple symbols became fashionable as T-shirt designs, stickers, and jewelry.

I found it remarkable that whether or not I thought the designs were good, certain symbols had a magnetic appeal and immediate emotional connection with the masses. I assumed that there must be some mysterious luck involved in the process of a spontaneously created design rising from obscurity to mass popularity.

It was about this time that I began to think that it would be really cool to design something that everyone wanted to stick on their bumper. Maybe because I was skinny and cut from the football team two years in a row, I was searching for some kind of heroic status apart from sports. It wasn't until I began exploring art-related careers in college that I heard the term "graphic design" and discovered I could actually get paid to do this stuff.

It was while I was trying to do math homework in the college library that I discovered some hardcover annuals full of really cool graphic design. By now, I realized I had math attention deficit disorder. I couldn't concentrate on my calculus homework because I was constantly tempted by

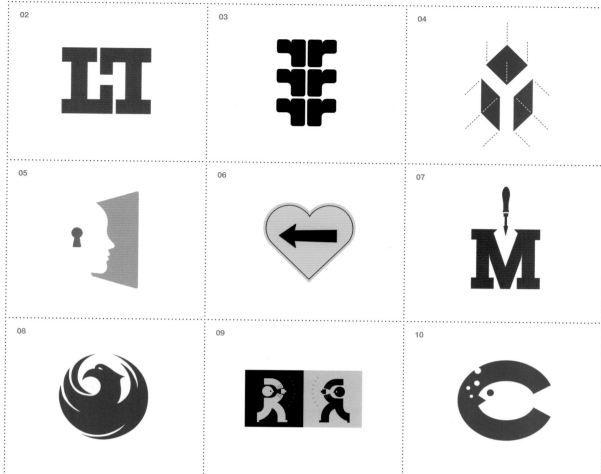

those books with all their amazing designs. I was particularly drawn to the sections with the winning logo designs. During college I worked in my father's small printing and office supply business. It wasn't long before I was designing a new logo for his business and studying those design books to learn what made a great design. During the next several years of working at the print shop, I redesigned the company logo three times, and once more after I left the printing business to start my career as a "real" graphic designer. My father patiently reprinted new company stationery with each new logo design. I'm happy to say that the fourth design is still in use after nearly 20 years.

I got my first job as a designer in 1982, working for a design studio owned by a software company. My big career goal at that time was to win an award for a logo design and to see it published in a book like the ones in the library. That opportunity came a year later when a logo I designed for my brother-in-law's construction company was featured in a local design show in Phoenix. I thought I had died and gone to heaven. I still consider this a defining moment in my career.

My next goal, although I believed it impossible, was to have a logo featured in a national publication before I retired. Then, I would consider my career a success. That finally happened five years later in 1987. I decided not to retire; I needed to keep working hard to take care of a growing family and nurture my growing obsession with identity design.

If I had a dream assignment, it would be to design a cultural icon — although I must admit, I have no idea how to do that. I'm sure it must involve voodoo, a billion-dollar marketing budget or kittens. I had the once-in-a-lifetime opportunity of discussing logo design with Paul Rand, my design hero, some years ago when he was in town judging our local design show. I asked him for suggestions on how to go from charging a miniscule amount for an identity design to charging a gazillion dollars, which I guessed was what he charged. He replied, "Write a book, like me." I'm still working on it. If Paul Rand were alive today, I would love to have him critique my work again.

There are plenty of challenges in the design business. For me, they typically involve the "business" of design, like writing proposals (fortunately my talented partner writes those now), crafting the occasional personal biography for a government RFP, and preparing design rationales for why I chose the color yellow when the truth is, I just liked the color and my gut told me it was right for the design. The client, however, is asking for "scientific proof" that yellow is right, since his favorite color is blue.

One of our biggest challenges presented itself when we were given the unique and monumental opportunity to design the master sign program for the Phoenix Art Museum. We had designed their logo a few years earlier, and now we were being asked to create a new program to coincide with a 30,000 sq. ft. expansion to their modern art wing. Not that the design process was overly challenging, but having a nationally-recognized architectural firm, local architects, the museum director, board of directors, and large donors as one giant client made the process somewhat demanding. Satisfying a large group of decision-makers who had strong and differing opinions about design became a project of its own.

Now that this project, which took us nearly three years to complete, is behind us, we look back and think, "Hey, that

wasn't so tough." Perhaps it's like a woman who gives birth, and later forgets the pain and decides to have another child. Not that I would know anything about that. We're very proud that we have more pieces of art hanging on the walls of the Phoenix Art Museum than any other artist. Of course, we haven't forgotten that gazing thoughtfully at Catapult's art serves a number of poignant purposes, including directing you to the nearest bathroom.

More about logo design — the object of this book. What makes a successful logo? Well, a number of things, or maybe just a couple. A good logo must be engaging for all the right reasons. A really bad design could equally command our attention, but for the wrong reasons, leaving the viewer with an impression contrary to the intended one.

A good logo will not only attract with its pleasing design and clever imagery, but will also clearly communicate the intended positioning and personality of the brand. A good logo needs to be unique and "ownable." In other words, it must stand out among the host of its competing marks with a design that is different and maybe even [gasp] unusual.

A good logo contains something that makes you remember it. We try, whenever possible, to design into our logos something for the viewer to discover in order to create an "a-ha!" moment. When we discover something in a design, that process of discovery causes us to more readily recall it — a mnemonic device, if you will. On a small scale, it's like the process of solving a riddle. The solving causes us

recognized for his imaginative and memorable trademarks. Art's work on logos and brand identities has garnered over 50 international, national and regional awards for design excellence. He designed nationally award-winning marks for the Mesa Art Center, the Phoenix Art Museum and Intel. His environmental graphics projects include sign programs for the Phoenix Art Museum, the Capitola Mall in Monterey Bay, California, and the award-winning sign system for the Phoenix Mountain Parks and Preserves. He served as creative director for the Heard Museum signage program and recently completed designs for the Rio Salado habitat restoration project sign program and the new monument signs for the City of Scottsdale parks. His work has been featured in prestigious design publications such as *Graphis Design Annual, Communication Arts, Print, New York Art Director's Annual*, and other design-related books.

Born in Arizona, Art studied Fine Art and Design at Arizona State University. He began his design career in 1982 at CYMA Software, where he designed packaging, brochures and print advertising that helped CYMA rise to become the second largest private accounting software firm in the nation. As a partner of Parker Johnson Lofgreen Design Associates and later as the owner of his own firm, he worked on design projects for such international companies as Estée Lauder, ITT and Alcatel. Art resides in Mesa, Arizona. He is married with three children.
Art Lofgreen portrait by Dave Duke

11

to remember the riddle and gives us a sense of accomplishment. Of course, with a logo the riddle needs to be solvable by anyone and in an instant.

A good logo should have a concept, not just be some random design. It should have meaning that's germane to the brand. Of course, many ubiquitous logos and icons aren't necessarily great designs, and many may even appear to be unrelated to their organization, yet they have acquired meaning and positive responses via the favorable history and mega-marketing efforts of the organization they symbolize. So I guess another key to creating a positively received logo is to do it for a company with aggressive promotion power.

As for the process that Catapult employs to design a successful logo — well, that's a closely guarded secret. Actually, it's not. It's probably the same process you learned in design school. We do research to understand as much as we can about the organization: their marketing and communication objectives, brand position, their competition, their audiences, etc. Then we turn on our computer and out pops a logo! Actually, firing up the Mac is the last thing you do in what should be a disciplined process of sketching a multitude of thumbnails, reviewing, and filtering them to find the few that are strategic, conceptually big in their idea, simple to read and understand, and have the potential to become the next cultural icon.

There, I wrote it. That wasn't so tough.

About Art Lofgreen:
One of three partners and Creative Director at Catapult Strategic Design, Art's responsibilities include design and creative direction. He has designed and directed numerous projects for notable companies and organizations such as APS (Arizona's largest public utility), City of Phoenix, City of Scottsdale, Del Webb Corporation, the Arizona Museum of Natural History and the Phoenix-Mesa Gateway Airport.
Experienced in many areas of graphic design, he is most

About Catapult Strategic Design:
What makes Catapult Strategic Design different? It's partly in the name — our ability to enable our clients to think strategically and act tactically in ways that ultimately move them forward, to launch them beyond their expectations. There are no partner initials to remember. No egos on our door. Just a company name that clearly describes what we do best for our clients.

The basis of our approach is to think and act strategically. This is accomplished by leveraging Catapult's proprietary process, Visual Intelligence™ — a marketing process and approach that begins with understanding, developing and implementing your brand positioning. It's about being analytical before thinking you can be creative. It's about developing creative that has concept, and therefore has meaning and is remarkable.

Everything we do for our clients disseminates from an established brand strategy. Whether it's a small start-up firm or a large enterprise, we clearly understand that great design is driven by intelligent, strategic thinking — not the other way around.

This is a business philosophy that transcends our client relationships, to those we hire and the business environment we've cultivated. Our designers and art directors understand brand positioning. They know how to assess the implications of a marketing plan: to be able to think analytically, not just creatively. In other words, they know how to think with both sides of their brains.

To you, this means we understand how to translate your critical marketing issues into marketing communications that are memorable, compelling and that drive your objectives. It's what makes our work stand out. From brand identity, collateral, advertising and packaging to point of sale, environmental design and new media, we know how to build brands.
Catapult Strategic Design:
4251 East Thomas Road, Phoenix, AZ 85018
Tel 602 381 0304 / Fax 602 381 0323

12

13

14

Joe Duffy's Poor Little Logo

Pity the poor logo, called upon to do so much, in oh so little space, in brevity of line, in never enough time. Expectations at impossible levels, minimal, miniature, minute, expressing every-thing that is known about a product, a service, a company, an earth-altering idea, a country? We want logos to change the face of time, reverse men's fortunes, and erase national debts, for crying out loud — all in the blink of an eye.

 How can we impose such cruel levels of respon-sibility on such a diminutive art form? We expect the logo to be the essence of all that came before, everything we know today, not to mention our hopes and dreams for the future. Yes, pity the poor little logo. How can it possibly do all we expect it to do? It can't. It never really has. It never really will. So many logos we've come to know and love, the ones we believed to have accomplished all this and more, have hardly accomplished so many objectives on their own. What separates the beautiful little works of art we celebrate in this book from those icons to which we attribute reversal of fortune or monumental change?

No single mark alone ever achieved significant change, monetary or otherwise. How many of the little darlings we admire in this book will ever be seen outside of it — except, of course, in other books like this?

Here we celebrate the logo as a beautiful form of artistic expression, and well we should. No other form of graphic design is as demanding of our reductive skills. Isn't that challenge of paring extraneous visual elements, without losing substance or the essential meaning of a subject, just what we designers strive for? Yes…and no. I personally want it all…and I like my logos extra-large. No, not the way the client sometimes does when they demand, "Make it big-ger!" (Sorry Paula.) Extra-large in terms of what the little bugger comes to mean. But take note: it doesn't achieve full meaning on its own any more than children succeed in life without their parents. Logos need love, and love comes in the form of a designer caring enough to think about the humble logo within the context of a broader communicative form, a language. This language serves a logo in so many ways. First and foremost, it causes the logo to stand for something. It conjures up true meaning when the logo signs off at the end of a message, blinks on at the entry of an envi-ronment, or fades to black at the end of a 30-second film.

Context is everything (well almost everything, anyway). You won't see context floating around in this book — it was never meant to. This book is about celebrating all there is to know about one very little, very specific thing — the naked little logo. I maintain there are two ways to do that celebrating. One is to appreciate the logo for its artistic form and what it achieves on its very own. As a designer, I can appreciate the crystal clarity that the best of these marks achieve in their own right, in their own little space. The second way is perhaps more difficult, but in a business sense, far more important: to look at how these marks fare as the center point of a compelling and unique language. No logo is an island. They all live in the midst of words and images that complete their "story." That story is what separates effective messaging from all the blather we must trudge through in our day-to-day lives. We live in a world surrounded by so much marketing junk, which often gives what we do for a living a bad rap.

Think of the Nike swoosh and all it conjures up without the help of any overt meaning. Or, think of Apple. Who would have ever thought a piece of fruit could mean so much about technology and entertainment and life? And when you walk into the store, or open the package, or, most importantly, experience the first touch and sound of a device that delights, it seems so right that it's Apple. The apple done in a proprietary and unified way — the Apple way.

What part of your work do you find most challenging?
Maintaining a creative environment in which we can do work we're proud of — every time out.

What would be your dream assignment?
We're currently designing for a bath & body gift line, a fast food brand, a bakery café brand, a tequila, beef jerky, an outdoor store restaurant concept, a natural food store brand, an Irish pub brand, a men's hair and skin care line, a sport equipment line, a line of nutroceuticals and a televi-sion network. On top of all that we're constantly working to invigorate our own brand. That range and breadth of design projects is a dream come true.

What is your definition of good design?
In my area of design it's discovering the truth about an idea and creating a story that brings people to it. When a story is complete and brought to you in a language that only one entity can speak. When the story moves you to become a member of a "team," the little logo is a very large badge that you'll be proud to wear.

What has been your greatest professional achievement?
Surrounding myself with incredibly talented people and maintaining a creative environment in which they can do work they're proud of.

About Joe Duffy, Principal and Chairman:
One of the most respected and sought-after creative direc-tors and thought leaders on branding and design, Joe has led award-winning branding efforts for some greatly admired companies including BMW, Coca-Cola, Sony, McDonald's and Starbucks. His work is regularly profiled in leading business, marketing and design publications and has been exhibited around the world. Joe has served as founding chair of the Environmental Committee of the American Institute of Graphic Arts and on the boards of the AIGA, the College of Visual Arts in St. Paul, MN, and the Minnesota State Arts Council. He is a member of the board of The One Club and has led their student design competitions in China for the past five years. He has been awarded the Legacy Medal from the AIGA for a lifetime of achievement in the field of visual communications, and his first book, *Brand Apart*, was released in July 2005. In 2006, Joe was featured in *Fast Company* as one of the "fast 50" most influential people in the future of business.
Joe Duffy portrait by his son, Joseph Duffy IV

About Duffy & Partners:
Duffy & Partners has been designing to make a difference for more than 20 years. The firm has been proud to be fea-tured in virtually every major branding, design, corporate and brand identity and packaging competition around the world. And they are equally proud of the marketplace results their work has made for many of the world's leading com-panies, including BMW, Coca-Cola, International Trucks, Sony, Nordstrom, and Kellogg's, among many others.
Duffy & Partners:
710 2nd Street South, Suite 602, Minneapolis, MN 55401
Tel 612 548 2333 / Fax 612 548 2334 / www.duffy.com

THE ISLANDS OF THE
bahamas

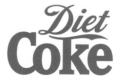

01 *Toyota Trucks*
Designers: Esther Mun,
David Mashburn
Client: Toyota Trucks
02 *V.I.O.*
Designers: Joseph Duffy IV,

Alan Leusink,
Ken Sakurai
Client: V.I.O.
03 *International Truck*
Designers: Tom Riddle,
Nate Hinz

Client: International Truck
04 *Islands Of The Bahamas*
Designers: Dan Olson,
David Mashburn
Client: Bahamas Ministry
of Tourism

05 *Duffy & Partners Logo*
Designer: Ken Sakurai
Client: Duffy & Partners
06 *Basin*
Designers: Dan Olson,
Kobe Suvongse

Client: Basin
07 *Diet Coke*
Designer: Joe Duffy
Client: Diet Coke

Graphics&Designing Inc.'s Toshihiro Onimaru: The Effective Logo

"Designers must win trust to be on an even playing field with their clients." Toshihiro Onimaru, *Art Director, G&D*

Now we see so many moving logos on websites and elsewhere. Businesses use video picture and sound for differentiation, appealing to audiences with huge images, rather than flat figures. Along with the diversifying media and changing communication environment, expression in logos is altering subtly. I also began to use motion logos in my presentations eight years ago, and consider the shape, movement and sound a very effective process. However, it makes no sense to use motion logos if the form itself is not the best. Here is what's important: The perfect 2D logo impresses people in the appropriate manner, and is the most effective communication of the client's message.

What is your definition of good design?
Good design can be defined in many ways depending on the situation; there's no single, right definition. I would call it good design when the message one wishes to convey is accurately transferred to the audience. It expresses a strong message to people's minds, moving them with emotion.

What part of your work do you find most challenging?
As a designer, I find myself pleased and motivated when I encounter brand new ideas and designs derived from various projects. In business, however, there are always certain conditions and challenges that must be overcome.

About Toshihiro Onimaru, Art Director:
Toshihiro Onimaru is involved in branding design for businesses and various organizations in broad-ranging areas including general graphic design — product design, package design and advertising design — as well as shop design and theatrical art. Recent work has focused on comprehensive branding design and deploying motion graphics using video image.

Toshihiro Onimaru has earned the Best Work Award in the image category at the 2003 JTA, and was nominated in as a Design Finalist at the 2003/2006 New York One Show Design (CI category) and for an Advertising/Design Award (CI Category) at the London International Award Show (LIAA).

In 2006, his typography design was selected In-Book at 2006 London D&AD. He also served as a judge at the Best of Best 2006 held in Russia.

Vice President, Graphics & Designing Inc.
Japan Graphic Designers Association Inc. (JAGDA) member
Japan Typography Association member
The Art Directors Club (NY) member
Type Directors Club (NY) member
D&AD (London) member
Toshihiro Onimaru portrait by Nacasa & Partners Inc.

01

02

03

For branding, it is important to analyze the company with my own filter. To that end, it is critical to do market research by myself, while consistently communicating with the client. Designers must also win trust to be on an even playing field with their clients.

Who do you admire most in the profession from the past or present?
I was first interested in the area of design when I saw a book of paintings by William Morris. Its beauty impressed me. The impact affects me still today, and has led to my current work and joy.

What would be your dream assignment?
It would be fun to be involved in a project that can impress people regardless of nationality. Projects outside Japan are exciting, and I am very interested in them.

About G&D:
Graphics & Designing Inc. (G&D) is based in Minato-ku, Tokyo. It was established in 1991, and now has 30 employees. The firm also works with excellent Designers from Hong Kong and South Korea. In addition to its Planning Department, G&D has a Creative Department, which includes Graphic Design and Space Design. The company is organized uniquely and constructs a project team for each assignment, incorporating every department's boundary or nature. G&D offers a broad range of Design with exacting quality.

Graphics & Designing Inc.:
3-3-1 Shirokanedai, Minato-ku, Tokyo 108-0071, Japan
Tel 81 3 3449 0651 / Fax 81 3 3449 0653
www.gandd.co.jp

01 *Akatsuki Printing:*
Branding for a printing business
Art Director: Toshihiro Onimaru
Designers: Toshihiro Onimaru,
Hiroki Ariyoshi
Client: Akatsuki Printing Inc.
02 *NINJA AKASAKA:*
Branding for a Japanese restaurant
Creative Director: Takanori Aiba
Art Director: Toshihiro Onimaru
Designer: Toshihiro Onimaru
Client: MTK
03 *GEORGE'S:*
Branding for an interior shop
Art Director: Toshihiro Onimaru

Designer: Toshihiro Onimaru
Client: George's Furniture Co.,Ltd.
04 *Chateraise Winery:*
Branding for a winery
Art Director: Toshihiro Onimaru
Designer: Toshihiro Onimaru
Client: Chateraise Winery
05 *CHIKARA no MOTO Company:*
Branding for restaurant business
throughout Japan
Art Director: Toshihiro Onimaru
Designer: Toshihiro Onimaru
Client: CHIKARA no MOTO
Company
06 *Quiche & Tarte:*

Branding for restraunt
Art Director: Toshihiro Onimaru
Designer: Toshihiro Onimaru
Creative Director: Takanori Aiba
Client: Graphics & Designing Inc.
07 *ONIMARU DESIGN Studio:*
Branding for a design studio
Art Director: Toshihiro Onimaru
Designer: Toshihiro Onimaru
Client: ODS
08 *Manhattan Dining:*
Branding for a restaurant
Art Director: Toshihiro Onimaru
Designer: Toshihiro Onimaru
Creative Director: Takanori Aiba

Client: MTK.
09 *CAVIAR BAR:*
Bar offering caviar
Art Director: Toshihiro Onimaru
Designers: Toshihiro Onimaru,
Hiroki Ariyoshi
Client: MTK
10 *Chateraise:*
National brand for Japanese /
western sweets
Art Director: Toshihiro Onimaru
Designer: Toshihiro Onimaru
Client: Chateraise Co., Ltd.

04

05

06

07

08

MANHATTAN DINING.

09

CAVIAR BAR

10

Gary Anderson's Sustainable Design

The Universal Recycling Symbol. You've seen it at home, at work, maybe even on your commute to and fro. If you have been lucky enough to travel abroad, you probably noticed it there, too. You would be hard-pressed to go a day without seeing it somewhere. Did you ever wonder who designed it? Graphis had the pleasure of catching up with the man himself: Gary D. Anderson, PhD, AIA, AICP.

It was spring, 1970. The first Earth Day was nearing. Gary, an Architecture student at University of Southern California, Los Angeles, noticed a poster on campus requesting a logo for Container Corporation of America (CCA) recyclable paperboard products. In return, CCA offered the winning entrant $2,500 for continued education. Unknown to Gary at the time, CCA prided itself on excellent design. Founder Walter Paepcke fostered design excellence within the company, hiring greats such as Albert Kner, Ralph Eckerstrom and John Massey. Clearly, CCA had the talent to design a logo themselves, but it was important to the company to call upon the next generation, as they were the "inheritors of the Earth." Thus, a nationwide call for entry was posted, appealing to environmentally conscious students. CCA intended to print the logo on their recyclable paperboard products and eventually offer it to the public domain.

Gary was finishing his fifth year in the Architecture program that spring, with plans to complete a Masters in Urban Design. He submitted three designs to the contest. The winning design was selected at the International Design Conference, in Aspen, CO, appropriately themed "Environment by Design." The esteemed panel of judges included Saul Bass, Herbert Bayer, Eliot Noyes, James Miho, and Herbert Pinzke, among others.

They selected the simplest of his three entries, out of a pool of over 500. William J. Lloyd, CCA's design manager, contest creator, and part of the panel of judges in Aspen, re-worked Mr. Anderson's winning symbol by rotating it 60 degrees. Others eventually added a circle, encompassing the mark, and this became the Universal Recycling Symbol we have today.

Gary went on to an illustrious career in planning and architecture, which has taken him around the world, working on development projects and teaching on the subject as he continually raises the bar on how to preserve our Earth.

What was the First Earth Day like?

That was quite a while ago, and I don't remember many details. I think everybody knew it was coming. There was a good deal of press. I only remember one event; it was a kind of all-day teach-in held on one of the athletic fields at school. Remembering it now, it probably would look like many other outdoor gatherings of young people of the time that celebrated the youth movement, but it was pretty calm compared to some of the large events that had been held in northern California. It was certainly a far cry from Woodstock. There were no musical performances that I recall, and it was a bright, sunny day — with no mud. As I recollect, everyone kept their clothes on. From time to time, though, the scent of burning hemp would waft across the field.

How did you create the original image?

Sometimes I'm asked if I could just sketch a copy of the recycling symbol. I doubt that I'd do a very good job of it. The symbol never was a freehand sketch. As I designed it, I was always working with drafting instruments. From the first time I put pencil to paper, it was with a T-square, triangle and circle template at hand. With tools, it's pretty simple to draw. It's all horizontal and vertical, 60° and 30° lines, with arcs of two radii — the inner arc larger and the outer one smaller. I think I got the idea for the two arcs from an elementary school field trip to a printing press. The long ribbon of paper that's fed through the presses before the pages are cut goes up and down over numerous rollers. I seem to remember that when the paper turned a

corner, the roller at that point wasn't a simple cylinder, but an elongated cone, allowing one edge of the paper to turn faster than the other. Since the recycling symbol was originally to be used for paper products, I wanted it to allude visually to that type of process. I guess since what is essentially a band of flat arrows turns three corners, it made sense to reflect the conical bend.

What else inspired you to come up with this design?

I was intrigued by the idea of the Mobius strip ever since I read the term in a limerick from a book of science-related poems that I checked out of the school library when I was in the third or fourth grade. It went: "Hickery, dockery dick, The mouse on the Mobius strip, The strip revolved, The mouse dissolved, In a chrono-dimensional skip."

When I was working on the recycling symbol, the Mobius strip symbolized a combination of the finite and the infinite. It is a finite object, but its surface is infinite in a way. That idea sort of fused with the image of the way paper goes over rollers when it's being manufactured and printed on — sometimes turning corners in the process. I realize now that that limerick probably had planted in my mind the idea of a connection between the Mobius strip and a revolving or cyclical motion — a connection that doesn't really exist, necessarily.

Of other influences that I'm aware, one is the Woolmark symbol, reminiscent of spinning fibers, which was relatively new then. Also, the work of M. C. Escher, much of which he had created 20 or 30 years before, was being rediscovered at the time. Two famous Escher drawings depicted people in architectural spaces that folded back on themselves. Finally, the idea of the mandala as a symbol of the universe had been very popular in the '60s. In a way, the recycling symbol is a mandala, but instead of being based on a circle and a square, as many are in the Eastern traditions, the recycling symbol is more like a circle and a triangle.

You've stated before that your initial design ideas for the project incorporated the notion of recycling water. How did water translate to paper fibers?

The concept of something being altered through use and then somehow being returned to its original state to be used once again is not unique to paper. Our urban design class, as part of a group exercise, had been documenting a variety of processes that support and constrain physical development. We examined these processes from the perspective of the systems approach, which was a hot topic in academic circles at the time. I was responsible for coming up with the diagram for Water Supply, and I had designed one consisting of bands of different widths, signifying the relative volumes of water that were drawn off from the source for different uses, and the relative amounts that could be returned to the system. These bands turned back into the main flow in circular arcs, and terminated in arrowheads consisting of 30° and 60° angles to indicate directionality. Because I had been playing with these arcs and angles recently in the context of recycling, it was that diagram that got me thinking of how I could devise a symbol representing recycling of paper. The big difference — graphically speaking — between the process diagram in class and the recycling symbol for the competition was that the diagram was two-dimensional, while the symbol was meant to appear to fold over on itself, creating a sense of 3-dimensionality.

As a student in Architecture, did you think about switching majors after winning this contest? What drew you so passionately to Architecture?

No, I really didn't. Following the award, I received an offer from a large graphics firm in New York. Although I gave the offer due consideration, I was just completing a six-year course of study in Architecture and Urban Design, and that was the general direction I had come to see my career taking. Still, I've always been interested in a wide variety of topics, and that didn't stop me from using the award money to study Social Science in Stockholm.

Did you find the prize fitting for such a contest, given that the rules stated no royalties would be given?

As for the appropriateness of the award, I think it was absolutely fitting. When the competition was held (going on 40 years ago!), $2,500 was worth a lot more than it is now. In any event, I don't think the award money was what motivated me to enter the contest. I just saw it as something I might be successful at, without requiring anything beyond my own creativity and limited resources and material that was readily at hand. It also was in support of a cause that I thought was commendable.

How do you feel about other companies today taking your design and re-tooling it for their purposes? Have you seen anyone improve upon it?

I would like to think that one of the reasons that the symbol eventually caught on is that it is general enough to withstand a lot of tinkering and still be recognizable as itself. I like some of the liberties that people or groups have taken with it. I also really enjoy seeing the creative ways that some people have found to incorporate it into other artwork, so I was delighted when a friend sent me an illustration in which Uncle Sam is deconstructing the symbol and reassembling individual arrows to create dollar signs.

Speaking of globally recognized symbols, do you think there are any that outnumber yours, in terms of recognition?

I read a short article recently in *Resource Recycling* that mentioned a research study that had been undertaken to measure the impact of the recycling symbol. They used the Volkswagen and Woolmark symbols as control subjects, and I guess the recycling symbol ranked favorably. I've also heard it compared to the Nike swoosh. So I guess it's right up there, and that's all very gratifying.

In Europe you certainly see the "green dot" yin and yang symbol used extensively. The green dot doesn't really mean the same thing, exactly, but one does get the impression that it is sometimes used in place of the recycling symbol. On the other hand, the first place I ever really saw the recycling symbol used extensively in the public arena was in Holland. I was overseas in Saudi Arabia for several years, not really aware that the recycling symbol was having much of any impact anywhere, and when I came back to the States through Europe, there it was, blown up to the size of a beach ball on colorful municipal recycling bins in Amsterdam.

You are highly respected in your field today, but considering few designs are as globally recognized as the Universal Recycling Symbol, how does relative anonymity in relation to this design make you feel? How does this success rank among your many others?

I am kind of a one-hit wonder in that regard. There's no doubt that the recycling symbol has a higher profile and is more recognizable than anything else I've done. That wasn't always the case. Because it gained its stature gradually, there was a period of time when, if I was preparing a resume for a new job opportunity, I wouldn't think of mentioning the recycling symbol. The type of work I was pursuing was not directly related to graphic design, and even though I was proud of the accomplishment, I was concerned that the prospective employer would think that I didn't understand what the position was all about if I used the design of the symbol as one of my qualifications. Hence, I kept the focus of the resume on planning

and architecture. In recent years, I have been receiving increased recognition, and I'm genuinely pleased with that, but I've also arrived at the point in my other career where I don't have to worry about the symbol being a distraction anymore. Now it almost seems strange that I could ever have seen it that way.

Currently, you teach Building and Site Design at John Hopkins Carey School of Business. What is the biggest design challenge you find in development today?

This is a required course for the Masters degree in the Real Estate program. Consequently, my course is quite different from most of the others in the program, which deal with the legal and economic aspects of real estate development. If you had asked this question several years ago, I would have said that engaging developers in any kind of discussion in the context of sustainable planning and design was the big challenge. It was hard to convince anyone of a positive relationship between green design and the bottom line. But it's remarkable how this concept has caught on, and most of the younger developers are eager to find out as much as they can. Their clients have been asking for green design. What still remains a challenge with a few students, however, is making a convincing argument that any planning or design can have a positive impact on the financial success of their projects, at all. Luckily, however, professional developers in the class who are returning to school after some years in practice can usually make that argument for me.

Do you live "green"?

There's always room for improvement.

On September 16, 1970, at the press conference to unveil his winning design and answer questions about the industry's recycling efforts, CCA's President and CEO, Henry G. Van der Eb, stated, "It is our hope that this new symbol will become the focal point for an industry-wide program to achieve this awareness." Thanks to the forward thinking of both Container Corporation of America and Dr. Anderson, the world now has a symbol that has infiltrated and transformed our consciousness, silently reminding us to preserve our resources, over and over and over again.

Article by Christine Mauritzen

About Gary D. Anderson:

Currently, Gary D. Anderson, PhD, AIA, AICP, is Dewberry's National Director of Master Planning. Gary has more than 30 years of experience in urban, regional, and master planning for both private developers and public agencies in the United States, Europe, and the Middle East. Anderson also teaches Building and Site Design in the Carey School of Business, Masters of Real Estate program at The Johns Hopkins University in Baltimore. Gary recently was inducted into the Society of American Military Engineers [SAME] Academy of Fellows and is a member of the National Land Economics Honor Society, Lambda Alpha. When not guest lecturing around the world, Gary remains active in his hometown of Baltimore by serving on various urban planning and museum boards.

Opposite Page: Gary Anderson portrait by Tadder Photography; This page: 1970 photo of CCA's Hans Buehler and Anderson courtesy of CCA and Anderson; Special thanks to Gary D. Anderson and Dewberry for their contributions to this article.

A Conversation with Pentagram's Michael Bierut

"Following the launch of the new logo in January 2007, Saks Fifth Avenue experienced double-digit comparable store sales in the first half of the year. This performance reflects many new initiatives and programs including improvements in merchandise, service, customer development and marketing. The launch of the new logo was timed to coincide with the introduction of these initiatives, giving Saks a new look to match its new direction."

Terron Schaefer, *Group SVP, Creative & Marketing, Saks Fifth Avenue*

When retail giant Saks Fifth Avenue needed a redesign of its famous logo to grab consumers' attention and elevate the brand, they approached Michael Bierut and Pentagram. In the creation of a logo that was both timeless and familiar yet visually stimulating, the two companies collaborated, marrying the classic and the contemporary in a frenzied grid of black and white squares, each expressing a piece of the original elegant, calligraphic Saks' logo so many people had continued to associate with the upscale clothing company. To achieve this effect, Bierut selected the 1973 Saks logo illustrated by Tom Carnese and designed by his mentor, Massimo Vignelli, gave it liposuction, and divided it into 64 squares. He then approached a Yale theoretical physicist to determine how many possible combinations of squares could be generated — 98.14 googols, as it turns out — and applied them to the company's shopping bags. With this unconventional design solution, not one bag is identical to another, and the result has certainly turned heads. The grid, mimicking that of Saks' and Bierut's hometown, is definitive and simple, while the calligraphy conveys the sense of beauty and movement that characterizes both the streets of New York and the continually evolving fashion industry. We spoke with Bierut about the redesign and his thoughts on the design world in general.

How would you describe your personal design style? How has it evolved over the years?

I like simplicity, humor and eclecticism. I think I've gotten to be a more effective designer over the years, but not necessarily a better one.

What is the role of design in the culture at large?

Graphic design's role is to help people and organizations communicate with clarity, wit and beauty in a world that has too little of all three.

What satisfies you most in your work?

Those few occasions when I find the missing piece that perfectly completes the puzzle.

What's most challenging about being a designer today?

The speed at which we're required to generate solutions, and the speed with which those solutions are superceded by others.

Paula Scher once said of you, "If knowledge is power, then Michael Bierut is the most powerful person in the entire design community." How do you feed your curiosities and stay current?

I read compulsively, everything all the time, from the moment I get up to the moment I go to bed. When I'm not reading, I'm talking to my very smart wife and kids, or my very smart partners, or my very smart friends. When I'm not reading or talking, I'm jogging (three miles every morning) or sleeping (not as much as I'd like to).

As one of the most respected names in graphic design, you constantly juggle multiple projects. In addition to your design work for Pentagram, you contribute to NPR's "Studio 360," are a senior critic at the Yale School of Art, and write frequently on the subject of design. What occupies your time outside of design?

I have three wonderful kids who in a perfect world would occupy all my time.

Your entrance into the design world was very organic/natural. You found yourself interested in fine art, music and drawing, which converged in album covers, and inspired you to study graphic design. Has your career evolution been as natural?

In June 1980, I took my first job working for Massimo and Lella Vignelli. In November 1990, I took my second job as a partner in the New York office of Pentagram. I also married (on July 26, 1980) the first girl I ever kissed (on February 20, 1974). I'm not a complicated person. Once I decide to do something, I do it and I don't look back. Any self-doubts I have are buried so deep it would take an army of psychiatrists to dig them up.

You studied design at the University of Cincinnati's College of Design, Architecture and Planning. Were there any instructors or mentors who were especially instrumental in your life?

The University of Cincinnati had some fantastic teachers who were there in the mid-70s and, amazingly, are still there today: Gordon Salchow, Joe Bottoni, Heinz Schenker, Stan Brod, Robert Probst. I learned from all of them. I also really value the bosses I had at internships while in school: Dan Bittman in Cincinnati and Chris Pullman at WGBH in Boston.

Giving back: Are you affiliated with any charitable organizations or educational programs? If so, why do you think this is important?

I've been involved for my whole career with the AIGA, and I've taught for more than 15 years at Yale University. I also serve on the boards of the Architectural League of New York and New Yorkers for Parks. Because I've gotten so much from these organizations, and from my own teachers, it seems absolutely wrong not to return the gifts.

What advice do you have for young designers?

Be curious, read everything, and don't be embarrassed to be head over heels in love with design.

Are there any young designers out there who've recently caught your eye?

I see another one every day.

Kurt Anderson has written, "Michael seems to do some of his most inspired work as a celebrant of New York City." What is it about New York?

New York is one of the world's most authentic places, and it's filled with the world's toughest critics. You can't get away with anything here, so when you squeeze out a success, it really counts for something.

Impressively, you've worked for only two companies in your entire design career. How did your experience working with Massimo and Lella Vignelli shape your understanding of design?

From Massimo and Lella I learned that great design needs great clients, that no detail is too small, and that joy, love and pleasure are indispensable parts of the design equation.

What drew you to Pentagram? How would you describe the working environment there?

Working at Pentagram is like attending one of the world's

best, most elite design conferences, five days a week, 52 weeks a year. There are no closed offices, the atmosphere is informal and fun, and design is everywhere. What could be better?

Identify one example of outstanding design.

Maya Lin's Vietnam Veterans Memorial is a big abstract metaphor (a scar in the earth) combined with an absolutely literal experience (the deeper in we get, the more the names pile up). Plus, it's a giant piece of typography (V is for Vietnam). She had to fight so hard for it because she was the only one who knew that it would work, and how: "People will cry and cry." And they do. That's powerful design.

Are there any projects in the world you would like to see redesigned?

I would love to see someone do for the hardware store what Starbucks did for the coffee shop, but even better.

The new Saks logo has been celebrated as a classic mark with a modern twist. Can you explain the inspiration and rationale behind the new Saks logo in your own words?

The Saks program had to both honor the history of a great New York institution, and project a constant sense of newness and excitement. These are two opposite requirements, of course. The solution was to combine a classic calligraphic logo that the store had begun using half a century ago with a combinational technique that would let us see it in a new way.

What is the relationship between the Saks logo and its hometown of New York?

New York is a black and white town — think of Berenice Abbott and Paul Strand, or Woody Allen's Manhattan — so the program is black and white. It combines old and new, with hundred-year-old buildings standing next to glass skyscrapers. Finally, most of Manhattan is laid out on a rigid grid pattern. But within that grid you get all the crazy variety of the city. We tried to evoke this, combining the organic elements of the calligraphy with a modular system based entirely on squares. It's all about contrast, just like the city.

We've heard that Saks has upcoming projects in the works with several celebrated designers, centered around the new logo. Can you tell us a little more about this?

They would be really mad if I said anything!

Interview by Anna Carnick & Melanie Madden

···

About Michael Bierut, Partner, Pentagram Design:

Michael Bierut was born in Cleveland, Ohio in 1957, and studied graphic design at the University of Cincinnati's College of Design, Architecture, Art and Planning, graduating summa cum laude in 1980. Prior to joining Pentagram in 1990 as a partner in the firm's New York office, he worked for ten years at Vignelli Associates, ultimately as vice president of graphic design. His clients at Pentagram have included the *New York Times*, Saks Fifth Avenue, The Council of Fashion Designers of America, Harley-Davidson, The Minnesota Children's Museum, The Walt Disney Company, Mohawk Paper Mills, the New York Jets, Princeton University, the Brooklyn Academy of Music, and the Morgan Library and Museum. He has won hundreds of design awards, and his work is represented in the permanent collections of the Museum of Modern Art and the Metropolitan Museum of Art in New York, and the Musee des Arts Decoratifs, Montreal. He served as president of the New York chapter of the American Institute of Graphic Arts (AIGA) from 1988 to 1990 and is president emeritus of AIGA National. He also serves on the boards of the Architectural League of New York, the Brooklyn Academy of Music Local Development Corporation, and New Yorkers for Parks. Michael was elected to the Alliance Graphique Internationale in 1989, to the Art Directors Club Hall of Fame in 2003, and was awarded the profession's highest honor, the AIGA Medal, in 2006.

Michael is a Senior Critic in Graphic Design at the Yale School of Art, where he has taught for several years. He writes frequently about design and is the co-editor of the five-volume series *Looking Closer: Critical Writings on Graphic* published by Allworth Press. His commentaries about graphic design in everyday life have been heard nationally on the Public Radio International program "Studio 360." Michael is a co-founder of the weblog DesignObserver.com, and his book, *79 Short Essays on Design*, was published this year by Princeton Architectural Press. His recent activities include creating new packaging for Saks Fifth Avenue and designing signage and displays for Renzo Piano's new headquarters building for the *New York Times*.

Michael Bierut portrait by Jens Umbach

Pentagram Design's Approach:

Pentagram is organized and run so that designers may achieve their best — because design at its best satisfies clients, pleases users and gratifies the designer. We design print and graphics, products, environments and buildings. We believe that ideas make design distinctive, and that identity, function, aesthetics and value make design work. We remain independent and owned by our partners, who are all designers.

Pentagram Design:
204 Fifth Avenue, New York, NY 10010
Tel 212 683 7000 / Fax 212 532 0181 / www.pentagram.com

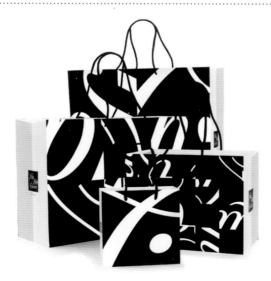

01

02

03

04

05

RBMM's Brian Boyd: Great Logo Design

"Great logo design does more than represent the brand in its simplest form. It captures the viewer's attention and creates an encounter that is memorable. Achieving that balance of simple and memorable is top of mind with each logo design we create. It's why RBMM executes a critical review process that allows us to be successful for every client." Brian Boyd, *Creative Director & Principal, RBMM*

06

07

08

09

01 Aubry Hair	Designer: Woody Pirtle	Olympics	Designer: Dan Lynch	07 TV Guide	Designesr: Steve Miller,
Client: Aubry Hair	03 Ellis Construction	Client: TGIF Restaurants	06 Neiman Marcus	Client: TV Guide	Woody Pirtle
Designer: Woody Pirtle	Client: Ellis Construction	Designer: Kenny Garrison	Epicure Shop	Designer: RBMM	09 Dallas Zoo
02 Dallas Opera	Designer: Matt Staab	05 Sports Illustrated	Client: Neiman Marcus	08 Earth Grains	Client: Dallas Zoo
Client: Dallas Opera	04 TGIF Bartender	Client: Sports Illustrated	Designer: Stan Richards	Client: Earth Grains	Designer: Dick Mitchell

About Brian Boyd:

Brian began his career at The Richards Group in 1978 after graduating from the University of North Texas with a Bachelor of Fine Arts degree in Advertising Design. He is a founding member of RBMM, where he is creative director and a principal. He also has served as a consultant for Richards Interactive, guiding Website design for The Richards Group's interactive subsidiary. His clients have included American Airlines, the American Heart Association, Armstrong World Industries Inc., A.H. Belo Corp., The Associates, AT&T, Boy Scouts of America, Brinker International, the ClubCorp, Continental Airlines, the Dallas Museum of Art, the Dallas Symphony Orchestra, Dresser Industries, the Episcopal School of Dallas, Feld Group, First USA, the Florida Department of Citrus, Glazer's Companies, Guaranty Bank, Highland Homes, i2 Technologies, Nokia, Nortel, Pilgrim's Pride, PlainsCapital Bank, the Presbyterian Healthcare System, Preservation Dallas, Reliant Energy, The Rouse Company, Terrabrook, Texas Capital Bank, Texas Instruments, Trammell Crow Company, Trane, Travelocity, Viscern, Women of Faith, and Zuzu.

Brian's work has been recognized in every major national and international creative competition, including works chosen for inclusion in the Library of Congress. In 1993,

Brian was named to Adweek's Southwest Creative Team as All-Star Designer. Brian has taught graphic design at his alma mater and at Texas A&M–Commerce. On weekends, he spends much of his time restoring his historic Spanish-eclectic style home. Brian and his wife have one son.
Brian Boyd portrait by Scott Harrison
About RBMM:
RBMM, the brand identity and design affiliate of The Richards Group, is one of the most awarded and best-known branding firms in America. Founded in 1956, the firm rapidly gained a nationwide reputation for creative, compelling design, as well as thoughtful, coherent graphic architecture and identity systems.
Today RBMM continues to create enduring relationships between brands and people—unique, memorable identities that stand out in a crowded marketplace. They understand the importance of brand stewardship and creative excellence, and expect their work to seamlessly combine both. RBMM exists to endear brands to people. They believe that a brand is a promise and that the promise should be expressed consistently at every point of contact to maximize a brand's clarity, relevance, and power.
RBMM:
7007 Twin Hills, Suite 200, Dallas, TX 75231
Tel 214 987 6500 / Fax 214 987 3662 / www.rbmm.com

For the past several years, it has been rare to be awarded the assignment of creating a logo without it being part of a complete identity or branding project that extends well beyond logo creation. Often we are also solving packaging needs or retail merchandising needs. Thus, the majority of our logo assignments are as they should be: a component of an overall identity or brand development and an integral part of the entire communications strategy. In such cases, a logo is created from the strategic big picture approach and not as a tactical communication.

Of the logo-only assignments, most are referred by advertising, PR or other strategic communications agencies that not only appreciate our ability to utilize their research and positioning strategies for their clients, but also expect that we'll bring some design brilliance to the execution. In these cases, the critical thing is to decipher which strategic insights are the ones that have enough depth and truth to endure, because we cannot be expected to solve the problem solely on the direction of an advertising campaign or positioning statement if those concepts are not expected to last as long as the logo is. I personally admire a logo that doesn't have any apparent better solution — a logo that just seems to be the right one. That's not often achieved. What we tend to appreciate most as designers are the marks that communicate the most with the least. These are the logos that have the potential to become cultural icons without the need for extensive marketing budgets.

Big media budgets and marketing exposure have made many logos famous, but of course this doesn't mean they are good. We have done some interesting marks, but the famous brands with the most exposure usually solicit more respect from clients, even if they are not our best work. Most often, working on identities for large, well-known or established brands will only allow the design to be an evolution or deft maneuver in order to maintain equity while attempting to express a new sensibility. Our firm frequently creates complete brand personalities. In doing so, we eliminate the need for a logo to communicate too much by building a better story surrounding it. Having a better story can provide a foundation for the logo to achieve more respect and to be liked for more than its clever, bold or beautiful graphic execution. However, we still make every attempt to make the logo something good on its own.

The Graphis Q&A: Steve Sandstrom
What has been your greatest professional achievement?
Truthfully, I hope the greatest achievement is still to come. I don't really care to rest on what has been done or what has been achieved. I don't think anyone at the firm is focused on anything other than what they are doing currently. Today's work is the most important.
As a firm I think we can say that we are proud of a significant percentage of the work we have done for our clients and the success this work has created for their businesses. Typically the awards and recognition achieved every year are for a number of clients and not just one or two. Perhaps that should be the notable accomplishment. That said, our history has not been without frustration, and it is quite possible that some of the most remarkable achievements might have been missed by a decision here or there. So when we think of the achievements, it has to be understood that there were clients who approved the concepts that made a difference, and we shared the success together.
What part of your work do you find most challenging?
For me it is time management. I spend too much time in

meetings and with emails, and not enough time on creative work, which often gets pushed well into the evenings.
What would be your dream assignment?
We have often had projects that might not have been considered "dream assignments" originally, yet turned into them. This could have been the result of a client relationship or an unexpected opportunity that arose out of a project. We believe that any assignment that allows for our strategic thinking and creative solutions to be maximized is a dream assignment. We love to start from scratch and bring a new brand into the world, but sometimes it's a great challenge to resurrect an older brand and make it relevant again.
What is your definition of good design?
I appreciate it when design solves a problem to the point that you never realize there was a problem. It just appears to have been an opportunity that somebody took complete advantage of.
Who do you admire most in the profession?
There are way too many designers to recall or remember. I admire dozens, and don't even profess to know all those who have impressed and influenced me. I love seeing what the other designers at our firm come up with. That serves as a kind of daily inspiration.
Peter Moore was my creative director at Nike (1984–88), and I respected his intelligence and passion. He believed enough in me to grant me creative freedom in my position at a time when Nike was struggling to get to the next level. At that time, Nike didn't have the commitment to design that they have now.
I think I have learned almost as much from the advertising world as the design world. Bill Borders and Tom Kelly at Borders Perrin & Norrander gave me the opportunity to create Sandstrom Design in conjunction with their agency. My first partner, Rick Braithwaite, was in account management at BP&N. Steve Sandoz of Wieden+Kennedy was an amazing creative partner and influence on my work for the years that we collaborated, until his death.

About Steve Sandstrom:
Steve Sandstrom is Creative Director and Partner of Sandstrom Design in Portland, Oregon. Clients have included Tazo Tea, Converse, Coca-Cola, Seeds of Change, Levi Strauss & Co., ESPN, Miller Brewing Co., Nike, Seagrams, Steppenwolf Theatre, adidas, Nissan, Virgin, Microsoft and Sony Pictures. Advertising agency relationships have included Wieden+Kennedy, TBWA/ChiatDay, Ogilvy & Mather, Y&R, GSD&M and Publicis. He was integrally involved with the creation of Tazo, a premium tea brand, and the development of its brand personality, and has been primarily responsible for Tazo's award-winning packaging and general design aesthetic. Within five years of launch, Tazo became the number one brand in natural foods sales in the United States. Steve was also invited to participate in the 2005 Design Biennial in Saint-Etienne, France. His piece was featured in several publications including the *New*

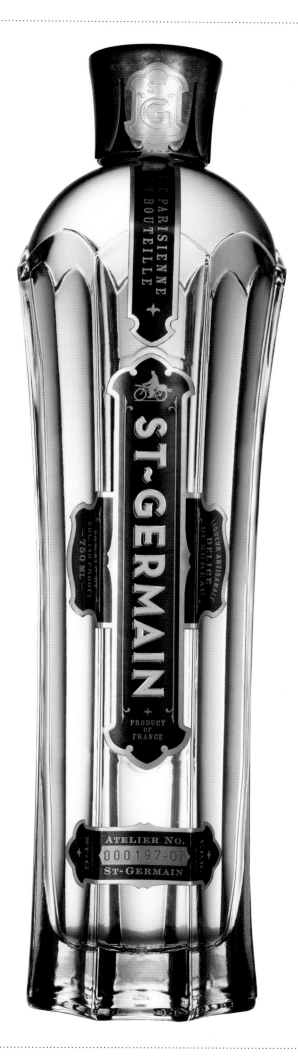

02

03

04

05

01 St-Germain
Designer: Steve Sandstrom
Client: Cooper Spirits
International
02 Noodlin' Restaurants
Designer: Steve Sandstrom
Client: The Holand Inc.
03 Tazo Logo
Designer: Steve Sandstrom
Client: Tazo

04 Cycle Oregon
Designer: Steve Sandstrom
Client: Cycle Oregon
(annual 7-day ride to benefit
rural areas in Oregon)
05 800.com
Designer: Dan Richards
Client: 800.com Electronics
(online home electronics retailer)
06 Miller High Life

Designer: Steve Sandstrom
Illustrator: Larry Jost
Client: Miller Brewing Co.
07 Castor & Pollux
Designer: Jon Olsen
Client: Castor & Pollux
(high quality pet products)
08 Miller Lite
Designer: Steve Sandstrom
Client: Miller Brewing Co.

09 Mint
Designer: Jon Olsen
Client: Mint Dental
10 Tazo Seal
Designer: Steve Sandstrom
Client: Tazo
11 Cocoa Via
Designer: John Olsen
Client: Masterfoods
12 Moonstruck Chocolatier

Designer: Jennifer Lyon
Client: Moonstruck Chocolates
13 Levi's Red Tab Jeans
(Retail Campaign Logo)
Designer: Steve Sandstrom
Agency: Foote Cone & Belding/SF
Client: Levi's Strauss & Co
14 Dove Lewis
Designer: Marc Cozza
Client: Dove Lewis Pet Hospital

06

07

08

09

10

11

12

13

14

"What we tend to appreciate most as designers are the marks that communicate the most with the least." Steve Sandstrom, *Creative Director, Sandstrom Design*

York Times Magazine, *Metropolis* and *ID*. Prior to founding Sandstrom Design in November 1988, he was a Senior Art Director at Nike, primarily responsible for brand image and collateral materials for the apparel division. He has received numerous design and advertising awards and recognition including Graphis Top Ten in Design, D&AD (London), CA, The One Show, ID, Clio's, Andy's, Kelly's, Belding's, Type Directors, New York Art Directors, London International Advertising and the American Advertising Federation. In 1994, he was honored as the Advertising Professional of the Year by the Portland Advertising Federation. He also won a Blue Ribbon at the 1961 Oregon State Fair for a crayon drawing of a cow. The drawing was evidently good enough to be eaten by his dog. Steve serves on the Board of Directors for The One Club, the most prestigious creative advertising organization in the U.S. He also serves on the Board of Visitors for the University of Oregon School of Architecture and Allied Arts and is a past president of the Portland Advertising Federation (the first designer elected to that position in its 100-year history). His firm has been featured in several publications including *Graphis*, *Adweek*, *Communication Arts*, *Critique*, *Novum* (Germany), *How*, *Creativity*, *@Issue* and in numerous books on design, packaging and corporate identity.
Sandstrom portrait by J. Carter Dunham, Polara Studios

About Sandstrom Design:
Sandstrom Design maintains a curious culture. We want to know everything about a company and their category. We subscribe to the notion that, "To every answer there is at least one question, usually more than one." We like questions, because they lead to strategies, and strategies lead to clarity, and clarity leads to innovation.
We think. Ponder. Wonder. Explore. We make unexpected connections. We think about what came before and what has never been, and while we invariably come to a conclusion, we know we can never stop thinking.
The culmination of all this is what you see in the work, but it's based on a much deeper core. Message, voice, form — everything is considered. Every touch point is critical. We know that for a brand to come to life, it has to be believable and holistic. All points communicate, and all messages are important.
And while our success ratio is high, we try to learn from every stumble. The more we absorb, the more we can add to the equation. So we keep looking for adventure and the unknown. It's where the great new ideas can be found.
Sandstrom Design:
808 SW Third Avenue, No. 610, Portland, Oregon 97204
Tel 503 248 9466 / Fax 503 227 5035
www.sandstromdesign.com

Haggar Clothing Spring Collection / Designer: David Beck / Client: Haggar Clothing Company

"Good design adds value. It invokes positive responses. Good design stands the test of time." Don Sibley, *Partner&Creative Director, Sibley/Peteet Design, Dallas*

Don Sibley, Sibley/Peteet Design, Dallas:
Designing Logos
Our process of designing logos begins with an initial research phase to identify the unique attributes and culture of the company that has retained our services. Only with a clear understanding of their positioning, their attitude, and their target customer can we initiate our task of creating an identity that projects them accurately. In our logo explorations, we concentrate on appropriateness to ensure we communicate the essence of the company. Our primary goal is to create an identity that is more than a mere symbol and one that conveys an idea. The best logos have strong concepts behind them — that extra level of communication that makes them distinctive and memorable. We are also big believers in simplicity. When you consider the wide variety of applications for a typical logo, getting overly complex is usually not the way to go. Plus, simplicity is another way of ensuring timelessness. Our logo process always includes multiple designers, nund we generate a "shotgun approach" of ideas that we critique and edit internally. Unlike some firms, we show numerous logo solutions in our first client presentation. We welcome input from our clients. We often find their insights into their industries to be helpful in the process. Plus, the logo selected will become the "face" for their company, so it's an important decision. Together, we

begin to isolate the solutions that are the most successful, and there is almost always — perhaps with some professional coaxing — a consensus on the perfect logo.
About Don Sibley:
Don Sibley, a native Texan, worked for several notable advertising and design firms, including The Richards Group, prior to forming Sibley/Peteet Design with partner Rex Peteet in 1982. In just five years after opening the business, Sibley/Peteet was featured in *Communication Arts* magazine and was servicing a national client base. Don was one of the founders of "Texas Design," a look that drew national attention for its fresh, colorful approach. His work has appeared in all the major design publications, and Don also judges and lectures for professional and academic institutions.
He is represented in the permanent collection of the Library of Congress and the Museum of Modern Art in Hiroshima. Over the years, Don has accumulated hundreds of awards for his design and illustration, and was awarded the prestigious "Golden Egg" for lifetime achievement in 2003 by the Dallas Society of Visual Communications. He is also a founding board member of the Texas Chapter of the American Institute of Graphic Arts. Don has continued to evolve his creative skills, recently serving as photographer on several of his design projects.
Don Sibley portrait by Neill Whitlock

Banana Joe / Art Director: Rex Peteet / Designer&Illustrator: Mark Brinkman / Client: Tropical Sportswear International, Banana Joe

"I admire work that really solves a problem in a totally unique fashion and breaks new ground." Rex Peteet, *Partner&Principal Designer, Sibley/Peteet Design, Austin*

Rex Peteet, Sibley/Peteet Design, Austin:
On Logo Design
Identities must work on many levels simultaneously to truly be successful. Particularly on larger branding assignments, the demands put on the identity is Herculean, in that they have to live on an international landscape, consider multicultural interpretations, and work equally well in all applications — everything from embroidery to electronic to environmental mediums, and everything in between. They must tell a story, be timeless, accessible, understandable, easily reproduced.

The identities that can satisfy the above as well as reveal something that provides additional meaning after a moment of consideration are the most impressive and most elusive — such as FedEx and its arrow, International Paper (IP) and its tree, and the Westinghouse "W" and its circuitry, to mention a few. Discovering that perfect solution for me requires considerable perseverance and an untiring work ethic. If you are lucky, you may have that flash of brilliance, but more likely it will arrive after that twenty-seventh perfect idea at 2 am. It's the ability to self-edit and continue pushing, re-examining, fine-tuning, and re-doing, that separates an ordinary design from a great design. If I keep at it, I might be fortunate enough to finally arrive. And if and when I do, it's magic.

About Rex Peteet:
After his early career with several prestigious design firms including The Richards Group and Pirtle Design, Rex co-founded Sibley/Peteet Design in Dallas in 1982 with partner Don Sibley, where they established a national presence and international recognition for design excellence. In 1994, Rex founded the firm's second office in Austin, providing identity strategies and comprehensive design and brand management solutions for a range of corporate, consumer, and institutional clients.

Rex's work is consistently recognized through regional and national design awards including the New York, Los Angeles, and San Francisco Art Directors Shows and the AR100, and he has several works in the permanent collection of the Library of Congress.

Rex has been widely published and featured in many industry magazines and annuals including *AIGA*, *Communication Arts*, *Graphis*, *HOW*, *Print* and *Step*. In 2005 Rex was the recipient of the Dallas Society of Visual Communications' highest honor and career achievement award, The Golden Egg. Rex is a member of Design Management Institute, the Society of Environmental Graphic Designers, and a founding member of the first Texas chapter of AIGA. He currently sits on the Advisory Board of AIGA Austin.
Rex Peteet portrait by Sarah Beal

03 *North Central Expressway*
Designer: John Evans
Client: City of Dallas
04 *Scattergories*
Designer: John Evans
Client: GHasbro Games
05 *Montgomery Farm Gardens*

Landscape Services
Designer: Geoff German
Client: Montgomery Farm
06 *Shiner Brewing Company*
Designer: David Beck
Client: The Gambrinus Company
07 *American Heart Association*

Designer: Diana McKnight
Client: American Heart Association
08 *Mary Kay Cosmetics*
Designer: John Evans
Client: Mary Kay
09 *King Photography*
Designer: Tom Kirsch

Client: King Photography
10 *North Texas Commission*
Designer: Brandon Kirk
Client: North Texas Commission
11 *Atomic Toys*
Designer: Ray Latham
Client: Atomic Toys

Q&A with Don Sibley & Rex Peteet:
What is your definition of good design?
DS: Good design is design that meets — and goes beyond — its intended objectives. It must be effective and appropriate. Good design adds value. It invokes positive responses. Good design stands the test of time.
RP: I admire work that really solves a problem in a totally unique fashion, and breaks new ground. The best work makes me wish I had done it, and when appropriate, makes me smile. Of course it must have impeccable craftsmanship, perfect execution, and be smart.
What has been your greatest professional achievement?
DS: My greatest professional achievement has been to lead a design firm with an excellent reputation known nationally for twenty-five years.
RP: Growing our two offices has been very satisfying; however, creating the company's second office in Austin might be the most gratifying. Building a studio that didn't exist a little over a decade ago into an organization that is a valued partner of national and international brands is

indeed an honor.
What part of your work do you find most challenging?
RP: Maintaining a proper balance between work life and personal life. The 24/7 requirements of staying ahead of the technology curve. Keeping fresh and inspired.
What would be your dream assignment?
RP: Creating the identity, print, exhibit, and environmental signing systems for the Sid Richardson Museum may have been it. We had the opportunity to work with visionary and philanthropist Ed Bass, renowned architect David Schwarz, and my good friends Leslye Nunnelee (Project Manager, The Projects Group) and Jack Summerford (Consultant, Summerford Design), and played a small part in preserving the rich history found in the Western art of Russell and Remington, as well as the legacy of the collector Sid Richardson, which is about as good as it gets.
DS: The dream assignment is anything that forces me to step outside the box and challenges my skills in some way. It would also be for a client who truly appreciates the value of good design and someone I enjoy.

12	13	14

15	16	17

18	19	20

12 Chili's
Creative Director: Tim McClure
Designer/Illustrator: Rex Peteet
Agency: GSD&M
Client: Brinker International/Chili's
13 Scotland Yards
Designer/Illustrator: Rex Peteet
Client: Scotland Yards/Designer
Fabrics & Furnishings
14 Pato Zazo

Creative Director: Gerald Tucker
Art Director/Illustrator: Rex Peteet
Designers: David Kampa, Rex Peteet
Client: Pato Zazo Tex-Mex Cafe
15 Rx.com
Designer/Illustrator: Rex Peteet
Client: Rx.com
16 Adobe Cafe
Art Director: Rex Peteet
Designer/Illustrator: David Kampa

Client: Adobe Texican Cafe
17 Lone Star Donuts
Designer/Illustrator: Rex Peteet
Client: Lone Star Donuts
18 Tequila Mockingbird
Designer/Illustrator: Rex Peteet
Client: Tequila Mockingbird
Sound Design
19 Macaroni Grill
Creative Director: Tim McClure

Designer/Illustrator: Rex Peteet
Agency: GSD&M
Client: Brinker International/
Romano's Macaroni Grill
20 Texas Commission on the Arts
Art Director: Rex Peteet
Designer/Illustrator: Mark Brinkman
Agency: Sherry Matthews Advocacy
Marketing
Client: Texas Commission on the Arts

Who do you admire most in the profession from the past or present?
RP: There are several.
Woody Pirtle — friend, mentor, and great designer; Joe Duffy — friend, savvy businessman, great designer, and a gentleman; Michael Vanderbyl — Friend, teacher, and a great multi-disciplined designer; John Casado — Great designer and photographer.

About Sibley/Peteet Design:
Two partners, two offices and two cities comprise the firm of Sibley/Peteet Design. The studio began in 1982 in Dallas as a two-person shop, consulting with large advertising agencies on identity and packaging, and providing creative and illustration services to a small but national client base. Since that time, Sibley/Peteet has grown to a staff of over twenty between its Dallas and Austin offices and has developed an expertise in a spectrum of identity applications, from annual reports and packaging to envi-

ronmental graphics and new media design. All the while, the name Sibley/Peteet has been synonymous with outstanding graphic design and communications.
The firm's mission and passion is to become partners with clients to develop consistent, comprehensive identities, tell their individual stories creatively, and help establish their unique personalities in all their points of contact with their audiences.
After more than twenty-five years of creating great work for national and global clients including Coca-Cola, Dell, Southwest Airlines, Brinker International, Sony, Hewlett-Packard, Wyndham International, Nokia, The Bellagio, JPMorgan Chase, Motorola, and Hasbro Games, the firm has created quite a diverse and impressive portfolio.
If you would like a closer look at SPD, stop by their virtual studios (www.spdaustin.com or www.spddallas.com); Austin: 522 6th Street, Austin, TX 78701, Tel 512 473 2333 Dallas: 3232 McKinney Avenue, Suite 1200, Dallas, TX 75204, Tel 214 969 1050.

GraphisGold&PlatinumAwardWinners

Award photograph by Henry Lewtyler

deadline

3 3
RBMM Rails Relationship Marketing
Sheaff Dorman Purins Push Advertising
Range, Inc. Targetbase-Omnicom
Barkley Barkley Evergreen & Partners

Barkley Barkley Evergreen & Partners
Addis Turn
Deka Design Studio Arc Magazine
Evia Ltd. Evia Ltd
Hirschmann Design Truad

Pollard Design Hay Processing Unlimited
Mark Oliver, inc. Bellwether Farms (second, fourth)
P&H Creative Group JRK Seed Company
3 Osuna Nursery

ARCHITECTURE

Muller + Company Architecture

Café Design Wallis Real Estate
Kate Resnick Design NicheInteriors
Alexander Isley inc. Becker+Becker Architecture
Planet Propaganda Strang, Inc.
Café Design Wallis Real Estate

The Bradford Lawton Design Group American Advertising Federation, San Antonio

Tim Frame Design Touristees. com
Initio Advertising The Trike Shop
Origin Design Corinthian Vintage Auto Racing
Hornall Anderson Truck Trax
Duffy & Partners Toyota Trucks

GSD&M Southwest Airlines
Greteman Group Wichita Aviation Festival
Hornall Anderson Design Works Eos Airlines
Origin Design ExpressJet
Range, Inc. Occidental Petroleum

Prejean Creative Belle Tresse
PLATINUM The Bradford Lawton Design Group Melody Nixon
Duffy & Partners Basin White

-FRESCA-

Hirschmann Design Velo Coffee Roasters
Blinn Design Kahuna Coffee
GSD&M Charles Schwab
Duffy & Partners Fresca
Greteman Group Cubano Coffee

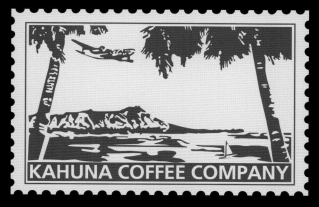

ORANGE
PEKOE

cream & bean

Ó! Mjolka
Together Design Orange Pekoe
Sukle Advertising & Design Deep Rock Water
Brinkley Design Cream & Bean

Coffeeology

,LLC.

RBMM TV Guide
Sandstrom Design ESPN
Peterson Ray & Company Circle Seven Radio
3G (Grand Gleaming Graphics) Jiang Su Broadcasting Corporation

Shinnoske Sugisaki Mainichi Broadcasting System

Sandstrom Design Marqui

Deep Design i3Media
McCann Erickson Russia Fund of Social Communications
Mine Dave Asheim
Lippincott Mercer Sprint
HZDG My-B-Line

VOICEWORKS

simplify

Mad Dog Graphx Osiyo Communications
Joe Miller's Company Air Zip, Inc.
Studio International Optima Telecom
MBA Voice Works
Mad Dog Graphx Simplify

™

Duffy & Partners V.I.O., Inc.

BOXEE

Grady Campbell, Inc. Global TechnologySolutions
Envelope Virtuosity
Graphics & Designing Inc. Nihon System Inc.
Method Boxee
3G (Grand Gleaming Graphics) Techno Peer Ltd.

Range, Inc. Metallect Software
Crave Design Agency Questionhound Technology Partners
Tompertdesign Scimagix
MiresBall Steve Woods
SullivanPerkins Surveillance Information System

CODEBREAKERS

QUALCON

Wallace Church, Inc. R & Z Products, LLC
Rick Johnson & Company Matteucci Construction
RBMM Champion Contractors
Drive communications Qualcon Construction Corp.
3 Measure Twice

NUVUK
CONSTRUCTION LLC

Blinn Design Build LinkAustralia
Rule 29 Collins Construction
EAT Advertising & Design ACS Log Build
Mad Dog Graphx Ukpeagvik Iñupiat Corporation
Hornall Anderson Design Works Weyerhaeuser Corporation

Deep Design Plemmons Associates
Les Kerr Creative People Results
Lienhart Design Wolf Management Consultants
B12 Coletti-Fiss
Tompertdesign Demand Solutions Group

Robertson Design Black Ink

Graphics & Designing Inc. VIA Holdings Inc.

3G (Grand Gleaming Graphics) BMT Trading Company
Okan Usta Palamut Group
Graphics & Designing Inc. OHGIYA Corporation
Concussion, LLC Quicksilver Gas Services
TOKY Branding + Design The Pyramid Companies

Lienhart Design Amercan Midwest Finance
Sibley/Peteet Design, Austin Buddy Systems Pet Toys
Graficode Poost ICT Brabant

Paul Black Design Production and Event Management, Inc.
A2/SW/HK A2 Type
3G (Grand Gleaming Graphics) All Natural Planning Inc.
Okan Usta Sinefekt Post Production Company
MBA White Hat Creative

Live!design Ltd. The Quality Label
AMEN Attraction Media
Supon Creative The Brand Trainer. com
Brand Plant Flash Loc
Mine Paradox

AILEY II

PLATINUM

Duffy & Partners Duffy & Partners

Tim Frame Design Tim Frame Design
Calagraphic Design Calagraphic Design
Alchemy Studios Alchemy Studios
Hornall Anderson Design Works Hornall Anderson Design Works
Tim Frame Design Tim Frame Design

VENTRESS DESIGN GROUP
INCORPORATED
GRAPHIC COMMUNICATORS

T2XI

[Z]™

Ty Wilkins Ty Wilkins
Greteman Group Greteman Group
TAXI Canada Inc. TAXI 2
Z Squared Design Z Squared Design
Mirko Ilic Corp. Mirko Ilic Corp.

601 Design, Inc. 601 Design, Inc.
Carmichael Lynch Thorburn Carmichael Lynch Thorburn
Irving (formerly Roberts & Co) No Twelve Queen Street
JWT Canada-Sauce Design Sauce Design
Tracy Sabin Sabingrafik, Inc.

Garfinkel Design University of Georgia Office of Public Service & Outreach
Hirschmann Design AIGA Colorado Literacy Poster Program
Catapult Strategic Design Universal Technical Institute, Inc.
Range, Inc. The Art of Life University
Rick Johnson & Company New Mexico Traffic Safety

ONTARIO
COLLEGE
OF ART &
DESIGN

1

FOOD FOR THOUGHT 2003

RBMM Lakewood Child Development Center
Hambly & Woolley Inc. Ontario College of Art & Design
Fujiwaki Design The Best of Graduation Works Executive Committee in Japan
Sullivan Perkins Yavneh Academy
Sibley/Peteet Design, Austin Communities in Schools

NNG

Beth Singer Design Cable in the Classroom
Hirschmann Design Vanderhoof Elementary School
Pentagram Design One Laptop per Child
RBMM Dream Tree
Graphics & Designing Inc. Nagasaki Nihon University Jr/Sr High School

THE MONARCH SCHOOL

Arny

Digtrox

Pirate

Xchysch

Tectronic

Human

Ginette Caron Grand Theatre de Provence
Concussion, LLC Fort Worth Zoo
Concussion, LLC Fire Lake Grand Casino
TOKY Branding + Design Opera Theatre of Saint Louis
Rickabaugh Graphics Self-Promotion

Wink Marshall Fields
Dfraile David Alcazar

Movie

Sibley/Peteet Design, Dallas Dallas Society of Visual Communications
Judson Design Associates The Chinquapin School
Cass Design Co. McNeilly Center for Children
Wink Marshall Fields
Dfraile David Alcazar

THE MODERN BALL

MBA St. Marks Episcopal Day School

Woodpile Studios The Recording Academy (top, bottom)
Range, Inc. Free Spirit Peace Initiative
Beth Singer Design American Israel Public Affairs Committee
Range, Inc. YPO Scotland University – Kids Program

Greteman Group Kansas Humane Society
Okan Usta Toy Industry Association
Sullivan Perkins Caldwell Zoo
Stritzel Design Group The buffalo club
Lanny Sommese Pets Extravaganza, State College

2006
Ball
Atlanta
Symphony
Orchestra

CONVERSE ONE

Indigo Palms

DENIM COMPANY

UNIT Design Collective Skate the Streets
Sandstrom Design Converse
Studio International Varteks
Graphics & Designing Inc. WORLD Co., Ltd.
Carmichael Lynch Thorburn Indigo Palms

Weymouth Design Harvard University Cycling Association

Big-Giant UNKL Brand
TAXI Canada Inc Lanctot
Weymouth Design Harvard University Cycling Association
Puma Puma
Deep Design Dead Man's Shoes

B A N A N A J O E

B A N A N A J O E

Sibley/Peteet Design, Dallas TSI tropical sportswear (top, bottom)
Ramp DenimHead
Graphics & Designing Inc. Miss Ashida 2006
Hirschmann Design Crocs Mambaz

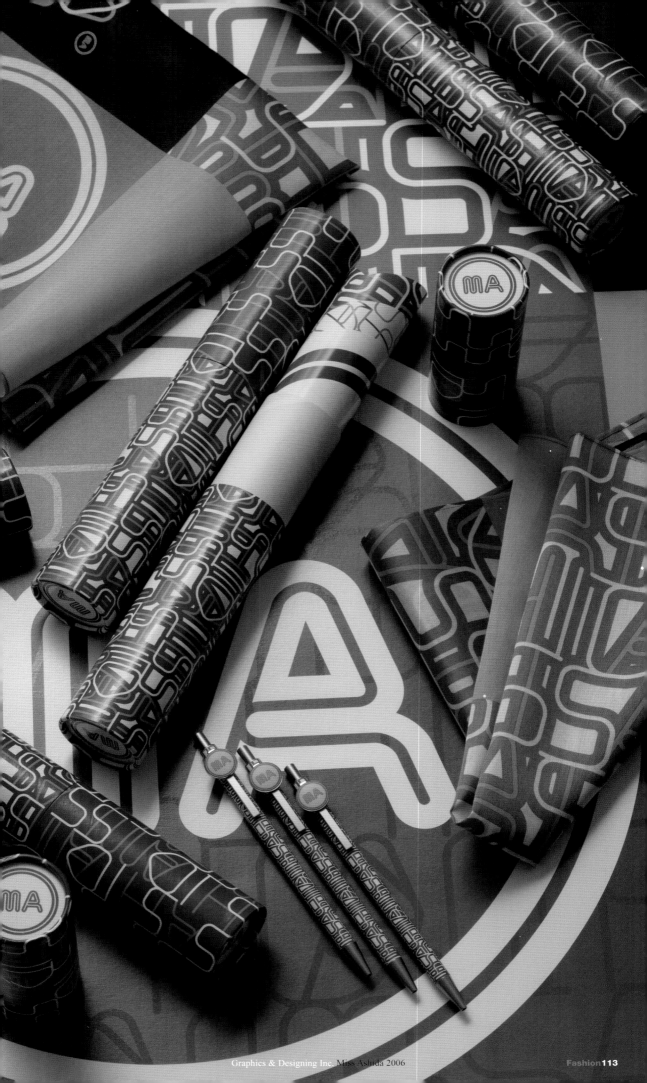

Graphics & Designing Inc. WORLD Co., Ltd. (this spread)

ƆFC

Intralink Film Graphic Design Fox Atomic/Karen Crawford

WESTERN IMAGE
COMMUNICATIONS, INC.

Ó! Square One Films
Liska + Associates Tim Bieber
STORY STORY
Chris Corneal Western Image Communications
Carmichael Lynch Thorburn Flying Circus Films

Gee + Chung Design DCM
The Bradford Lawton Design Group Air Force Federal Credit Union (middle)

Dfraile Ruta Solidaria
Graphic Content Pilgrims Pride
Murillo Design Atlas Culinary Adventures

Duffy & Partners Mill City Farmers Market, Farm In The City
Dfraile El Campillo
MiresBall Bochner chocolates
Strømme Throndsen Design Tre Søstre AS
Tim Frame Design Billy's Bakery

Mark Oliver, Inc. Piller Rock Salmon

Tim Frame Design Charley's Steakery

Tim Frame Design Charley's Steakery (top, bottom)
Michael Schwab Andy Skov/Point Reyes Capital
Hotsauce Wyndy's Hotsauce
GSD&M Garden State Sala

COME & DISH

COME & DISH

COME & DISH

Tracy Sabin Seafarer baking Company
RBMM Lobo Tortilla Factory
Matsumoto Incorperated Azen
Concussion, LLC Treehouse Foods
Delikatessen. Agentur für Marken und Design GmbH Rewe Austria

Guster &
Gusterica

UNIQUE FLAVORED PASTA

Graphics & Designing Inc. VIA Holdings Inc.
Hornall Anderson Design Works Cold Standard
Stand Advertising Rich Products
Spela Draslar Guser&Gusterica
Alterpop Pastabilities

Prejean Creative Lafayette Utilities System (top)
601 Design, Inc. National Conference of State Legislatures

 Republic
of Croatia
Ministry
of Culture
Republika
Hrvatska
Ministarstvo
kulture

St!Louis

Giotto Design Conamu
TURF The City of New York
Studio International Croatian Ministry of Culture
Fleishman-Hillard Creative St. Louis Regional Chamber & Growth Association
Grady Campbell, Inc. Lake County

The Bradford Lawton Design Group Oak Hills Periodontics
Tompertdesign VeraLight
The Bradford Lawton Design Group Easy Inch Logo
A3 Design Bryant & Duffey
iHua Design Pomiard Pharmaceuticals

LOOT

John Nordyke LAKS laboratories
Mark Oliver, Inc. Dugan Physical Therapy
Tracy Sabin Shepherd's ranch
Sandstrom Design Root
Adventa Lowe Adventa Lowe

modus

Lippincott Mercer Hyatt Corporation
Craig-Teerlink Design Sierra Club
VIVA DESIGN! studio Kronos, Crimean Riviera Hotel Complex
Mirko Ilic Corp. Joule Hotel & Resort
Carlson Marketing Worldwide Carlson Hotels Worldwide

Naughtyfish design Dictionary of Australian Artists Online (DAAO) (this spread)

Jan Sabach Fresh Research
Hirschmann Design CaringFamily
Pentagram SF Radial Point
GSD&M fishdirectory.net
Jan Sabach Unilever

™

John Michael Pugsley Design Inc. Creata

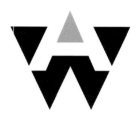

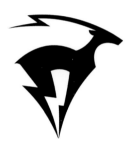

Go Welsh Armstrong World Industries
Hornall Anderson Design Works Active Wear
Oxide Design Co. Springbok, Inc.
The Design Studio of Steven Lee HotSteel
Nicholas M. Agin Sanivera

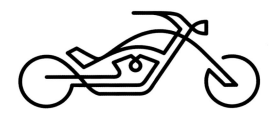

Tactical Magic Jay Etkin Gallery

Matsumoto Incorporated Fabric Workshop and Museum
Studio International Museum Documentation Centre (middle)

Poulin + Morris Inc. Newseum/Freedom Forum
Beth Singer Design Museum of the Shenandoah Valley
Graphics & Designing Inc. Tokyo Food Museum
Bandujo Donker & Brothers The Museum of Lower Manhattan
Sussman/Prejza & Company, Inc. Museum of the African Diaspora

Hiebing SongVest
Ventress Design Group Zia Music Production
Toolbox Studios, Inc. Good For The Soul Music

MUSIC
FOR EVERYONE

Volt Positive New Talent Conservatory
Go Welsh Music for Everyone
Frost Design Warner Music (middle, fourth)
Peterson Ray & Company Zeus Rooster

Range, Inc. Teen Talk
Mark Oliver, Inc. Valley Alliance
Deadline Advertising AIAS (The Academy of Interactive Arts & Sciences)
Joe Miller's Company Build
The Bradford Lawton Design Group Friends for the Fight

haddad

555-W23
NYC

PH₂OTO

3 Light Switch Studio
TODA Darrin Haddad
Stockland Martel Stockland Martel
Creation House Mr.Ho Underwater Photography
Sibley/Peteet Design, Dallas Julian Noel Photography

Catapult Strategic Design Prisma Graphic Corp.
Sandstrom Design Printing Today
Range, Inc Printworx

Company B

Pollard Design National Safe Tire Coalition
Sandstrom Design Three Mile Canyon Farms
Interbrand Voq, Sierra Wireless
Sibley/Peteet Design, Dallas Atomic Toys
@Radical media The City of New York Mayor's Office of Film, Theatre & Broadcasting

Tracy Sabin Luxury Dog Products

Wray Ward Laseter Springs Global
Range, Inc Marbles Childrens Learning
Zync Communications Inc. Weston Forest Group
Bernhardt Fudyma Design Group Bloom Craft Home
Kitemath Retrobotics

Lam Design Group Kyriakos and Megan Pagonis

issimbow

petanica

Pentagram SF Fuego North America
Range, Inc McCue Corporation
Ginette Caron Knoll International/Trent Baker
Supon Creative Petanica
Mirko Ilic Corp. Paradoxy Products

segue

pfw design Cook County Canines
Gouthier Design: a brand collective Desirability
Sugarlab The Presentation Coach - Ellen Lee
Buzzsaw Studios, Inc Bend Valet
Kate Resnick Design Segue

Tompertdesign X Development

@Radical media The City of New York Department of Information, Technology and Telecommunications
Braley Design Southern Truth And Reconciliation
Meta4 Design McCormick Tribune Foundation
Beth Singer Design ICHEIC
Wall-to-Wall Studios, Inc. Pittsburgh Arts & Lectures

Squires & Company Young Executive Association

Catapult Strategic Design Boy Scouts of America, Grand Canyon Council
Graphic Content Living Dream Foundation
The Bradford Lawton Design Group Wildlife Rescue and Rehabilitation
Duffy & Partners Kerzner Marine Foundation
Hirschmann Design What's Driving You?

Unit Design collective Chinatown Community Development Center
RBMM The Home Depot
Keith Harris Design Stadtmarketing Konstanz
Studio International Museum Documentation Centre
Greteman Group Kansas Children's Service League

le Biarritz

Sullivan Perkins DSVC
Prejean Creative Simon & Schuster
El Paso, Galeria de Comunicacion Buchmann Ediciones
Stritzel Design Group Le biarritz magazine
Miriello Grafico, Inc Hyperion

N E W Y O R K

N E W Y O R K

N E W Y O R K

N E W Y O R K

Tracy Sabin Barratt American
Pentagram Design Somerset Partners
Rees Masilionis Turley Architecture Alsation Land Company
Catapult Strategic Design AAM
Tracy Sabin Kimball Hill Homes

Littleton Advertising and Marketing Maida Vale
Sibley/Peteet Design, Dallas Jackson Cooksey
Rogue Element Inc. Marcia Cegavske
Catapult Strategic Design Element Homes
Brad Simon National Beverage Properties

EST. 1989

ANTLER
RANCH

Helium Diseño Proasa
Frank Worldwide 55 West Wacker
Helium Diseño Picciotto Arquitectos
Hornall Anderson Design Works Schnitzer West
Concussion, LLC N3

SUMMIT

Sullivan Perkins Food, Friends and Company
Peterson Ray & Company The Gecko Lounge
Brandoctor Boris Juric, Gajba
Mirko Ilic Corp. The Broadmoor
Sibley/Peteet Design, Austin Adobe Texican Cafe

Wish you were here!

Louise Fili LTD. Mermaid Inn
Sibley/Peteet Design, Dallas Victor's Sea Grill
Dfraile DELADO
Jessica Campbell Noir Ultra Lounge
Range, Inc Iron Horse Saloon

zeist design, llc CKE Restaurants
Deep Design A Sharper Palate
Graphics & Designing Inc. RC Japan Co., Ltd.
HZDG C3fix
HKLM King Pie Holdings

Duffy & Partners Atlantis: Paradise Island, Resort
RBMM Drum Room
HOOK Restaurant Development Associates
Louise Fili LTD. ShoreHouse
Shikatani Lacroix Brandesign Second Cup

RBMM Patti's Place
Dennard, Lacey & Associates 3rd Base Sports Bar & Grill-
Sibley/ Peteet Design, Austin El Pato Fresh Mexican Food
Gestudia Nona's Pantry
Concrete Design Communications Inc. Pizza Nova

Totem Visual Communications Alan Dalton Goldsmith
Proteus Design Longs Drugs
Peterson Ray & Company Crossroads Coffehouse & Music Company
William Homan Design West Yellowstone Fly Shop
MBA Hill Country Weavers

ART GLASS EMPORIUM

HOME ON THE RANGE INC

Concussion, LLC Hello Labels
Team Young & Rubicam Art Glass Emporium
601 Design, Inc. Home on the Range
3G (Grand Gleaming Graphics) KAIHONG PLAZA
Rick Johnson & Company Bone Bistro

IKD Design Solutions Marquis Philips

Graphics & Designing Inc. Mercian Corporation
BlackDog The Wine Group
Turner Duckworth Tommy's Margarita
Graphics & Designing Inc. Takus office
Delikatessen. Agentur für Marken und Design GmbH Radeberger Gruppe

SIDE JOB
CELLARS

Delikatessen. Agentur für Marken und Design GmbH Radeberger Gruppe
Bailey Lauerman Miletta Vista
Mark Oliver, Inc. Santa Rita Hills Wine Growers Alliance
Rob Duncan Design, Thermostat Side Job Cellars
tbdadvertising Odell Brewing Co.

Synergy Graphix Piranha Extreme Sports
Daniel Green Eye-D Design Green Bay East High Soccer Booster Club
Planet Propaganda Cambiatta
Ford Weithman Design Adidas
Greteman Group Butler College

Hornall Anderson Design Works Seattle Seahawks
Andreas Zalewski Proposal work
MBA 2 Man Tour
Goodby, Silverstein & Partners USA Cycling
Carmichael Lynch Thorburn IMBA(International Mountain Biking Association)

SARDEGNA

Carbone Smolan Brooklyn Botanic Garden
Group One Kasba Lake Lodge
Pentagram Design Ltd Regione Autonoma della Sardegna
601 Design, Inc. The Denver Post
ID Creative Services, LLC Bend Visitors Bureau

COIT

TOWER
SAN FRANCISCO

MARINA

GREEN
SAN FRANCISCO

CONSERVATORY OF
FLOWERS

GOLDEN GATE PARK

UNION

SQUARE
SAN FRANCISCO

JAPANESE
TEA

GARDEN
GOLDEN GATE PARK

Cronan Design San Francisco Parks Trust

Michael Schwab Red & White Fleet
RBMM Golden State Movers
RBMM MOVESTAR, Inc.
Fusion Advertising Oak Cliff Transit Authority
GodwinGroup KLLM Transport Services

M Space Design Zip Car

Michael Doret Alphabet Soup Type Founders

CALDWELL
— ZOO —

Credits

Advertising

30 Deadline Logo | Design Firm: Deadline Advertising | Creative Director: Amir Parstabar | Client: Deadline Advertising

Deadline is an entertainment-based ad agency, with clients including motion picture studios, home entertainment divisions, television networks and videogame publishers. Our logo is a literal, if entertaining, interpretation of our company name, signifying the police line around a dead person for arresting effect.

31 (first) 3 Logo | Design Firm: 3 | Creative Director: Sam Maclay | Account Director: Chris Moore | Design Director: Tim McGrath | Client: 3

Logo for an advertising design firm called 3. The three partners' last names all begin with the letter M.

31 (second) Rails Relationship Marketing | Design Firm: RBMM | Designer: Kevin Baile | Client: Rails Relationship Marketing

Company specializing in marketing development and brand building to create stronger, lasting, unique relationships with clients.

31 (third) Push logo | Design Firm: Sheaff Dorman Purins | Art Director: Uldis Purins | Designer: Karen White | Client: Push Advertising

31 (fourth) Target Base Marketing | Design Firm: Range, Inc | Designer/Design Director: John Swieter | Client: Targetbase-Omnicom

31 (fifth) Barkley Logo | Design Firm: Barkley | Executive Creative Director: Craig Neuman | Chief Creative Officer: Brian Brooker | Art Director/Designer: Eric Jones | Client: Barkley Evergreen & Partners

32 (first) 40th Anniversary Logo | Design Firm: Barkley | Creative Director: Craig Neuman | Designer: Eric Carver | Client: Barkley Evergreen & Partners

32 (second) Turn Corporate Identity | Design Firm: Addis | Creative Director: John Creson | Designer: Rebecca Au-Williams | Client: Turn

32 (third) Periodical | Design Firm: Deka Design Studio | Art Directors: András Szentpéteri, Róbert Tóth | Designer: Gyöngyi Bokor | Client: ARC Magazine

A project to redesign traffic signs. I aspire to give deeper meaning to simple signs, and find it exciting to add a new sense to an ordinary, well-known frame. One of the most disturbing problems for me is the behavior of consumer society. People are often forced into unreasonable, permanent consuming situations. It is a significant problem for both society and the environment. I target and caricature this question with my logo. There is a famous, annual Hungarian open-air exhibition, which deals with social problems. This logo was exhibited in the summer of 2006.

32 (fourth) New Blood | Design Firm: Evia Ltd. | Creative Director/Art Director: Tommi Mustonen | Print Producer: Kai Haikonen | Client: Evia Ltd.'

A page-wide recruitment ad for advertising agency Evia was published in the largest daily newspaper. The bloody letters provoked huge interest in the open positions for AD and Copy.

32 (fifth) TruAd | Design Firm: Hirschmann Design | Art Director/Designer/Illustrator: Karl Hirschmann | Client: TruAd

This is a symbol for mobile advertising media.

Agriculture

33 Montgomery Farm Gardens Logo | Design Firm: Sibley/Peteet Design, Dallas | Creative Director: Don Sibley | Designer/Illustrator: Geoff German | Client: Montgomery Farm

34 (first) Hay Processing Unlimited Corporate Identity | Designer: Jeff Pollard | Client: Hay Processing Unlimited

Northwest-based horse farm. The identity captures the client's fun, irreverent sense of humor while depicting a very different take on the processing of hay. My additional design/brand goal was to create a mark that at first glance looked and felt like an old-family business-style logo or crest with the pay-off coming upon closer inspection.

34 (second) Bellwether Farms Logo | Design Firm: Mark Oliver, Inc. | Creative Director/Art Director: Mark Oliver | Illustrator: Sudi McCollum | Client: Bellwether Farms

Logo identity for a small, family-owned creamery that produces award-winning artisan cheeses.

34 (third) JRK Seed Company Brandmark | Design Firm: P&H Creative Group | Creative Director/Illustrator: Tom Baker | Art Director: Roger Remaley | Designers: Rich McGowen, Roger Remaley | Client: JRK Seed Company

The brandmark needed to work on a wide range of substrates and printing methods, some quite crude, so intricate details were avoided and a somewhat bold approach was chosen. The logo has a heritage feel that harkens back to smaller, high-quality seed companies of yesteryear, which resonates with today's consumers. Primary usage is on canvas sacks. The type and illustration were hand-done to further enhance the brand personality and make the brandmark more proprietary. We wanted this mark to have a kinship with farmer almanacs, old seed companies, implement companies, etc., and a truly mid-western feel.

34 (fourth) Osuna Nursery Logo | Design Firm: 3 | Chief Creative Officer: Sam Maclay | Designer: Tim McGrath | Client: Osuna Nursery

Osuna Nursery prides itself on providing healthy plants and a nurturing environment for its products.

Architecture

35 Boulder Associates | Design Firm: Hirschmann Design | Art Director: Elizabeth Stout | Designer/Illustrator: Karl Hirschmann | Client: Boulder Associate

Logo for a firm specializing in healthcare architecture.

36 Architecture | Design Firm: Muller+Company | Art Director: Jeff Miller | Client: Architecture

37 (first) Project Logo | Design Firm: Café Design | Creative Director: Attila Simon | Art Director/Designer: Zsolt Kathi | Project Manager: Balazs Szentey | Client: Wallis Real Estate

Stadium office building: This is the project logo for an office block offering places to departments of the Hungarian Economic University as well as commercial offices.

37 (second) Niche Interiors | Design Firm: Kate Resnick Design | Designer: Kate Resnick | Client: Niche Interiors

Logo for an architecture and interior design company.

37 (third) The Octagon | Design Firm: Alexander Isley Inc. | Creative Director/Art Director: Alexander Isley | Designers: Hayley Capodilupo, Alexander Isley | Client: Becker + Becher Architecture

This architectural firm hired us for creative development and design of all graphics and communications materials, including identity, sales brochures, posters, advertising, website, a panel exhibit system, site maps, exterior and interior signage, as well as signage for an ecological park. In a nutshell, we were hired to give 'The Octagon' its visual voice. The Octagon is the restoration of the historic Octagon building on Roosevelt Island in Manhattan.

37 (fourth) Strang Logo | Design Firm: Planet Propaganda | Creative Director: Dana Lytle | Designer: Geoff Halber | Client: Strang, Inc.

Logo for an architecture firm.

37 (fifth) Project Logo | Design Firm: Café Design | Creative Director: Attila Simon | Art Director/Designer: Zsolt Kathi | Project Manager: Balazs Szentey | Client: Wallis Real Estate

Residential property project logo.

ArtistRepresentative

38 American Advertising Federation San Antonio | Design Firm: The Bradford Lawton Design Group | Creative Director: Bradford Lawton | Art Director/Designer: Rolando G. Murillo | Client: American Advertising Federation San Antonio

Identity for the local chapter of the AAF.

39 Starvn Artist | Design Firm: DarbyDarby Creative | Creative Director/Art Director/Designer: Keith L. Darby | Client: Starvn Artist

Starvn Artist is an artist (singer, songwriter and musician) management company. The logo represents the professionalism of the company and the ambitious, hungry nature of its talent.

Automotive

40 Model A Ford Club | Design Firm: Sibley/Peteet Design, Dallas | Designer: Craig Skinner | Client: Model A Ford Club

Logo for a car enthusiast club in Dallas.

41 (first) Motor Skills | Design Firm: Tim Frame Design | Designer: Tim Frame | Client: Touristees.com

41 (second) Roadsmith | Design Firm: Initio Advertising | Creative Director: Paul Chapin | Art Directors: Joe Monnens, Randy Pierce | Designer: Joe Monnens | Illustrator: Steve Kemmerling | Writer: Joann Plockova | Client: The Trike Shop

Logo is the result of a complete re-branding effort for a line of trikes — motorcycles converted into three-wheeled bikes, crafted by The Trike Shop. Shop has been converting bikes to trikes with a hands-on approach for over 30 years. The name and logo needed to communicate expert positioning as well as craftsmanship, attention to detail and strength. Simultaneously, it needed to exude the qualities of a motorcyclist: attitude and a desire for the open road. The logo will be placed on the back of the trikes, retail store signage, sales materials, advertising, and vehicle graphics.

41 (third) CVAR Logo | Design Firm: Origin Design | Chief Creative Officer/Creative Director: Jim Mousner | Art Director/Design Director: Denise Madera | Artist /Designer: Martin Pepper | Client: Corinthian Vintage Auto Racing

Logo for an auto club that supports and races vintage cars.

41 (fourth) TruckTrax | Design Firm: Hornall Anderson Design Works | Art Director: Jack Anderson | Designers: Gretchen Cook, Kathy Saito | Client: TruckTrax

Logo for an automated truck tracking system, designed for the ready-mix industry fleet.

41 (fifth) Toyota Trucks | Design Firm: Duffy & Partners | Executive Creative Director: Joe Duffy | Creative Director: Dan Olson | Designers: David Mashburn, Esther Mun | Client: Toyota Trucks

The solution builds off of Toyota's equities, while at the same time pointing to a bold future. Reinforces attributes of quality, reliability and dependability. Mark was designed to be strong yet humble, timely yet timeless. Featured throughout all truck communications and will eventually be integrated onto the vehicles.

Aviation

42 (first) Southwest Airlines Logo | Design Firm: GSD&M | Creative Director: Tim McClure | Designer/Illustrator: Dale Minor | Photographers: Dave Mead, Michael Patrick | Client: Southwest Airlines

The new logo reflects the airline's total brand makeover, including their new plane livery design.

42 (second) Wichita Aviation Festival logo | Design Firm: Greteman Group | Art Directors: Sonia Greteman, James Strange | Designer: James Strange | Client: Wichita Aviation Festival

42 (third) Eos Airlines Logo | Design Firm: Hornall Anderson Design Works | Creative Director: Jack Anderson | Art Director: Mark Popich | Designers: Mark Popich, Larry Anderson, David Bates, Andrew Wicklund, Leo Raymundo, Jacob Carter, Yuri Shvets | Illustrators: Mark Popich, David Bates, Andrew Wicklund, Leo Raymundo, Jacob Carter, Yuri Shvets | Client: Eos Airlines

...

Credits

...

Named for the Greek goddess of dawn, Eos Airlines, a transatlantic airline catering to business travelers, provides passengers 21 square feet of personal space by placing 48 seats on a plane that usually accommodates over 200. The premium class service targets the discerning traveler, offering the comfort of suites, not seats.

42 (fourth) ExpressJet Logo | Design Firm: Origin Design | Chief Creative Officer/Creative Director: Jim Mousner | Art Directors: Jennifer Gabiola, Saima Malik | Designer: Saima Malik | Illustrator: Saima Malik | Client: ExpressJet

42 (fifth) N9OR, aircraft logo | Design Firm: Range, Inc | Creative Director/Designer: John Swieter | Client: Occidental Petroleum

43 Platinum Jetnova | Design Firm: Dfraile | Art Director/Designer/Illustrator: Eduardo del Fraile | Client: Jetnova

Identity of a private jet rental company.

Beauty
44 (top) Belle Tresse Logo | Design Firm: Prejean Creative | Creative Director: Kevin Prejean | Designer/Illustrator: Brent Pelloquin | Client: Belle Tresse

A beauty/hair salon;'Belle Tresse'is French for 'Beautiful Braid.'

44 Platinum (middle) Melody Nixon Logo | Design Firm: The Bradford Lawton Design Group | Creative Director/Art Director: Bradford Lawton | Illustrator: Jason Limon | Client: Melody Nixon

Identity for a local hairstylist.

44 (bottom) Design Firm: Duffy&Partners | Executive Creative Director: Joe Duffy | Creative Director/Designer: Alan Leusink | Client: Basin White

Basin White — an upscale version of Basin, retailer of unique bath and beauty products — is designed to create an experience that extends the brand, presents unique, new products, and gives a new audience reason to connect. Designed to appeal to a more affluent and sophisticated audience, Basin White will be located in Disney's flagship hotel, the Grand Floridian Resort & Spa.

Beverage
45 100% Molokai Coffee | Design Firm: MCM Design Studio | Creative Director/Designer/Illustrator: Matthew McVane | Project Manager: Jessica Johnson | Client: Coffees of Hawaii

Series of logos for exclusive line of coffee that reflects the unique Hawaiian culture and origins in the coffee industry.

46 (first) Velo Coffee Logo | Design Firm: Hirschmann Design | Art Director/Designer/Illustrator: Karl Hirschmann | Client: Velo Coffee Roasters Logo

Symbol for drive-thru espresso.

46 (second) Kahuna Coffee | Design Firm: Blinn Design | Creative Director/Designer: K.C. Blinn | Client: Kahuna Coffee

Identity development for Hawaiian-theme coffee shop chain, known for roasting Kona Coffee beans on the premises.

46 (third) Coffee Corner Logo | Design Firm: GSD&M | Creative Director: Tim Sabo | Designer: Tom Kirsch | Client: Charles Schwab

Logo for a mock coffee shop used in Charles Schwab commercial.

46 (fourth) Fresca | Design Firm: Duffy & Partners | Executive Creative Director: Joe Duffy | Chief Creative Officer: Dan Olson | Designer: George Katz | Client: Fresca

46 (fifth) Cubano Coffee Logo | Design Firm: Greteman Group | Creative Director: Sonia Greteman | Designer: James Strange | Client: Cubano Coffee

47 Kahuna Coffee | Design Firm: Blinn Design | Creative Director/Designer: K.C. Blinn | Client: Kahuna Coffee

48 (first) Mjólka | Design Firm: Ó! | Art Director/Designer: Örn Smári Gíslason | Client: Mjólka

Mjólka is dairy production company in Iceland.

48 (second) Orange Pekoe Branding | Design Firm: Together Design | Creative Directors: Heidi Lightfoot, Katja Thielen | Designer: Sabine Schaefer | Writer: Maf Bishop | Client: Orange Pekoe

Orange Pekoe is a privately owned venture aiming to become the industry leader in premium quality tea, offering a selection of more than 100 teas, as well as up-market tea rooms. Orange Pekoe needed an identity to convey quality, expertise and tradition, while still capturing contemporary appeal. The logo conveys the nature and quality of the business, and the sophisticated droplet shapes give a sense of the aromatic splendor of the teas.

48 (third) Corporate Logo | Design Firm: Sukle Advertising & Design | Creative Director: Mike Sukle | Designer: Jamie Panzarella | Client: Deep Rock Water

48 (fourth) Cream & Bean | Design Firm: Brinkley Design | Art Director: Leigh Brinkley | Designers: Leigh Brinkley, Leslie Houser | Illustrator: Felix Scokwell | Client: Cream & Bean

Created for a new retail concept for the South, frozen custard creamery and specialty coffee house.

49 Coffeeology Logo | Design Firm: Huber Creative, LLC | Art Director: Blaine Huber | Client: Coffeeology, LLC

Broadcast/TV/Radio
50 Toonami Logo | Design Firm: Dream Empire | Designer: Vinko Kalcic | Client: Toonami (Cartoon Network)

This logo won the Ridley Scott Award for Motion Graphics in the International competition, organized by Escape Studios in London (biggest 3D and Special Effects studios in Europe). More than 7,000 artists/designers competed for the Award. The task was to create a sketch of a new logo for their tv station and storyboard showing the logo in animation. I finalized the logo after the competition.

51 (first) TV Guide Logo | Design Firm: RBMM | Creative Director: Dick Mitchell | Client: TV Guide

51 (second) ESPN U Logo | Design Firm: Sandstrom Design | Creative Director/Senior Designer: Steve Sandstrom | Project Manager: Jim Morris | Client: ESPN

Identity for a cable tv network specializing in college sports.

51 (third) Circle Seven Radio Logo | Design Firm: Peterson Ray & Company | Creative Director/Designer: Miler Hung | Client: Circle Seven Radio

Logo for a radio station that plays local music talents.

51 (fourth) JiangSu Broadcasting Corporation Mark | Design Firm: 3G (Grand Gleaming Graphics) | Creative Director: Wang Chao-Ying | Art Director: Hiroyuki Hayashi | Designers: Hiroyuki Hayashi, Shanghai PAOSNET Image Design Co., Ltd. | Client: JiangSu Broadcasting Corporation

Motif created by combining the Chinese character initials gJSh from the Romanized name for this tv station located in Jiangsu (Nanjing), China, with the Chinese character glh for person.

52 Theater Brava! | Design Firm: Shinnoske Sugisaki | Creative Director: Mikio Uno | Art Director: Shinnoske Sugisaki | Designer: Chiaki Okuno | Client: Mainichi Broadcasting System

All-purpose theater whose central activity is drama. "BRAVA!" is an Italian exclamation used in admiration of women. The logotype is based on those letters and visualizes cheering and clapping. Colors and construction may be changed according to purposes.

Communication
53 Logo for Revere Communications | Design Firm: Fleishman-Hillard Creative | Designer: Buck Smith | Client: Revere Communications

54 Marqui logo | Design Firm: Sandstrom Design | Creative Director/Designer: Jon Olsen | Project Manager: Kelly Bohls | Client: Marqui

Our goal was to position Marqui as a communication management service provider by creating a mark which conveys Marqui's positioning line: "changing communication."

55 (first) i3Media logomark | Design Firm: Deep Design | Creative Director: Rick Grimsley | Art Director/Designer/Illustrator/Design Director: Heath Beeferma | Client: i3Media

An independent media services company.

55 (second) OK | Design Firm: McCann Erickson Russia | Creative Director: Alexander Alexeev | Art Director/Designer: Oleg Pudov | Client: Fund of Social Communications

55 (third) Guide by Cell | Design Firm: Mine | Designer: Christopher Simmons | Client: Dave Asheim

Company offering guided audio tours via cell phone. The stylized "G" in the shape of a phone is created from a single, continuous line (the guided path).

55 (fourth) Sprint | Design Firm: Lippincott Mercer | Creative Directors: Rodney Abbot, Connie Birdsall | Designers: Adam Stringer, Ryan Kovalak, Alissa Tribelli | Strategists: Kim Rendleman, Chiaki Nishino | Client: Sprint

Sprint and Nextel merged. Sprint's broad market awareness and history of innovation made it the most appropriate choice for the brand name of the new company, yet it was important to retain the entrepreneurial and instant communications traits of Nextel. We needed to integrate the most valuable assets of each company's corporate identity to support the redefined brand strategy and signify the powerful convergence of two strong, confident brands. We designed a new logo combining elements of Sprint's signature "pin drop" identity (representing clarity) and Nextel's signature palette of bold yellow and black. This new "wing" symbol reflects a sense of motion and flight, evoking the energetic, dynamic and visionary characteristics of the new company.

55 (fifth) My-B-Line logo | Design Firm: HZDG | Executive Creative Director: Karen Zuckerman | Creative Director: Tamara Dowd | Art Director: Mike Palanza | Client: My-B-Line

56 (first) Osiyo logo | Design Firm: Mad Dog Graphx | Art Director/Designer: Kris Ryan-Clarke | Client: Osiyo Communications

American Indian-owned communications consulting company that works with many Native-owned corporations needed a logo that reflected their heritage without looking dated or too specifically Indian (since they also work with Alaskan, Hawaiian, and South American Native companies). The feather and simple beadwork of the logo are also common to all these Native groups.

56 (second) AirZip Igotype | Design Firm: Joe Miller's Company | Designer: Joe Miller | Client: AirZip, Inc.

Wireless communications and data company logo.

56 (third) Optima | Design Firm: Studio International | Creative Director/Art Director/Designer/Design Director/Artist/Writer: Boris Ljubicic | Account Director: Igor Ljubicic | Editor: Roland Zuvanic | Client: Optima Telecom

First letter has a movable part, representing a phone receiver.

56 (fourth) VoiceWorks Identity | Design Firm: MBA | Designer: Mark Brinkman | Client: VoiceWorks

Voice-activated telephone services.

56 (fifth) Simplify logo B | Design Firm: Mad Dog Graphx | Art Director/Designer: Kris Ryan-Clarke | Client: Simplify

Refines business and company/client communications. Their name demanded a logo that epitomized the idea of simplicity. Two versions were created: one visually expressed an epiphany; the other distilled the logo to a simple wordmark.

57 Logo Hieke de Zeeuw | Design Firm: Design Raymann BNO | Designer: Willem Raymann | Client: Hieke de Zeeuw communicatie&management bv

Multicolored logo designed in three versions for use in different

Credits

applications. The logo is an abstract "Z" divided into triangles and quadrants. The logo's clean, simple feel and its expressive colors create a recognizable and memorable identity.

Computer&Technology

58 V.I.O., Inc. | Design Firm: Duffy & Partners | Creative Director: Alan Leusink | Designer: Joseph Duffy IV | Project Managers: Bridget Schumacher, Pooh Keoraj | Client: V.I.O., Inc.

Video. In. Out. The letters in VIO are combined in a unique form to suggest an eye and camera lens. The strategic underpinning of the final design is that VIO allows you to record digital video from your personal perspective so others can see exactly what you have seen. The logo is just one component of an entire brand language which will inform product badging, packaging, the technology interface, and website and marketing communications materials.

59 (first) GTS Logo | Design Firm: Grady Campbell, Inc. | Creative Director/Design Director: Kerry Grady | Designers: Kerry Grady, Mark Stammers | Account Directors: Kerry Grady, Don Campbell | Client: Global Technology Solutions

GTS is a privately owned, Portugal-based corporation. With offices in Europe and North America, the company provides services from commercial real estate to banking, and is a key product supplier to the world's cork market. This logo is based upon a three-part, dynamic, and forward-moving company that has the founding family at its core.

59 (second) Visual Identity | Design Firm: Envelope | Art Director/Designer: Blair Kennedy | Client: Virtuosity

The identity for an upcoming software application that lets users create their own avatars for online gaming. The logo uses a stylized human retina to represent the uniqueness of every individual.

59 (third) General Entertainment Company | Design Firm: Graphics & Designing Inc. | Art Director/Designer: Toshihiro Onimaru | Client: Nihon System Inc.

The information that flows in the hexagon represents the software and energy of a company that operates amusement facilities. Flat hexagon is designed to appear as a 3D box.

59 (fourth) Boxee | Design Firm: Method | Art Director: Robert Murdock | Account Director: Geoff Katz | Project Manager: Stephanie Curran | Client: Boxee

Boxee is developing software that brings digital media to the tv screen and living room. Whether the content sits at the home network or the Internet, this software enables people to watch videos, listen to music, view photos and access a variety of Internet services through their tv, using a remote control. We designed the identity mark and collateral system. The client wanted a young and edgy mark that conveyed a playful personality without being overly complex. It had to appeal to a broad audience, from gamers to mature couples and families.

59 (fifth) Techno Peer Ltd. Mark | Design Firm: 3G (Grand Gleaming Graphics) | Art Director/Designer: Hiroyuki Hayashi | Client: TECHNO PEER LTD.

Develops computer software. Initials of the company's name were given a 3D shape and combined so that when viewed from any direction — the top, side, front, etc. — "T" or "P" appears.

60 (first) Software Solutions Company | Design Firm: Range, Inc. | Creative Director: John Swieter | Designers: Ray E. Gallegos, John Swieter | Client: Metallect Software

60 (second) Questionhound Logo | Design Firm: Crave Design Agency | Designer: David Edmundson | Client: Questionhound Technology Partners

Questionhound is your trusted advisor to explore, acquire, support and implement the latest technology solutions.

60 (third) Scimagix Logo | Design Firm: Tompertdesign | Designer: Claudia Huber Tompert | Client: Scimagix

A leading provider of image informatics software allowing people to search large databases of scientific images not only by keywords, but also by image content.

60 (fourth) Steve Woods Brand Identity | Design Firm: MiresBall | Creative Director: Scott Mires | Designer: Mario Porto | Project Manager: Holly Houk | Client: Steve Woods

Steve Woods needed his young, Phoenix-based printing company to stand out in an industry prone to commoditization. The straightforwardness of the logo design — clean, classic typography combined with smooth lines and subdued colors — is intended to communicate approachability, quality and dependability.

60 (fifth) SurvIS Logo | Design Firm: SullivanPerkins | Designer: Jarrett Washburn | Client: Surveillance Information System

61 Codebreakers | Design Firm: RBMM | Designer: Brian McAdams | Client: Codebreakers

Creates codes and handbooks for PC and video games console.

Construction

62 Platinum Zwick Construction Company | Design Firm: Catapult Strategic Design | Creative Director/Art Director/Designer: Art Lofgreen | Illustrator: Jon Arvizu | Account Director: Dave Duke | Client: Zwick Construction Company

Hands-on, customer service-oriented construction management.

63 (first) R & Z Quick Mix | Design Firm: Wallace Church, Inc. | Creative Director: Stan Church | Designer/Illustrator: Akira Yasuda | Client: R&Z Products, LLC

63 (second) Matteucci construction | Design Firm: Rick Johnson & Company | Designer: Tim McGrath | Client: Matteucci Construction

63 (third) Champion Contractors logo | Design Firm: RBMM | Creative Director/Art Director: Brian Boyd | Designer/Illustrator: Brian McAdams | Client: Champion Contractors

63 (fourth) Qualcon Company Logo | Design Firm: Drive Communications | Creative Director: Michael Graziolo | Designers: Michael Graziolo, Matthew Simmons | Client: Qualcon Construction Corp.

63 (fifth) Measure Twice | Design Firm: 3 | Creative Director: Sam Maclay | Account Director: Chris Moore | Design Director: Tim McGrath | Client: Measure Twice

Logo for a general contractor. Two measuring squares were used to create the letter "M."

64 (first) BuildLink | Design Firm: Blinn Design | Creative Director/Designer: K.C. Blinn | Client: BuildLink Australia

64 (second) Collins Construction Logo | Design Firm: Rule29 | Art Director: Justin Ahrens | Designer: Justin Ahrens | Client: Collins Construction

Construction company specializes in remodels and additions.

64 (third) ACS log Build Logo | Design Firm: EAT Advertising & Design | Creative Director: Patrice Eilts-Jobe | Art Directors: DeAnne Dodd, Rachel Eilts | Designers: DeAnne Dodd, Rachel Eilts, Davin Watne | Client: ACS Log Build

Log construction company. Logo embodies the elements of building and captures the essence of the materials they use in nature.

64 (fourth) UIC/Nuvuk logo | Design Firm: Mad Dog Graphx | Art Director/Designer: Kris Ryan-Clarke | Client: Ukpeagvik Iñupiat Corporation

Nuvuk is one of UIC's construction companies (UIC is the Native-owned village corporation of Barrow, Alaska). The Native hunter is one of a handful of Barrow icons with a powerful local connection, and was chosen by the village as the symbol of its construction divisions. The orange sun unifies all of UIC's business marks. Barrow is called the land of the midnight sun because it enjoys 84 days of continuous sunlight each summer — a period during which the sun never dips below the horizon.

64 (fifth) iLevel | Design Firm: Hornall Anderson Design Works | Creative Director: Jack Anderson | Art Director: James Tee | Designers: James Tee, Andrew Wicklund, Elmer dela Cruz, Holly Craven, Jay Hilburn, Hayden Schoen, Belinda Bowling, Yuri Shvets, Michael Connors | Client: Weyerhaeuser Corporation

Consulting

65 Edge Advantage | Design Firm: Ryan Russell | Art Director: Ryan Russell | Client: Edge Advantage

66 Brandtailor | Design Firm: Creation House | Creative Director/Art Director: Michael Miller Yu | Illustrator: Henry Yu | Client: Brandtailor Ltd.

A brand consulting firm offering tailor-made service to clients.

67 (first) Power of One Logo mark | Design Firm: Deep Design | Creative Director/Illustrator: Fernando Lecca | Client: Plemmons Associates

A healthcare-based executive search firm.

67 (second) People Results | Design Firm: Les Kerr Creative | Creative Director/Designer: Les Kerr | Client: People Results

PeopleResults develops workforce strategies and solutions for corporate change management, talent development, employee communications, and human relations outsourcing.

67 (third) Wolf Management Consultants | Design Firm: Lienhart Design | Designer: Jim Lienhart | Client: Wolf Management Consultants

Specializes in helping companies reach maximum effectiveness.

67 (fourth) Incentive Xpress | Design Firm: B12 | Creative Director/Designer/Illustrator: Dave Prescott | Client: Coletti-Fiss

A consulting company that helps businesses develop variable rate compensation plans for sales and marketing employees through software-driven algorithms.

67 (fifth) Demand Solutions Group Logo | Design Firm: Tompertdesign | Designer: Claudia Huber Tompert | Client: Demand Solutions Group

Consulting group specializing in turn-key on-demand.

68 American Physicians Management Consulting | Design Firm: MBA | Art Director/Designer: Mark Brinkman | Client: American Physicians Management Consulting (APMC)

The medical caduceus was the crowning jewel of this malpractice insurance agency that provides strategic services for physicians.

69 Platinum Black Ink logo | Design Firm: Robertson Design | Art Directors: Jeff Carroll, John Robertson | Client: Black Ink

Black Ink is in the business of retail consulting. They help clients determine correct inventory levels to keep profits high and excess inventory to a minimum, reducing the costly need for discount sales. The positioning line is "Are You Operating in the Black?"

Corporate

70 Holding company of wide-ranging businesses | Design Firm: Graphics & Designing Inc. | Creative Director: Takanori Aiba | Art Director/Designer: Toshihiro Onimaru | Client: VIA Holdings Inc.

Holding company with a variety of business interests, such as restaurants, software, and printmaking. Logo is designed in the spirit of an enterprise that creates new value. Human knowledge takes the form of a pyramid. It represents one's mission, a spirit of innovation, collective strength, solidarity, and permanence.

71 (first) BMT Trading Company | Design Firm: 3G (Grand Gleaming Graphics) | Art Director/Designer: Hiroyuki Hayashi | Client: BMT Trading Company

This is a trading company in Pusan, South Korea. The arrows express the movement of products around the world.

71 (second) Palamut Group | Design Firm: Okan Usta | Art Director: Okan Usta | Designer: Okan Usta | Client: Palamut Group

71 (third) Branding for restaurant industry | Design Firm: Graphics & Designing

Inc. | Art Director/Designer: Toshihiro Onimaru | Client: OHGIYA Corporation

Ohgi-ya runs a Japanese restaurant franchise. Ohgi, a Japanese paper fan that sways from side to side, points to dramatic growth and business expansion.

71 (fourth) Quicksilver Gas Services Logo | Design Firm: Concussion, LLC | Art Director: Andrew Yanez | Designer: Charlie Howlett | Project Manager: Scott Kirk | Client: Quicksilver Gas Services

This logo combines the key operational component of Quicksilver's business — natural gas transportation pipes — with the company's iconic "Q."

71 (fifth) Mercantile Exchange | Design Firm: TOKY Branding+Design | Creative Director: Eric Thoelke | Designer/Ilustrator: Travis Brown | Client: The Pyramid Companies

High-end retail and entertainment district downtown.

72 (top) Amercan Midwest Finance | Design Firm: Lienhart Design | Creative Director/Designer: Jim Lienhart | Client: Amercan Midwest Finance

Mortgage company logo reflects stability, trust and dependability.

72 (middle) Buddy Systems Pet Toys Logo | Design Firm: Sibley/Peteet Design, Austin | Art Director/Designer/Illustrator: Rex Peteet | Client: Buddy Systems Pet Toys

Logo containing shape suggests the familiar dog tag adorned with the classic mug of "man's best friend" with the spotted eye and studded red collar.

72 (bottom) ICT Brabant Logo | Design Firm: Grafico de Poost | Art Director/Designer/Illustrator: René Paré | Client: ICT Brabant

This is an extremely simple yet tantalizing logo with a pleasant, face-like typographic statement. The logo builds a strong and sympathetic reputation for ICT Brabant, a virtual and physical community for ICT businesses in the south of the Netherlands.

73 GTS Logo | Design Firm: Grady Campbell, Inc. | Creative Director/Design Director: Kerry Grady | Designers: Kerry Grady, Tom Zurowski | Account Directors: Kerry Grady, Don Campbell | Client: Global Technology Solutions

Portugal-based, privately-owned corporation with offices in Europe and North America provides services from commercial real estate to banking, and is a key product supplier to the world's cork market. Represents the cork producing division. The circular shape suggests the globe, and the curving, linear layers suggest sheets of cork sheered from trees.

CreativeServices

74 Mark | Design Firm: Kara King | Designer: Kara King | Client: Guiding Eyes

75 (first) Trish Parks | Design Firm: Paul Black Design | Creative Director/Art Director/Designer: Paul Black | Client: Production and Event Management, Inc.

Created for Trish Parks, an executive producer of large scale, Fortune 200 corporate events.

75 (second) A2 Type Foundry | Design Firm: A2/SW/HK | Executive Creative Directors/Creative Directors/Art Directors/Design Directors/Chief Creative Officers/Authors/Artists: Henrik Kubel, Scott Williams | Account Director: Henrik Kubel | Client: A2 Type Foundry

75 (third) All natural planning Inc. | Design Firm: 3G (Grand Gleaming Graphics) | Art Director/Designer: Hiroyuki Hayashi | Client: All natural planning Inc.

This is a space planning and design company. The solid shape with soft curves emphasizes how this company is different from others in the industry that use many straight lines.

75 (fourth) Sinefekt | Design Firm: Okan Usta | Art Director/Designer: Okan Usta | Client: Sinefekt Post Production Company

75 (fifth) White Hat Creative Identity | Design Firm: MBA | Designers: Mark Brinkman, Caroline Pledger | Client: White Hat Creative

Agency that focuses on environmental sustainability.

76 (first) The Quality Label | Design Firm: Live!design Ltd. | Creative Director: Kristian Keinänen (Live!design Oy) | Designer: Erkki Tuorni | Strategist: Heli Hirvonen | Client: The Quality Label

A quality standard and networking model developed for Finnish art and design products; a sign of skill and high quality.

76 (second) Attraction Media | Design Firm: AMEN | Creative Director/Art Director/Designer: David Kessous | Client: Attraction Media

Holding of four commercial production companies.

76 (third) The Brand Trainer | Design Firm: Supon Creative | Art Director/Designer: Supon Phornirunlit | Illustrator: Jae Wee | Client: TheBrandTrainer.com

76 (fourth) Flash Brand | Design Firm: Brand Plant | Creative Director/Designer/Illustrator: Alexander Sakhel | Client: FlashLoc

Offers locations for the professional film and photo business.

76 (fifth) Paradox Logo | Design Firm: Mine | Designer: Christopher Simmons | Client: Paradox

Dance

77 Ailey II | Design Firm: Nicholson Kovac, Inc. | Creative Director: Jime Radosevic | Art Director: Rudy Wohlgemuth | Writer: Kate Andersen | Client: Ailey II

Ailey II, the acclaimed junior company of Alvin Ailey American Dance Theater, is a highly trained dance company and one of America's most exciting touring ensembles. Kansas City hosted them for a series of performances and benefits. We created collateral material capturing the performers' energy and vitality; it introduced them to a younger audience while capturing their essence for patrons who enjoy the performances year after year.

Designers

78 Platinum Duffy & Partners Logo | Design Firm: Duffy & Partners | Executive Creative Director: Joe Duffy | Creative Director: Dan Olson | Designer: Ken Sakurai | Client Duffy & Partners

Is it a "D" or a "P"? A thought bubble or an arrow? A frame or a portal to new ideas? It's simple. It's about collaboration. A conversation. Good thinking. Great ideas, and breakthrough design. All aspects of Duffy & Partners, the firm behind the identity.

79 (first) Driven Design Performance | Design Firm: Tim Frame Design | Designer: Tim Frame | Client: Tim Frame Design

79 (second) Calagraphic Design logo | Design Firm: Calagraphic Design | Creative Director/Art Director/Designer/Illustrator: Ronald J. Cala II | Client: Calagraphic Design

An award-winning design studio specializing in political posters and design for fine art. The work oftentimes includes optical illusions. This logo takes the simplest elements in design, a square, triangle, and circle, and transforms them into a unique and impossible symbol that couldn't exist in the real world. (Based off of an impossible triangle, the same perspective often used by M.C. Escher.)

79 (third) Logo | Design Firm: Alchemy Studios | Designer: Margaret King | Client: Alchemy Studios

79 (fourth) Hornall Anderson Logo | Design Firm: Hornall Anderson Design Works | Art Directors: Jack Anderson, John Hornall | Designers: Jack Anderson, Henry Yiu, Andrew Wicklund, Mark Popich | Client: Hornall Anderson Design

Seattle-based branding and interactive design firm.

79 (fifth) Tim Frame Design Logo | Design Firm: Tim Frame Design | Designer: Tim Frame | Client: Tim Frame Design

80 Ventress Design Group Logo | Design Firm: Ventress Design Group | Designer/Photographer: Tom Ventress | Client: Ventress Design Group

81 Tokyo Good Idea | Design Firm: Graphics & Designing Inc. | Creative Director/Art Director/Designer: Toshihiro Onimaru | Client: Tokyo Good Idea Development Institute Co., Ltd.

Tokyo Good Idea suggests plans to the world, derived from their country's unique thoughts and style. With kanji typography and the motif of a gourd, "hyotan," which supposedly brings luck, the logo is expressed in a traditional Japanese image. Hyotan is used in a Japanese old saying for unexpected ideas.

82 (first) TY | Design Firm: Ty Wilkins | Designer: Ty Wilkins | Client: Ty Wilkins

By combining the letters of my first name, "T" and "Y," I formed a gestalt and a smiling face.

82 (second) Greteman Group Burn to Create Logo | Design Firm: Greteman Group | Creative Director/Art Director: Sonia Greteman | Designer: Garrett Fresh | Client: Greteman Group

82 (third) TAXI 2 Logo | Design Firm: TAXI Canada Inc. | Creative Director: Lance Martin | Designers: Lance Martin, Stephanie Yung | Producer: Tracy Haapamaki | Typographers: Peter Hodson, Susan Bolder | Client: TAXI 2

82 (fourth) Z Squared Design logo | Design Firm: Z Squared Design | Creative Director/Art Director/Designer: Dave Zauhar | Client: Z Squared Design

82 (fifth) Mirko Ilic Corp. | Design Firm: Mirko Ilic Corp. | Creative Director/Designer: Mirko Ilic | Client: Mirko Ilic Corp.

83 Tompertdesign Logo | Design Firm: Tompertdesign | Designer: Claudia Huber Tompert | Client: Tompertdesign

84 Visual Range Icons | Design Firm Range, Inc | Creative Director/Designer: Ray E. Gallegos | Client: Range Icon

85 (first) Design Firm moving logo | Design Firm: 601 Design, Inc. | Art Director/Designer/Illustrator: Bruce Holdeman | Client: 601 Design, Inc.

For design firm's move to Steamboat Springs, a ski resort town.

85 (second) Bandit Passion | Design Firm: Carmichael Lynch Thorburn | Creative Director: Bill Thorburn | Designer: Steve Jockisch | Client: Carmichael Lynch Thorburn

This represents the culture and beliefs of our design group. The flame is for our passion for the work. The crossbones are for our lustful abandon. We dive in, go deep and never compromise.

85 (third) No Twelve Queen Street logotype | Design Firm: Irving (formerly Roberts&Co) | Designer: Julian Roberts | Calligrapher: Peter Horridge | Client: No Twelve Queen Street

85 (fourth) JWT Sauce | Design Firm: JWT Canada - Sauce Design | Creative Directors: Christopher O'Shaughnessy, Beverly Ritz | Art Director/Designer/Illustrator: Christopher O'Shaughnessy | Client: Sauce Design

Creative chefs depend on sauce to bring the perfect finishing touch to everything. So what better name for JWT's creative design studio then Sauce? Our logo depicts a human shape created from the sauce droplet. The ripple effect illustrates our fluid, creative contribution as a partner within the JWT agency.

85 (fifth) Sabingrafik logo | Design Firm: Tracy Sabin | Designer/Illustrator: Tracy Sabin | Client: Sabingrafik, Inc.

Education

86 (first) Office of Public Service and Outreach | Design Firm: Garfinkel Design | Art Director/Designer: Wendy Garfinkel-Gold | Client: University of Georgia, Office of Public Service & Outreach

86 (second) AIGA Colorado literacy poster icon | Design Firm: Hirschmann Design | Art Directors: Tim & Idie McGinty | Designer/Illustrator: Karl Hirschmann | Client: IGA Colorado Literacy Poster Program

Symbol for literacy poster. You Are What You Read.

86 (third) UTI Foundation Logo | Design Firm: Catapult Strategic Design | Creative Director/Art Director/Designer: Art Lofgreen | Account Director: Dave Duke | Client: Universal Technical Institute, Inc.

Provides financial aid to Automotive Technician students at UTI.

Credits

86 (fourth) England University | Design Firm: Range, Inc | Creative Director/Designer: John Swieter | Client: The Art of Life University

86 (fifth) Walk Your Kids to School Day | Design Firm: Rick Johnson & Company | Designer: Tim McGrath | Client: New Mexico Traffic Safety

87 Written Word Workshop Logo | Design Firm: The Decoder Ring Design Concern | Designer: Christian Helms | Client: Written Word Workshop

Mark for a creative writing program in Lafayette, LA.

88 (first) Lakewood Child Development Center | Design Firm: RBMM | Designer: Yvette Wheeler | Client: Lakewood Child Development Center

Daycare facility for children ages 6 weeks to 5 years old.

88 (second) Ontario College of Arts & Design | Design Firm: Hambly & Woolley Inc. | Creative Director/Art Director: Bob Hambly | Client: Ontario College of Art & Design

The OCAD Cornerstone logo is made up of formally stacked Roman titling capitals, set in a tablet. The letterforms are truncated to suggest energy and the asymmetric design indicates movement. The typography is open-ended and suggests an unfinished journey — like a good education.

88 (third) The Best of Graduation Works in Japan | Design Firm: Fujiwaki Design | Art Director: Shingo Fujiwaki | Designer: Yohei Ogawa | Client: The Best of Graduation Works executive committee in Japan

88 (fourth) Yavneh Academy logo | Design Firm: Sullivan Perkins | Designer: Chuck Johnson | Client: Yavneh Academy

A modern Orthodox high school with an emphasis on science.

88 (fifth) Food for Thought | Design Firm: Sibley/Peteet Design, Austin | Art Director/Designer/Illustrator: David Kampa | Client: Communities in Schools

Identity for public school program assisting underprivileged children, allowing them to eat healthier at school, ultimately contributing to their improved ability to concentrate and learn in class.

89 Family Life Development Center | Design Firm: Wells Communications Consulting | Creative Director: Jerry Wells | Designer: Barbara Wells | Client: Family Life Development Center, College of Human Ecology, Cornell University

90 Safari U icons | Design Firm: BlackDog | Art Director: Michele Wetherbee | Designer/Illustrator: Mark Fox | Client: O'Reilly Media

91 UC Davis Facilities Logo | Design Firm: Gee + Chung Design | Creative Director/Art Director/Designer/Illustrator/Design Director/Typographer: Earl Gee | Client: UC Davis Facilities

Symbols for University of California facilities group convey theme of "Caring for the Campus" and values of responsiveness, service and responsible guardianship.

92 (first) Cable in the Classroom Logo | Design Firm: Beth Singer Design | Art Director: Beth Singer | Designers: Chris Hoch, Sucha Snidvongs | Client: Cable in the Classroom

Formed by cable industry to promote learning opportunities for children. Cable is the nexus for learning, technology and connectivity.

92 (second) Vanderhoof Elementary School Spelling Bee | Design Firm: Hirschmann Design | Art Director/Designer/Illustrator: Karl Hirschmann | Client: Vanderhoof Elementary School

92 (third) One Laptop per Child | Design Firm: Pentagram Design | Art Director: Michael Gericke | Designer: Dimitris Stefanidis | Client: One Laptop per Child

Symbol for a foundation providing $100 computers to the world's poorest children, living in its most remote environments.

92 (fourth) Dream Tree | Design Firm: RBMM | Designer: Christy Gray | Client: Dream Tree

92 (fifth) NNG | Design Firm: Graphics & Designing Inc. | Art Director/Designer: Toshihiro Onimaru | Client: Nagasaki Nihon University Jr/Sr High School

Two flags swinging in the wind represent a junior high school and high school; "N" for Nagasaki and Nihon University. The wind indicates the invisible force of teachers and the environment.

93 Monarch School Logo | Design Firm: Douthit Design Group | Art Director: Dwight Douthit | Designer: Darlene Migl Polly | Client: The Monarch School, Houston, Texas

A school for special needs children.

Entertainment

94, 95 Game Image | Design Firm: Café Design | Creative Director/Art Director: Attila Simon | Client: Mediak Ltd

Gal6 is a computer game; characters are the logos of the product.

96 Randy "E" | Design Firm: Sibley/Peteet Design, Dallas | Designer: Craig Skinner | Client: Randy "E"

Logo for a local entertainer.

97 (first) Nature of the business/theater logo | Design Firm: Ginette Caron | Art Director/Designer: Ginette Caron | Account Director: Paolo Colao (Gregotti Associati International) | Client: Grand Theatre de Provence

97 (second) Arachnitopia Logo | Design Firm: Concussion, LLC | Art Director: Andrew Yanez | Designer: Lisa Montgomery | Client: Fort Worth Zoo

This comic book-style illustrated logotype was designed to make spiders more fun and less creepy for an expansive exhibit.

97 (third) FireLake Grand Casino Logo | Design Firm: Concussion, LLC | Art Director: Andrew Yanez | Project Manager: Amanda Gibson | Client: FireLake Grand Casino

This icon takes cues from the Frank Lloyd Wright-influenced architecture of the casino itself and integrates the core visual elements of fire and water inspired by its name.

97 (fourth) Opera Theatre of St. Louis 2006 Titles | Design Firm: TOKY Branding + Design | Creative Director: Eric Thoelke | Designer/Illustrator: Karin Soukup | Client: Opera Theatre of Saint Louis

97 (fifth) Cher Logo Concept | Design Firm: Rickabaugh Graphics | Designer: Eric Rickabaugh | Client: Self-Promotion

Events

98 (first) National Student Show and Conference Logo | Design Firm: Sibley/Peteet Design, Dallas | Creative Director: Don Sibley | Designer: Jeff Barfoot | Client: Dallas Society of Visual Communications

98 (second) Dr. Leaky's "Wildlife Wars" Lecture | Design Firm :Judson Design Associates | Creative Director: Mark Judson | Designer: Greg Valdez | Client: The Chinquapin School

For a lecture by Dr. Richard Leaky on his book, *Wildlife Wars*.

98 (third) McNeilly in May Derby Fundraiser | Design Firm: Cass Design Co. | Creative Director/Art Director/Designer/Illustrator: Ted Cass | Client: McNeilly Center for Children

Center provides childcare for low-income families trying to better their situation. The McNeilly in May event is a Kentucky Derby viewing party that serves as the Center's primary fundraiser.

98 (fourth) Day of Music | Design Firm: Wink | Creative Directors: Scott Thares, Richard Boynton | Designer/Illustrator: Scott Thares | Client: Marshall Fields

Marshall Field's Day of Music is an annual, free 24-hour musical event in Minneapolis, Chicago and Detroit. It showcases area musicians and celebrates all genres of music, from bagpipes to salsa. The idea was to have nature and music fuse together harmoniously. The music aspect was treated to reflect the multiple musical genres involved. The use of musical notes, sheet music and vintage detail imagery from album jackets of the 50s seemed the right fit. It worked well with the natural images. Both image styles combined created a simple, sophisticated approach with a slight fashion twist.

98 (fifth) Movie | Design Firm: Dfraile | Creative Director/Art Director: Eduardo del Fraile | Designers: Eduardo del Fraile, Juan Jimenez | Client: David Alcazar

Brand for an advertisement contest broadcasted in cinemas. The trophy for the most creative spot winner is their own logo built in a dyed wood volume with the graph.

99 The Modern Ball Logo | Design Firm: Elixir Design | Art Director: Jennifer Jerde | Designer/Photographer: Nathan Durrant | Client: San Francisco Museum of Modern Art

The identity for the premier of SFMOMA's largest fundraising event needed to work in tandem with the existing SFMOMA identity and be flexible enough to be refreshed each year in the future.

100 Silent Auction Identity | Design Firm: MBA | Designer: Mark Brinkman | Client: St. Marks Episcopal Day School

101 (first) 2005 Grammy Awards Logo series | Design Firm: Woodpile Studios | Creative Directors: Peter Buttecali, Rikki Poulos, Dave Konjoyan | Art Director/Illustrator: Peter Buttecali | Client: The Recording Academy

Logos produced for this year's (CBS) GRAMMY Awards celebration, for use in the broadcast and all general event promotion, related pre-telecast events, and for the after-party celebration held at the LA Convention Center. Developed to convey the elegance and excitement of the event, which was viewed by approximately 700 million people. The challenge was to integrate the established brand (grammophone) icon into each of the three distinctly individual designs, conveying unique concepts for each mark.

101 (second) Free Spirit | Design Firm: Range, Inc | Creative Director/Designer: John Swieter | Client: Free Spirit Peace Initiative

101 (third) AIPAC 2005 Conference Logo | Design Firm: Beth Singer Design | Art Director: Beth Singer | Designers: Sucha Snidvongs, Chris Hoch | Client: American Israel Public Affairs Committee

"Israel: An American Value" was the theme of the 2005 Policy Conference for the American Israel Public Affairs Committee, which is dedicated to ensuring a strong U.S.-Israel relationship.

101 (fourth) Wee Bairns | Design Firm: Range, Inc | Creative Director/Designer: John Swieter | Client: YPO Scotland University-Kids Program

102 (first) Woof Stock 2003 | Design Firm: Greteman Group | Creative Director: Sonia Greteman | Designer: James Strange | Client: Kansas Humane Society

102 (second) Toy Fair 2007 | Design Firm: Okan Usta | Creative Director: Marco Moretti | Art Director/Designer: Okan Usta | Client: Toy Industry Association

Logo design for American International Toy Fair '07, the largest toy trade show in the Western Hemisphere. More than 1,500 manufacturers, distributors, importers and sales agents from 30 countries showcase toy and entertainment products.

102 (third) Caldwell ZooFest Logo | Design Firm: Sullivan Perkins | Designer: Rob Wilson | Client: Caldwell Zoo

Designed for the grand reopening of the zoo in Tyler, TX.

102 (fourth) Buffalo Club Valentine | Design Firm: Stritzel Design Group | Creative Director/Designer: Mark Stritzel | Client: The buffalo club

102 (fifth) 2004 Pets Extravaganza | Design Firm: Lanny Sommese | Art Director/Artist/Typographer: Lanny Sommese | Designers: Lanny Sommese, John Heinrich | Client: Pets Extravaganza, State College

103 GLC DC - Eagle | Design Firm: Range, Inc | Creative Director/Designer: John Swieter | Client: YPO Global Leadership Conference

104 Design Firm: Savannah College of Art and Design | Creative Director: David Duran | Art Director/Designer/Illustrator: Scott Newman | Client: Atlanta Symphony Orchestra

Created for the 2006 Atlanta Symphony Orchestra Ball, which raised money to construct the new Atlanta Symphony Center, de-

signed by Santiago Calatrava, to be built in Midtown Atlanta. The symbol of the Phoenix is representative of Atlanta, and serves as inspiration for the design of the Symphony Center, and the logo.

105 Royal Caribbean Health Banners | Design Firm: Greteman Group | Creative Director: Sonia Greteman | Designer: James Strange | Client: Royal Caribbean Cruises Ltd.

Fashion

106 Simecki | Design Firm: Studio International | Creative Director/Art Director/Design Director/Designer/Artist/Writer: Boris Ljubicic | Account Director Igor Ljubicic | Editor: Ivan Ivancic | Client: Simecki

In Croatian, "voice" has a small hook above the letter S and is created with a woman's shoe for this fashion company.

107 TORCH | Design Firm: El Paso, Galería de Comunicación | Creative Director/Art Director/Designer/Writer: Álvaro Pérez | Client: Torch Spain

A "little and annoying" avant-garde fashion design company.

108 (first) Skate the Streets | Design Firm: UNIT Design Collective | Creative Directors: Shardul Kiri, Ann Jordan | Designer: Shardul Kiri | Client: Skate the Streets

108 (second) Converse One | Design Firm: Sandstrom Design | Creative Director/Senior Designer: Steve Sandstrom | Designer: James Parker | Illustrators: Steve Sandstrom, James Parker | Project Manager: Kirsten Cassidy | Client: Converse

Converse One is an online program allowing individuals to customize Converse shoes and order them over the Internet.

108 (third), **109** (top) Vart | Design Firm: Studio International | Creative Director/Art Director/Designer/Design Director/Artist/Account Director/Writer: Boris Ljubicic | Editor: Ankica Mamic | Client: Varteks

Logo VART illustrates the textile industry.

108 (fourth), **109** (bottom) MEDITERRASSE | Design Firm: Graphics & Designing Inc. | Creative Director: Takanori Aiba | Art Director/Designer: Toshihiro Onimaru | Client: WORLD Co., Ltd.

General Apparel Maker, Kobe Fashion Building "World." Logo is done in a typography design. Staying true to the spirit in which the fashion building is constructed, the ironwork motif evokes the historic feeling of an antique building.

108 (fifth) Indigo Palms Logo | Design Firm: Carmichael Lynch Thorburn | Designer: Travis Olson | Writer: Riley Kane | Client: Indigo Palms

Supports line of premium, casual, island-inspired denim wear.

110, 111 (third) HUCA Logo | Design Firm: Weymouth Design | Art Director: Bob Kellerman | Designer: Lucas Roy | Photographer: Michael Weymouth | Client: Harvard University Cycling Association

The objective was to create an exciting and dynamic image that fostered visibility and attracted new cyclists and sponsors.

111 (first) UNKL logo | Design Firm: Big-Giant | Art Directors/Designers: Jason Bacon, Derek Welch | Client: UNKL Brand

111 (second) Nivo | Design Firm: TAXI Canada Inc | Creative Director: Dominique Trudeau | Art Directors/Designers: Mike Lapointe, Neelan Rach | Client: Lanctot

A line of clothing for golfers.

111 (fourth) Puma Logo | Design Firm: Puma | Chief Marketing Officer: Antonia Bertone | Client: Puma

Created in 1948, the logo has had small facelifts over the years, but essentially remained the same since then.

111 (fifth) Dead Man's Shoes | Design Firm: Deep Design | Creative Director: Rick Grimsley | Designer/Illustrator: Heath Beeferman | Client: Dead Man's Shoes

A retail store specializing in pre-owned footwear.

112 (first, fifth) Banana Joe | Design Firm: Sibley/Peteet Design | Art Directors: Mark Brinkman, Laura Bettor | Designer/Illustrator: Mark Brinkman | Client: TSI tropical sportswear

TSI was entering into the high price point level in the tropical sportswear market. A sophisticated but fun approach was developed to keep the brand feeling friendly.

112 (second) WashBox | Design Firm: Ramp | Creative Directors: Rachel Elnar, Michael Stinson | Designers: Claire De Leon, Michael Stinson | Client: DenimHead

Product logo for a sample box that includes various types of fabric treatments and washes to forecast trends in the denim industry.

112 (third), **113** Miss Ashida 2006 | Design Firm: Graphics & Designing Inc. | Art Director/Designer: Toshihiro Onimaru | Client: Miss Ashida 2006

For Global Fashion Brand, Miss Ashida. Graphic design for the 2006 Spring-Summer collection. Development of graphic designs for logos, as well as posters, novelties, and apparel products.

112 (fourth) Crocs Mambaz | Design Firm: Hirschmann Design | Art Directors: Stacey Schuham (Brandplay), Aaron Dignan (Brandplay) | Designer/Illustrator: Karl Hirschmann | Client: Crocs Mambaz

Symbol for sub-brand of shoe manufacturer.

114, 115 DOO ROO MOO | Design Firm: Graphics & Designing Inc. | Creative Director: Takanori Aiba | Art Director/Designer: Toshihiro Onimaru | Client: WORLD Co., Ltd.

Fashion building of the general apparel manufacturer, World.

Film

116 (first, second, fourth, fifth) Studios International | Design Firm: Blinn Design | Creative Director/Designer: K.C. Blinn | Client: Studios International

116 (third) Canadian Film Centre Corporate Logo | Design Firm: TAXI Canada Inc | Creative Director: Steve Mykolyn | Associate Creative Director: Stephanie Yung | Account Director: Katherine Craig | Account Manager: Jacinte Faria | Artist: Lorin Altomonte | Client: Canadian Film Centre

117 Fahrenheit Pictures | Design Firm: Digital Flannel | Art Directors: John Turner, Eric Campbell | Designer: John Turner | Writer/Project Manager: Eric Campbell | Client: Fahrenheit Pictures

We positioned client in a unique way by developing a powerful tagline, "180° Degrees From Ordinary," and a strong mark. I first drew the character "Fire Retardant Man" holding a 16mm hand-held camera. We then incorporated the text, flame icons and the tagline.

118 Senior VP of Creative Print Advertising | Design Firm: Intralink Film Graphic Design | Chief Creative Officer: Anthony Goldschmidt | Creative Director: Mark Crawford | Art Director/Designer: Michael Golob | Client: Fox Atomic/Karen Crawford

Logo for movie studio (a division of Fox Filmed Entertainment) producing theatrical films, comics, and digital content targeting the 17-24 year old demographic. It needed to be adaptable to various style treatments in the same way the MTV logo is. It also makes a slight nod to the spotlight logo of its parent company.

119 (first) Square One Films Logo | Design Firm: Ó! | Art Director/Designer: Einar Gylfason | Client: Square One Films

119 (second) Tim Bieber Logo | Design Firm: Liska + Associates | Designer: Steve Liska | Client: Tim Bieber

When filmmaker/director Tim Bieber began promoting his independent work, we created this logo, which makes him the star by playfully representing his initials.

119 (third) STORY | Design Firm: STORY | Designer: David Orr | Client: STORY

STORY is a TV commercial production company.

119 (fourth) Logo | Design Firm: Chris Corneal | Designer: Chris Corneal | Client: Western Image Communications

Film production company specializing in western/rodeo events.

119 (fifth) Flying Circus | Design Firm: Carmichael Lynch Thorburn | Creative Director: Bill Thorburn | Designer: David Schwen | Client: Flying Circus Films

Logo made for an independent film company, combining the graphic qualities of the circus with a fresh, contemporary feeling. The overarching theme for the brand is "We like to Watch."

Financial

120 (top, bottom) DCM Year of the Boar Logo | Design Firm: Gee + Chung Design | Creative Director/Art Director/Designer/Illustrator/Design Director/Typographer: Earl Gee | Client: DCM

A venture capital firm with significant investments in China welcomes the Year of the Boar using the company's initials to create the festive ornamentation on the lunar calendar animal.

120 (middle) Air Force Federal Credit Union | Design Firm: The Bradford Lawton Design Group | Creative Director: Bradford Lawton | Designer: Jennifer Z. Murillo | Client: Air Force Federal Credit Union

121 Logo | Design Firm: Café Design | Creative Director/Art Director/Designer: Zsolt Kathi | Project Manager: Balazs Szentey | Client: Milton Finance PCL

A subsidiary of one of the biggest investment holdings in Hungary.

122 Corporate Logo | Design Firm: Café Design | Creative Director/Designer: Aniko Majlath | Project Manager: Balazs Szentey | Client: Saxum Investments

123 (first) Capital Partners | Design Firm: Pentagram Design | Art Director: Michael Gericke | Designers: Seong Yang, Dimitris Stefanidis | Client: Capital Partners

Symbol for Capital Partners, Kazakhstan Investment Company with two closely connected principal partners.

123 (second) Loon Lake Investments | Design Firm: Hirschmann Design | Art Director/Designer/Illustrator: Karl Hirschmann | Client: Loon Lake Investments

123 (third) Gold Café | Design Firm: Go Welsh! | Creative Director: Craig Welsh | Designer/Illustrator: Ryan Smoker | Client: Gold Café at Union National Community Bank

123 (fourth) Landes Investments | Design Firm: RBMM | Designer: Philip Smith | Client: Landes Investments

123 (fifth) Identity | Design Firm: Ferreira Design Company | Creative Director/Designer: Lionel Ferreira | Client: United Capital Financial

United helps home buyers get the credit help they need from lenders in the mortgage market.

Food

124 (top) Ruta Solidaria | Design Firm: Dfraile | Creative Director/Designer/Account Director: Eduardo del Fraile | Client: Ruta Solidaria

Supportive project for reuse of hospital goods in Mauritania.

124 (middle) Spread the News Beyond Your Roost | Design Firm: Graphic Content | Creative Director/Designer: Art Garcia | Artist: Jesus Nava | Strategist: Debbie Evens | Client: Pilgrims Pride

An icon for a newsletter provided to the poultry industry.

124 (bottom) Atlas Culinary Adventures | Design Firm: Murillo Design | Creative Directors: Stan McElrath, Rolando G. Murillo | Art Director/Illustrator: Rolando G. Murillo | Client: Atlas Culinary Adventures

Culinary trips led by expert guides who are language-fluent and passionate about foods and cultures of the destinations visited.

125 (first) Mill City Farmers Market | Design Firm: Duffy & Partners | Executive Creative Director: Joe Duffy | Creative Director/Designer: Alan Leusink | Project Manager: Jen Jagielski | Client: Mill City Farmers Market, Farm In The City

Identity juxtaposes farm and city icons. Color signifies the products are of the earth and brings vibrancy to the market. Used on website, posters, sidewalk sandwich boards, advertising, tote bags and flyers.

125 (second) BEEE | Design Firm: Dfraile | Art Director/Designer: Eduardo del Fraile | Client: El Campillo

A brand of environmentally-friendly goat dairy products. As opposed to cows, goats only have two teats, and this is didactically represented in the logo.

Credits

125 (third) Bochner chocolates | Design Firm: MiresBall | Creative Director: Jose Serrano | Designer: Miguel Perez | Project Manager: Holly Houk | Client: Bochner chocolates

Challenge: Give client the look-and-feel of a premium brand. Working within the constraints of a limited start-up budget, we created a sophisticated, yet economical, design. The logo uses deep colors and elegant text to position the client as a premium chocolatier with a rich heritage. To more fully brand the company, we've recommended the logo's chocolate "b" become the model for a line of individually wrapped Bochner chocolates.

125 (fourth) Madam Bergen | Design Firm: Strømme Throndsen Design | Creative Director/Art Director: Morten Throndsen | Designer: Kjersti Benjaminsen | Client: Tre Søstre AS

125 (fifth) Billy's Bakery | Design Firm: Tim Frame Design | Designer: Tim Frame | Client: Billy's Bakery

126 Piller Rock Salmon | Design Firm: Mark Oliver, Inc. | Art Director/Designer: Mark Oliver | Illustrator: Harry Bates | Client: Piller Rock Salmon

127 Platinum Gourmet | Design Firm: El Paso, Galería de Comunicación | Creative Director/Art Director/Author/Writer: Álvaro Pérez | Client: Gourmet Pescadarias

There is a difference between Gourmet and other fish shops: the absolute freshness of their fish and seafood. The aim was designing a "just fished" logo.

128 Real Cheese | Design Firm: Tim Frame Design | Designer: Tim Frame | Client: Charley's Steakery

129 (first) Gourmet Fries | Design Firm: Tim Frame Design | Designer: Tim Frame | Client: Charley's Steakery

129 (second) Blue Fog Market | Design Firm: Michael Schwab | Designer: Michael Schwab | Client: Andy Skov/Point Reyes Capital

A neighborhood grocery specializing in locally grown produce, organic meats and high-end gourmet foods. The logo evokes the romance of the historic, fog-shrouded San Francisco neighborhood.

129 (third) Wyndy's Hotsauce Logo | Design Firm: Hotsauce | Creative Director/Art Director/Designer: Wyndy Wilder Sloan | Illustrator: Leah Faust | Client: Wyndy's Hotsauce

The purpose of this logo/brand is to create a hip rock 'n roll-style attitude for a line of super-spicy, tongue waggin' dips.

129 (fourth) Garden State Salsa Logo | Design Firm: GSD&M | Art Director/Designer: Marc Ferrino | Client: Garden State Sala

The product is New Jersey salsa made from the finest Beefsteak tomatoes of the northeast. The logo was Mafia inspired, illustrating a trip to the vegetable morgue for one beautiful, ripe tomato.

129 (fifth) Fresh Baked Bread | Design Firm: Tim Frame Design | Designer: Tim Frame | Client: Charley's Steakery

130 Come & Dish Logo | Design Firm: SamataMason | Creative Director/Art Director: Kevin Krueger | Designer/Photographer: Emily Pratzel | Client: Come & Dish

Come & Dish provides the finest ingredients for their customers to prepare months worth of wholesome meals for themselves and their families in a stress free and social environment.

131 (first) Panettone Logo | Design Firm: Tracy Sabin | Art Director: Bridget Sabin | Designer: Tracy Sabin | Client: Seafarer baking Company

131 (second) Lobo Tortilla Factory | Design Firm: RBMM | Designer: Kevin Bailey | Client: Lobo Tortilla Factory

A manufacturer of flour tortillas, corn tortillas (fresh and corn flour) and pre-cut corn chips.

131 (third) Azen | Design Firm: Matsumoto Incorporated | Creative Director/Art Director/Designer: Takaaki Matsumoto | Client: Azen

Branding image for a health-oriented food products company in Japan. The products were sold at the retail level.

131 (fourth) Treehouse Foods Logo | Design Firm: Concussion, LLC | Art Director: Andrew Yanez | Project Manager: Alice Cantu | Client: Treehouse Foods

This logo not only literally captures the company, but conveys a familiar sense of security that a treehouse provides.

131 (fifth) Hofstaedter sign | Design Firm: Delikatessen. Agentur für Marken und Design GmbH | Creative Director: Robert Neumann | Designer: Karsten Kummer | Client: Rewe Austria

Logo for premium brand of sliced meats that reflects the Austrian butcher tradition. The sign is typical for small shops in old Austrian cities. Red and white are the colors on the Austrian flag.

132 (first) Foodream | Design Firm: Graphics & Designing Inc. | Art Director/Designer: Toshihiro Onimaru | Client: VIA Holdings Inc.

Branding for Foodream, a business that runs diversified restaurants. The continuous line of "F" and "D" from the name signifies a united form of the business that deploys broad-ranging restaurant businesses, and implies "connection" with customers.

132 (second) Blisscotti Logo | Design Firm: Hornall Anderson Design Works | Creative Director/Art Director: Larry Anderson | Designers: Larry Anderson, Holly Craven, Jay Hilburn, Chris Freed | Client: Cold Standard

132 (third) Goodies Logo for Target Stores | Design Firm: Stand Advertising | Designer: Mike Telesco | Photographer: Walter Colley | Client: Rich Products

Introduces new bakery items in Food Avenue at Target. Seeing the product in a playful way, juxtaposed with a very old-fashioned name, brought them to life. Simple idea. Clean execution. Goodies. Everybody loves them.

132 (fourth) Guser&Gusterica | Design Firm: Spela Draslar | Art Director/Designer: Spela Draslar | Client: Guser&Gusterica

Logo for homemade, traditional treats (wine, olives, and marmelades) from south Croatian coast. Communicates love of life and good food. The logo is all about that slow, lazy pace of life typical to this part of the Europe. The two Sand lizzards are the perfect symbol for that. May also be seen as a bridge between old and new. Product targeted at travelers and locals.

132 (fifth) Pastabilities logo | Design Firm: Alterpop | Designer: Christopher Simmons | Client: Pastabilities

The logo draws its color inspiration from the company's product. It is whimsical in nature, but with a nod to the traditions and craftsmanship of its Italian heritage.

133 Willa's logo | Design Firm: Wray Ward Laseter | Chief Creative Officer: Jennifer Appleby | Creative Director: John Roberts | Art Director/Designer: Brandon Scharr | Client: Willa's

Family-run bakery from Madison, TN, with homey feel.

Government

134 (top) Hurricane Rita Power Restoration | Design Firm: Prejean Creative | Creative Director/Designer: Kevin Prejean | Client: Lafayette Utilities System

134 (middle) State-Tribal Institute | Design Firm: 601 Design, Inc. | Art Director/Designer: Bruce Holdeman | Client: National Conference of State Legislatures

Advancing innovation, cooperation and collaboration between state governments and American Indians.

134 (bottom) NCSL2003 Annual Meeting | Design Firm: 601 Design, Inc. | Art Director/Designer: Bruce Holdeman | Client: National Conference of State Legislatures

135 Phoenix Convention Center Logo | Design Firm: Catapult Strategic Design | Creative Director: Art Lofgreen | Art Director/Designer/Illustrator: Spencer Walters | Account Director: Brad Ghormley | Client: City of Phoenix

This is a mark created for new Phoenix Convention Center, a place where people come together for business and commerce.

136, 137 (third) Ministry of Culture | Design Firm: Studio International | Creative Director/Art Director/Designer/Illustrator/Account Director/Design Director/Writer/Editor/Artist: Boris Ljubicic | Client: Croatian Ministry of Culture

Semicolon creates apparent "H" (for Hrvatska/Croatia), while red and blue colors represent the Croatian national identity.

137 (first) Conamu | Design Firm: Giotto Design | Creative Director/Art Director/Account Director: Sandro Giorgi (Giotto) | Client: Conamu

Conamu is the national women's council, part of the Republic Presidency. It promulgates laws to protect women.

137 (second) The Big Green Apple | Design Firm: TURF | Creative Director: Mark Trippetti | Associate Creative Director: Soohyen Park | Designer: Yujin Chang | Illustrator: Blake E. Marquis | Project Manager: Olivia Choi | Client: The City of New York

TURF was asked by The Office of the Mayor to create an identity celebrating The City of New York's sustainability effort, Green NYC. Combining the essence of both the Big Apple and the infinity symbol, the logo acts as a rallying cry for one of the greenest cities in the U.S. It will be applied throughout the city, from participating businesses to hybrid cabs to consumer marketing efforts.

137 (fourth) St. Louis Regional Chamber & Growth Association logo | Design Firm: Fleishman-Hillard Creative | Designer: Jim Heys | Client: St. Louis Regional Chamber & Growth Association

137 (fifth) Lake County Logo | Design Firm: Grady Campbell, Inc. | Art Director/Designer/Design Director: Kerry Grady | Account Directors: Kerry Grady, Don Campbell | Client: Lake County

Lake County is located along Lake Michigan, just north of Chicago. Designed as a symbol of the county's mission and its diverse branches of government programs and services, the logo appears wherever the Lake County name is used.

Health

138 (first) Oak Hills Periodontics logo | Design Firm: The Bradford Lawton Design Group | Creative Director: Bradford Lawton | Designer: Leslie Magee | Client: Oak Hills Periodontics

138 (second) VeraLight Logo | Design Firm: Tompertdesign | Art Director: Claudia Huber Tompert | Designers: Anneka Cerny, Claudia Huber Tompert | Client: VeraLight

VeraLight is a medical device company offering screening solutions using laser light for non-invasive diabetes checks.

138 (third) Easy Inch Logo | Design Firm: The Bradford Lawton Design Group | Creative Director: Bradford Lawton | Designer: Leslie Magee | Client: Easy Inch Logo

138 (fourth) Bryant&Duffey | Design Firm: A3 Design | Art Director/Account Director: Amanda Altman | Artists: Alan Altman, Lauren Gualdoni | Client: Bryant&Duffey

As these practicing optometrists partnered, they needed a new logo. The "b" and "d" in the logo create the glasses frames. The heavy line weight gives the logo personality and character.

138 (fifth) Corporate Identity | Design Firm: iHua Design | Art Director/Designer: I-Hua Chen | Account Director: Jonathan Lui-Kwan | Project Manager: Craig Kennett, Kent Yunk | Client: Pomiard Pharmaceuticals

Biopharmaceutical company focused on discovery, development and commercialization of innovative oncology products.

139 OsteoCorp | Design Firm: Tompertdesign | Art Director: Claudia Huber Tompert | Designer: Anneka Cerny | Illustrator: Raygun Studio | Client: OsteoCorp

A developer of novel drugs that reverse skeletal thinning caused by osteoporosis by stimulating re-growth of new bone tissue.

140 Nutrition Brand | Design Firm: Brand Plant | Creative Director/Designer/Photographer: Andreas Bednareck | Client: Biance Schmidt

Bianca Schmidt is a nutritionist providing consultation. The logo presents a positive connotation with food. The pear stands for healthy/light/digestible/sweet/appetite. The color supports the clean, hygienic aspect of nutrition consultation.

141 (first) LAKS logo | Design Firm: John Nordyke | Creative Director/Designer/Typographer: John Nordyke | Client: LAKS laboratories

Engaged in research and development of pharmaceutical and bio-mechanical engineered products.

141 (second) Dugan Physical Therapy | Design Firm: Mark Oliver, Inc. | Art Director/Designer/Illustrator: Mark Oliver | Client: Dugan Physical Therapy

141 (third) Shepherd's ranch logo | Design Firm: Tracy Sabin | Art Director: Michele Travis | Designer: Tracy Sabin | Client: Shepherd's ranch

Logo for a vocational training/substance abuse recovery facility.

141 (fourth) Root logo | Design Firm: Sandstrom Design | Creative Director/Senior Designer: Steve Sandstrom | Print Producer: Prue Searles | Client: Root

141 (fifth) Network of the green pharmacies | Design Firm: Adventa Lowe | Creative Director: Oleksiy Pasichnyk | Art Director/Designer: Nikolay Kovalenko | Client: Adventa Lowe

Logo consists of three component parts:1. Image of the heart, a symbol of health and love to customers; 2. Image of green leaf - life, natural medicines; 3. Image of the medical cross - symbolizes that network of pharmacies belongs to medical organizations.

Hotels

142 (first) Hyatt Place | Design Firm: Lippincott Mercer | Creative Directors: Su Mathews, Randall Stone | Designers: Su Mathews, Kevin Hammond, Matt Simpson, Dolores Phillips | Strategists: Kim Rendleman, David Mayer, Su Mathews, Randall Stone | Client: Hyatt Corporation

Challenge - Hyatt Corporation acquired Amerisuites, a limited service hotel, and was seeking to create a new hotel offering. characterized by a distinctive guest experience for discerning frequent travelers, and a focus on comfort and quality. We were engaged to develop a complete identity program including positioning, image attributes, naming, logo design and overall hotel vibe.

Solution - The symbol is based on the idea of a gathering place. The geometric circles come together to form a sense of place or locality. The colored dots form the letter "H." The mark is friendly, direct, modern and unique among the competition brand.

142 (second) Clair Tappaan Logo | Design Firm: Craig-Teerlink Design | Art Director/Designer: Jean Craig-Teerlink | Client: Sierra Club

The Clair Tappaan Lodge is a rustic retreat in the Sierra mountains hand built by members of the Sierra Club in 1934. The symbol and letters are hand drawn to reflect the spirit of the lodge and the majestic landscape that surrounds it.

142 (third) Pool Bar | Design Firm: VIVA DESIGN! studio | Art Director/Designer: Sergiy Minyuk | Client: Kronos, Crimean Riviera Hotel Complex

Logo for PoolBar, part of the Crimean Riviera Hotel Complex, emphasizing the atmosphere typical of a poolside bar. The result was an active, daredevil logo inviting everyone to join in. The black square, unstable in its standing, reinforces the vivid colors of the logo's letters. The informality of the solution is accentuated with the "O's" substituted by the bar-glass bottom prints and the inverted "A," encapsulating a contour of a glass.

142 (fourth) Joule Hotel | Design Firm: Mirko Ilic Corp. | Creative Director/Art Director/Designer: Mirko Ilic | Client: Joule Hotel & Resort

142 (fifth) Modus | Design Firm: Carlson Marketing Worldwide | Chief Creative Officer: Jo-Anne Ebensteiner | Creative Director: Stephan Faerber | Art Director: Kessin Knaur | Client: Carlson Hotels Worldwide

Designed as a global brand identity for our several hotel guest rewards programs. It had to translate across 80 countries with different languages and expand and evolve according to the ad or product, while keeping the 'this is our method of service idea.'

143 Maia | Design Firm: HKLM: Executive | Creative Director: Gary Harwood | Creative Director: Bev Field | Art Director/Designer: Beverley Field | Typographer: Beverley Field | Client: Southern Sun

Primary identity uses an image of bright pink Frangipanis pasted into typography designed specifically for Maia. The logotype, especially the "A," takes inspiration from the oversized thatch roofing at Maia and has a code-like expression to hint at the eastern philosophies Maia embodies. Secondary logos are expressed differently on each element to fully capture the riot of color and texture that is the Seychelles.

Internet

144, 145 DAAO Brand Identity | Design Firm: Naughtyfish design | Creative Director/Designer: Paul Garbett | Design Director: Danielle de Andrade | Client: Dictionary of Australian Artists Online (DAAO)

Web-based search tool with links to data archives from Australia's major universities and art galleries. We used the dictionary metaphor to inform the design: not a traditional logo, but 26 dynamically arranged pixels, each representing a letter of the alphabet. The pixels can be rearranged in a multitude of configurations.

146 Spout Identity | Design Firm: BBK Studio | Chief Creative Officer: Kevin Budelmann | Art Director: Yang Kim | Design Directors: Michele Chartier, Henk Dawson | Client: Spout

Web 2.0 community-based website dedicated to film and movie enthusiasts. We helped name, brand, design, and market Spout.

147 (first) Fresh Research Logo | Design Firm: Jan Sabach | Creative Director/Art Director/Designer: Jan Sabach | Client: Fresh Research

Logo for an Internet-based research company. Logo uses magnifying glass effect to show the research aspect of the company while creating the split "F" and "R" effect.

147 (second) CaringFamily | Design Firm: Hirschmann Design | Art Director: Don Wrege | Designer/Illustrator: Karl Hirschmann | Client: CaringFamily

Symbol for a private family network.

147 (third) Radial Point Logo | Design Firm: Pentagram SF | Creative Director: Kit Hinrichs | Designer: Erik Schmitt | Client: Radial Point

147 (fourth) FishDirectory.net Logo | Design Firm: GSD&M | Designer: Simon Walker | Client: fishdirectory.net

An online directory of Christian, family-owned businesses and corporations in the San Antonio area.

147 (fifth) Window on Women Logo | Design Firm: Jan Sabach | Art Director/Designer: Jan Sabach | Writers/Project Managers: Jaroslav Cir, Joanne Loader | Client: Unilever

Logo for an Internet-based community.

Landscaping

148 (top) Know Logo | Design Firm: SERVE | Creative Director: Gary Mueller | Art Director: Scott Krahn | Writers: Ross Lowinske, Gary Mueller | Client: Know Before You Mow

Created for a charity to raise lawnmower safety awareness.

148 (middle) C.M. Hobbs Logo | Design Firm: Scofield Design + Communications | Creative Director/Account Director: Ted Scofield | Designers: Casey Cordry, Lori Fox | Client: C.M. Hobbs

A commercial nursery selling quality nursery stock exclusively to professional landscape companies, institutions and contractors. The company was founded over 150 years ago and remained in Hobbs family ownership until 2006. The new owner hired us to create a mark that retained the name and reflected the rich heritage of the family-owned business.

148 (bottom) Black Bear Tree Service Logo | Design Firm: Salt Industries | Designers: Craig O'Brien, Tamara Smallwood | Client: Black Bear Tree Service

Legal

149 Dallas Legal Foundation logo | Design Firm: RBMM | Designer/Illustrator: Kevin Bailey | Client: Dallas Legal Foundation

Manufacturing

150 Creata Logo | Design Firm: John Michael Pugsley Design Inc. | Creative Director: John Michel Pugsley | Designers: Stephen Lau, Rick Wong, Judy Glenzer | Illustrator: John Alvin | Client: Creata

Logo for an international marketing and manufacturing company.

151 (first) Tileman | Design Firm: Go Welsh | Creative Director: Craig Welsh | Designer/Illustrator: Mike Gilbert | Client: Armstrong World Industries

Icon developed for commercial flooring division.

151 (second) Active Wear Logo | Design Firm: Hornall Anderson Design Works | Art Director: Jack Anderson | Designers: Kathy Saito, Gretchen Cook | Client: Active Wear

Trade-based textile company that manufactures fleece.

151 (third) Springbok Logo | Design Firm: Oxide Design Co. | Art Director: Drew Davies | Designers: Drew Davies, Joe Sparano, Bill Bollman, Lance Lethcoe | Client: Springbok, Inc.

Logo for Springbok, Inc.- a company that designs and manufactures precision test equipment for high-voltage power lines.

151 (fourth) HotSteel | Design Firm: The Design Studio of Steven Lee | Creative Director/Art Director/Designer/Illustrator: Steven Lee | Client: HotSteel

151 (fifth) Corporate Identity | Design Firm: Nicholas M. Agin | Designer: Nick Agin | Illustrator/Project Manager: Matt Reckner | Client: Sanivera

A corporate mark developed for a company manufacturing various sanitizing gels for the restaurant industry. The droplet counter form references the cleansing and purity of the product and the chief delivery system of the company's primary products (a liquid gel).

Motorcycles

152 (top) Identity | Design Firm: Ferreira Design Company | Creative Director/Illustrator: Lionel Ferreira | Client: Point b/Demolition Cycles

A demolition company that also creates custom and customized motorcycles.

152 (middle) Motorcycle Logo | Design Firm: Mono | Creative Directors: Travis Olson, Troy Longie | Designer/Writer: Travis Olson | Photographer: Chris Sheehan | Client: Custom Chrome

An established after-market parts maker for V-Twin bikes. Identity signified their initial launch into a full line of custom bikes.

152 (bottom) Identity | Design Firm: Ferreira Design Company | Creative Director/Designer/Illustrator: Lionel Ferreira | Client: Point b/Demolition Cycles

Multimedia

153 ReThink logo | Design Firm: Paul Black Design | Creative Director/Art Director: Randall Hill | Designer: Paul Black | Client: The ReThink Companies

Logo for international corporate events and branding company.

Museums&Galleries

154 Jay's Logo 4 | Design Firm: Tactical Magic | Designer: Ben Johnson | Client: Jay Etkin Gallery

Credits

155 (first, second, fourth, fifth) Fabric Workshop and Museum | Design Firm: Matsumoto Incorporated | Creative & Art Director/Designer: Takaaki Matsumoto | Client: Fabric Workshop and Museum

Institution is both a workshop where art is made and a museum. The logo intimates patterns or sewing, recalling the institution's origins as a textile workshop. The sophistication and simplicity of the logo communicate its seriousness as a permanent institution of art guardianship.

155 (third) MDC | Design Firm: Studio International | Creative Director/Art Director/Designer/Design Director/Artist/Writer: Boris Ljubicic | Account Director: Igor Ljubicic | Editor: Visnja Zgaga | Client: Museum Documentation Centre

MDC is the sum of contents, and their documentation on a rectangular square grid represents Croatian national identity.

156 Quilt | Design Firm: Bailey Lauerman | Creative Director: Carter Weitz | Art Directors: Ron Sack, James Strange | Client: International Quilt Study Center

International museum and study center devoted to quiltmaking.

157 hdc Croatian Design Centre/ Logo "hdc" | Design Firm: Studio International | Creative Director/Art Director/Designer: Boris Ljubicic | Illustrator: Igor Ljubicic | Client: hdc Croatian Design Centre

HDC stands for the Croatian Design Centre, a project of the Croatian Designers Association. The square network, which represents the Croatian visual identity, forms the letters "h," "d" and "c," with the proviso that the letter ("d"=design) is raised above the "h" and the "c" like a gold medalist on the Olympic platform.

158 (first) Newseum/Freedom Forum World Headquarters Logotype | Design Firm: Poulin + Morris Inc. | Designers: Douglas Morris, Brian Brindisi, AJ Mapes | Client: Newseum/Freedom Forum

The client occupies the last available site on Pennsylvania Avenue in Washington, D. C. Located between the Capitol Building and the White House and adjacent to the Smithsonian museums on the National Mall, this new 600,000-square-foot facility features museum displays and experiences dedicated to the First Amendment and a free press. The six-story, mixed-use building also houses foundation offices and residential condominiums.

158 (second) Museum of the Shenandoah Valley Logo | Design Firm: Beth Singer Design | Art Director: Beth Singer | Designer: Sucha Snidvongs | Client: Museum of the Shenandoah Valley

Museum dedicated to interpreting art, history and culture of the Shenandoah Valley region. Property also showcases spectacular gardens. The goal was to combine a sense of regional history with the museum's modern architecture, designed by Michael Graves.

158 (third), **159** Tokyo Food Museum | Design Firm: Graphics & Designing Inc. | Creative Director Takanori Aiba | Art Director/Designer: Toshihiro Onimaru | Client: Tokyo Food Museum

Facility focused on Tokyo's food culture. Tokyo Tower, a symbolic structure of the city, is expressed in Japanese kanji character.

158 (fourth) Pathways | Design Firm: Bandujo Donker & Brothers | Creative Director: Bob Brothers | Art Director: Ryosuke Matsumoto | Client: The Museums of Lower Manhattan

A collection of 15 museums that chose to market themselves as a collective group in 2004. As each museum had its own logo, our challenge was to create one that represented the group, while communicating the diversity of each institution and their proximity. Each uniquely shaped and colored "stepping stone" represents the diversity of experience and the path you follow as you travel from one museum to the next.

158 (fifth) MoAD | Design Firm: Sussman/Prejza & Company, Inc. | Lead Designer: Holly Hampton | Senior Designer: Miles Mazzie | Designers: Hsin-Hsien Tsai, Ana Llorente-Thurik | Principal in Charge: Deborah Sussman | Photographer: Jim Simmons | Project Managers: Deborah Sussman, Holly Hampton, Randy Walker | Client: Museum of the African Diaspora

MoAD, is located in the first three floors of the St. Regis Hotel in the Yerba Buena cultural district of San Francisco, near the city's Museum of Modern Art and the Moscone Convention Center. It is a museum of people, not objects, dedicated to telling the stories of the African Diaspora that interconnects all of humanity.

Music

160 (top) SongVest | Design Firm: Hiebing | Creative Director: Sean Mullen | Designer: Darren Halbersma | Account Director: Jaimi Brinkman | Client: SongVest

Acts as a broker in online sale of songwriter's rights. Exclusivity and the chance of return make this a cool and unique investment.

160 (middle) Zia Music Production Logo | Design Firm: Ventress Design Group | Designer: Tom Ventress | Client: Zia Music Production

Festival production and consultation company.

160 (bottom) "Good For The Soul Music" Logo | Design Firm: Toolbox Studios, Inc. | Creative Director: Paul Soupiset | Art Director/Designer/Illustrator: Jennifer Zinsmeyer-Murrillo | Client: Good For The Soul Music

161 Platinum Lyrics and Legacy Identity | Design Firm: MBA | Designers: Mark Brinkman, Caroline Pledger | Client: Hill Country Conservancy

A concert to raise funds for preservation of the Hill Country featuring father/son musical arts.

162 D'Ambrosio | Design Firm: Ogilvy | Creative Director: Jeff Dahlberg | Art Directors: Noah Rosenberg, Carolin Harris | Designer: Carolin Harris | Design Director: Noah Rosenberg | Client: D'Ambrosio

D'Ambrosio guitars are finely crafted works of art, hand-made specifically for their owners. Mark communicates this craftsman-

ship and musical artistry by utilizing brush-like letterforms that incorporate but are not limited by tradition. Elongated lines create a tension like guitar strings and remind of musical notes in play.

163 (first) The Pear Symphony Orchestra | Design Firm: Volt Positive | Creative Director/Designer: Ziad Alkadri | Client: New Talent Conservatory

Orchestra consists of young musicians studying at the New Talent Conservatory in Canada. The logo represents a bitten pear; bites on each side make it look like a cello or violin. The double-edged symbolism reflects key qualities of this young, upcoming orchestra in a playful, witty manner. The logo is applied in four colors, which correspond to the four seasons. The season's name between brackets is optional.

163 (second) Headphones | Design Firm: Go Welsh | Creative Director/Designer/Illustrator: Ryan Smoker | Client: Music for Everyone

Identity for non-profit that provides funding for music education in Lancaster County, PA.

163 (third, fourth) Mushroom Logo | Design Firm: Frost Design | Chief Creative Officer/Creative Director/Art Director: Vince Frost | Designers: Vince Frost, Anthony Donovan | Client: Warner Music

Mushroom Records started out in the late 70s, signing acts such as Spilt Enz, Skyhooks and later Kylie Minogue to become Australia's leading independent music label. Warner Music Australia bought the label in 2005 and approached Frost to create a new logo and identity. The brief was to stay true to the label's independent roots, while creating a new look to carry it forward as the banner for Warner's Australian artists roster. Our idea is based on mushrooms growing up to form the letter "m." The simplicity of the symbol and complete integration of the mushroom visual into "m" was critical to delivering a marquee that could work at a very small scale on CDs and function as an iconic and merchandisable brand. The supporting identity drew on other mushroom references, including the use of stocks typically used for mushroom bags and using this as a background texture for ads — also helping to give a street feel true to the label's roots.

163 (fifth) Zeus Rooster Logo | Design Firm: Peterson Ray & Company | Creative Directors/Designers: Miller Hung, Carl Peterson | Illustrator: Miller Hung | Client: Zeus Rooster

Logo for an alternative band.

Non-profit

164 (first) Teen Talk | Design Firm: Range, Inc | Creative Director: John Swieter | Designer: John Swieter | Client: Teen Talk

Non-Profit organization encouraging teens to help each other.

164 (second) Logo | Design Firm: Mark Oliver, Inc. | Art Director/Designer/Illustrator/Writer: Mark Oliver | Client: Valley Alliance

The Valley Alliance is a non-profit group devoted to the preservation of rural Santa Ynez Valley. We created an alpha glyph in the form of an old western brand for use on their communications.

164 (third) DICE Logo | Design Firm: Deadline Advertising | Creative Director: Amir Parstabar | Client: AIAS (The Academy of Interactive Arts & Sciences)

Not-for-profit professional membership organization serving the entertainment software community. The Academy's annual D.I.C.E. Summit (Design, Innovate, Communicate, Entertain) was created to explore approaches to the creative process and artistic expression as they uniquely apply to the development of interactive entertainment. We created a new D.I.C.E. logo that is easily adaptable and will be used for years to come.

164 (fourth) Build Logotype | Design Firm: Joe Miller's Company | Designer: Joe Miller | Client: Build

Build is a non-profit youth entrepreneurship program in under-resourced urban areas.

164 (fifth) Friends for the Fight | Design Firm: The Bradford Lawton Design Group | Designers: Leslie Magee, Jason Limon | Client: Friends for the Fight

Non-profit Cancer Support.

165 Sundance Preserve | Design Firm: Michael Schwab | Chief Creative Officer: Julie Mack | Creative Director/Designer/Illustrator: Michael Schwab | Art Director: Jamie Redford | Client: Sundance Preserve

Non-profit organization founded by Robert Redford, dedicated to environmental stewardship and developing creative strategies for social and cultural change. Set in the splendor of its own protected lands, the Preserve seeks to promote positive powerful action by cultivating the exchange of innovative ideas among artists, scholars, scientists and other leaders.

Painters

166 Paint Specialists | Design Firm: k birnholz | Designer: Karen Birnholz | Client: G de Ru

G de Ru is a small family-owned, paint specialists business since 1921, recognized as one of Holland's best.

PaperCompanies

167 Logo | Design Firm: GROUP T DESIGN | Creative Director/Designer/Illustrator: Thomas Klinedinst | Client: Crinkle Co.

A new company specializing in designing and manufacturing quality paper products like wrapping paper, gift bags, etc.

Photography

168, 169 (fourth) PH2OTO | Design Firm: Creation House | Designer: Michael

Miller Yu | Client: Mr.Ho Underwater Photography

169 (first) Light Switch Studio Logo | Design Firm: 3 | Creative Director: Sam Maclay | Account Director: Chris Moore | Design Director: Tim McGrath | Client: Light Switch Studio

Photography and digital imaging studio that provides ideas along with the standard services. We designed a logo to appeal to their business target, namely, creative folks looking for fresh insights on how to make their own work better.

169 (second) Darrin Haddad Logo | Design Firm: TODA | Creative Director: Tyson Thorne | Art Director: Marcos Chavez | Designer: Farrah Hussain | Print Producer: Gillian Spilchuk | Client: Darrin Haddad

Darrin Haddad is a NY-based still life photographer who needed to evolve his brand in keeping with a growing client base. TODA developed his identity to be a simple, effective mark that communicates his name in a minimal way. The cropped last name uses ascended letterforms to bridge the vowels in his last name. An accidental result is a logo that looks like sans serif Arabic writing, hinting at his Lebanese descent.

169 (third) Photo Agency | Design Firm: Stockland Martel | Creative Director: Bill Stockland | Art Director: Maureen Martel | Designer: Design MW | Writer: Vicki Goldberg | Client: Stockland Martel

For a promotional book showcasing the work of photographers represented by Stockland Martel.

169 (fifth) Julian Noel Photography | Design Firm: Sibley/Peteet Design, Dallas | Designer: Craig Skinner | Client: Julian Noel Photography

Logo for a local Dallas photographer.

Printers

170 (top) PrismaGraphic Corp. Logo | Design Firm: Catapult Strategic Design | Creative Director/Art Director/Designer: Art Lofgreen | Account Director: Brad Ghormley | Client: PrismaGraphic Corp.

170 (middle) Printing Today Logo | Design Firm: Sandstrom Design | Creative Director/Art Director/Designer: Steve Sandstrom | Print Producer: Kirsten Cassidy | Client: Printing Today

170 (bottom) Printworx | Design Firm: Range, Inc | Creative Director/Designer: John Swieter | Client: Printworx

171 Mailer Magic | Design Firm: RBMM | Designer: Brian Owens | Client: Williamson Printer Co.

172, 173 Company B Logo | Design Firm: Finished Art Inc. | Art Directors: Donna Johnston, Kannex Fung | Designers/Illustrators: Barbara Dorn, Luis Fernandez, Kannex Fung, Li-Kim Goh, Mary Jane Hasek, Cory Langner, Ake Nimuswan, Larry Peebles, Anne Vongnimitra | Client: Company B Inc.

Finished Art, Inc. of Atlanta used the capital letter "B" as a primary design element in a series of logos for Company B. Illustrators used the shape as a working space to create representations of the company's services, such as brilliant printing, large format printing and kit packing. Specific logos are used to tie into appropriate applications on collateral material. Printing of the logos utilizes CompanyB's vibrant 6-color output for strong color impact.

Products

174 (first) SmartTread product identity | Design Firm: Pollard Design | Designer: Jeff Pollard | Client: National Safe Tire Coalition

SmartTread is a product developed by National Safe Tire Coalition, which is making strides with the U.S. government to make their so-called "smart tire" technology a requirement for all vehicles. As the tire tread wears out, color belts beneath the tread begin to show through, telling the driver a tire is becoming unsafe.

174 (second) Oregon Garden Logo | Design Firm: Sandstrom Design | Creative Director/Designer/Illustrator/CopyWriter: Marc Cozza | Project Manager: Spike Selby | Client: Three Mile Canyon Farms

Secondary logo for Oregon Garden Compost Products.

174 (third) Voq Logo | Design Firm: Interbrand | Creative Director: Todd True | Designer: Roman Ley | Client: Voq, Sierra Wireless

174 (fourth) Atomic Gaming logo | Design Firm: Sibley/Peteet Design, Dallas | Creative Director: Don Sibley | Designer: Rey Latham | Client: Atomic Toys

Logo for a very dynamic gaming company.

174 (fifth) Made in NY | Design Firm: @ Radical media | Creative Director: Rafael Esquer | Art Director: Wendy Wen | Executive Producer: Geoff Reinhard | Client: The City of New York Mayor's Office of Film, Theatre & Broadcasting

The NYC Mayor's Office of Film, Theatre & Broadcasting wanted a design to serve as communications for the tax incentive program as well as a seal of quality on all things made in NY.

175 White Owl Logo | Design Firm: Sandstrom Design | Creative Director: Steve Sandstrom | Art Director/Designer: Greg Parra | Illustrator: Larry Jost | Project Manager: Kelly Bohls | Client: Garcia y Vega

Part of a complete brand packaging redesign honoring their 100-year heritage while creating a younger, more contemporary look.

176 Luxury Dog Products Logo | Design Firm: Tracy Sabin | Art Director: Troy Martz | Illustrator: Tracy Sabin | Client: Luxury Dog Products

177 (first) Sofine | Design Firm: Wray Ward Laseter | Creative Director: John Roberts | Art Director/Designer: Brandon Scharr | Client: Springs Global

New bedding line with finer cotton weave than traditional sheets.

177 (second) MARBLES | Design Firm: Range, Inc | Creative Director: John Swieter | Designer: Ray E. Gallegos | Client: Marbles Childrens Learning

177 (third) Logo for Handy Horse | Design Firm: Zync Communications Inc. | Creative Director: Marko Zonta | Art Director/Designer: Mike Kasperski | Client: Weston Forest Group

Logo for a new product called Handy Horse that visually depicts the product and demonstrates its key features: low-ticket price, plus easy to use, handle and store. It's a no-nonsense design that stands out to home project enthusiasts.

177 (fourth) Bloom Craft Home | Design Firm: Bernhardt Fudyma Design Group | Designers: Janice Fudyma, Angela Valle | Client: Bloom Craft Home

177 (fifth) Retrobotics Logo | Design Firm: Kitemath | Creative Director: Christopher Jennings | Designer: Christopher Jennings | Client: Retrobotics

This logo alludes to what Retrobotics is about, namely the creation of high-end, vintage robot toy art. It was created in the image of a gear or cog with tines made from the hand of the first robot offered for sale. The "Robot" portion of the text is emphasized, adding overall symmetry to the logo. There is also a stencil variant of the mark that can be spray painted onto boxes and other surfaces to allude to a "construction or manufacturing" process.

178 The Wine Tie Logo | Design Firm: Lam Design Group | Executive Creative Director/Chief Creative Officer/Creative Director/Art Director/Designer/Illustrator/Account Director/Design Director/Artist/Typographer: Linda T. Lam | Client: Kyriakos and Megan Pagonis

Neck Tie sits on the neck of a wine bottle and catches the drips.

179 ISSIMBOW | Design Firm: Shin Matsunaga | Creative Director/Art Director/Designer: Shin Matsunaga | Client: ISSIMBOW, Inc.

ISSIMBOW is a brand created by a fusion of the knowledge compiled in "Ishinho," Japan's oldest medical dictionary (dating back 1000 years) and 21st-century science. In this modern age, being more healthy, lively and beautiful is a desire involving all five senses. To satisfy this desire, ISSIMBOW creates products based on the wellness theme. The Ishinho dictionary is a world-class cultural asset, designated as a Japanese national treasure, while ISSIMBOW is a registered trade name of Nippon Kodo Co., Ltd., a leading incense manufacturer. While incense related products are created by Nippon Kodo, the rest are created in collaboration with companies in different fields, which support the brand concept. The key visual element is based on the freely applied logotype.The initial stage design items are shown here.

180 (first) Fuego North America logo | Design Firm: Pentagram SF | Chief Creative Officer/Art Director: Kit Hinrichs | Designer: Erik Schmitt | Client: Fuego North America

Fuego is a modernist rethink of outdoor living, pioneering designs that are original, innovative and bold. The color invokes heat, while the strong, square shapes reflect the product's design.

180 (second) McCue Corporation | Design Firm: Range, Inc | Creative Directors: John Swieter, Chuck Pennington | Designer: Chuck Pennington | Client: McCue Corporation

Develops damage prevention products for retail environments.

180 (third) Head of Marketing Systems Knoll Europe | Design Firm: Ginette Caron | Art Director/Designer: Ginette Caron | Client: Knoll International/Trent Baker

180 (fourth) Petanica Logo | Design Firm: Supon Creative | Art Director/Designer: Supon Phornirunlit | Illustrator: Jae Wee | Client: Petanica

180 (fifth) Swiss Army Greeting Cards | Design Firm: Mirko Ilic Corp. | Creative Director: Daniel Young | Art Directors: Daniel Young, Mirko Ilic | Designer: Mirko Ilic | Client: Paradoxy Products

A conventional "happy face" has been "Swissified" and made to wink to convey both the multi-functional nature of greeting cards, which cover 36 different celebrations, and the witty irreverence of this departure from the norm.

181 Goody's Paint | Design Firm: A3 Design | Art Director: Alan Altman | Account Director: Amanda Altman | Artists: Alan Altman, Lauren Gualdoni | Client: Goody's Paint

A spin-off product line of a NH interior design company.

ProfessionalServices

182 (first) Cook County Canines | Design Firm: pfw design | Creative Director/Designer: Patience Williams-Whang | Illustrator: Pat McDarby | Client: Cook County Canines

Cook County Canines strives to educate and support families who share their homes with challenging canines. Through training programs, Cook County Canines addresses the "no, no bad dog" syndrome and helps dog owners learn to correct negative behaviors and nurture a well-behaved member of the family.

182 (second) Desirability: God, Marriage, Intimacy | Design Firm: Gouthier Design: a brand collective | Creative Director/Illustrator: John Kissee | Client: Desirability

A marriage and intimacy counselor that uses Biblical foundations for the attraction between man and wife. The concept for the logo came from the Bible's Book of Solomon, also called the Song of Songs. This is a love letter written by a man and his lover, interpreted in the nuzzling of the two animals in the identity.

182 (third) Presentation Tweaker | Design Firm: Sugarlab | Art Director/Designer: Shawn Fagan | Client: The Presentation Coach - Ellen Lee

Ellen Lee offers presentation tweaking for successful speaking.

182 (fourth) Bend Valet Brand Mark | Design Firm: Buzzsaw Studios, Inc | Creative Director: Tim Parsons | Client: Bend Valet

Logo is direct and sophisticated, like a valet attendant. The "B" and "V" are incorporated into the valet attendant's body, making this Addy-winning logo stand out.

Credits

182 (fifth) Segue LLC. | Design Firm: Kate Resnick Design | Designer: Kate Resnick | Client: Segue

183 Whitehall University Logo | Design Firm: Catapult Strategic Design | Creative Director/Art Director/Designer: Art Lofgreen | Account Director: Dave Duke | Client: Whitehall University
Management training for medical professionals.

184 X Development Logo | Design Firm: Tompertdesign | Designers: Claudia Huber Tompert, Michael Tompert | Client: X Development
Small company helping inventors bring their inventions to market.

PublicRelations
185 Identity | Design Firm: Young&Laramore | Creative Director: Carolyn Hadlock | Art Director: Pamela Schiff | Client: Tamarindo

Public&SocialServices
186 (first) DIAL 311 | Design Firm: @ Radical media | Creative Director/Designer: Rafael Esquer | Executive Producer: Geoff Reinhard | Client: The City of New York Department of Information, Technology and Telecommunications
We developed the DIAL 311 Citizen Service Campaign to launch NYC's DIAL 311 program and raise awareness of the services and information residents can easily access by dialing 311. The logo became a poster, billboard, bumper sticker and more: a direct communication through typography and color. A basic color palette of yellow and black was used to achieve maximum visual impact in a graphically busy city landscape.

186 (second) S.T.A.R. Logo | Design Firm: Braley Design | Art Director/Designer: Michael Braley | Account Director: Matthew Bersagel Braley | Client: Southern Truth And Reconciliation
S.T.A.R. responds to requests from communities with histories of lynching and other communal forms of racial and ethnic violence, and partners with communities to adapt the truth and reconciliation process to local needs, on the premise that truth-telling and acknowledgement by all stakeholders must precede healing, reconciliation, and justice for the entire community.

186 (third) Identity System | Design Firm: Meta4 Design | Art Director: Fred Biliter | Designer: Audrey Saberi | Client: McCormick Tribune Foundation
The challenge was to create an identity that provides a sense of cohesion between McCormick Tribune Foundation as an entity in its own right and its three operations: the forthcoming Freedom Museum, Cantigny, the First Division Museum and the McCormick Conference Series. The Foundation is an organization that focuses on advancing the ideals of a free, democratic society through children, communities and country. Our logo is accessible and warm in tone, with a sense of discipline originating from a military history. The stripes of the "M" represent the military accolades awarded to those who perform superior service.

186 (fourth) International Commission on Holocaust Era Insurance Claims Logo | Design Firm: Beth Singer Design | Art Director: Beth Singer | Designer: Chris Hoch | Client: ICHEIC

186 (fifth) Identity/Logo | Design Firm: Wall-to-Wall Studios, Inc. | Chief Creative Officer: James Nesbitt | Creative Director/Art Director/Designer: Larkin Werner | Client: Pittsburgh Arts & Lectures
An identity system for the region's premier literary organization.

187 San Francisco Parks Trust | Design Firm: Cronan Design | Designer/Illustrator: Michael Cronan | Client: San Francisco Parks Trust

188 Young Executive Association logo | Design Firm: Squires & Company | Creative Director: Brandon Murphy | Designer: Jerome Marshall | Client: Young Executive Association
Albuquerque Chamber of Commerce's monthly meeting bringing young executives together to learn from seasoned business professionals.

189 (first) Changing Times Enduring Values Campaign Logo | Design Firm: Catapult Strategic Design | Creative Director: Art Lofgreen | Art Director/Designer/Illustrator: Frank Corridori | Account Director: Dave Duke | Client :Boy Scouts of America, Grand Canyon Council
Logo for capital fundraising campaign to raise money for the Boy Scouts' Grand Canyon Council programs.

189 (second) Living Dreams | Design Firm: Graphic Content | Creative Director/Art Director/Designer: Art Garcia | Client: Living Dream Foundation
Non-profit empowering women in underdeveloped nations.

189 (third) Wildlife Rescue and Rehabilitation Logo | Design Firm: The Bradford Lawton Design Group | Creative Director: Bradford Lawton | Art Director/Designer: Rolando Murillo | Client: Wildlife Rescue and Rehabilitation

189 (fourth) Kerzner Marine Foundation | Design Firm: Duffy & Partners | Executive Creative Director: Joe Duffy | Creative Director: Dan Olson | Designer: Joseph Duffy IV | Client: Kerzner Marine Foundation
Private, non-profit foundation fostering preservation and enhancement of global marine ecosystems through scientific research, education, and community outreach. Identity creates an optical illusion of a human face and a dolphin tail. This design, along with the marine blue color of the mark, effectively communicates their mission of defending the integrity of tropical marine ecosystems. The Foundation was created to promote awareness and education of the need to protect the world's marine environments.

189 (fifth) What's Driving You? | Design Firm: Hirschmann Design | Art Director: Tor Bennstrom | Designer/Illustrator: Karl Hirschmann | Client: What's Driving You?
Symbol for anti-drunk driving program.

190 (first) Chinatown Community Development Center Logo | Design Firm: Unit Design Collective | Creative Directors: Ann Jordan, Shardul Kiri | Designers: Ann Jordan, Virginia Yeh | Project Manager: Amy Ho | Marketing Manager: Shalini Sadhwani | Client: Chinatown Community Development Center
In conjunction with a non-profit funding program, Taproot Foundation, we designed a logo to engage Chinatown CDC's non-Chinese constituency without alienating their Chinatown roots. Chinatown CDC is a non-profit dedicated to establishing and funding low-income housing for ethnically diverse San Francisco residents, building community, and enhancing quality of life through its advocacy programs. The identity uses a stylized version of the Chinese character for "people." The character also forms a house, using the home and "people" character as a symbol for community. This way, it is understood in both the broader and Chinese communities.Using the chop form, we reinforced the center's Chinatown heritage.

190 (second) The Home Team | Design Firm: RBMM | Designer: Christy Gray | Client: The Home Depot
Habitat for Humanity and Home Depot renovation team logo.

190 (third) Beleuchtungsgruppe Logo | Design Firm: Keith Harris Design | Creative Director: Keith Harris | Art Director: Keith Harris | Designer: Keith Harris | Client: Stadtmarketing Konstanz
Logo for group seeking to promote Konstanz, Germany, through the professional lighting of historic buildings and public places.

190 (fourth) 200 Reading room | Design Firm: Studio International | Creative Director/Art Director Designer/Account Director/Design Director/Writer/Artist: Boris Ljubicic | Editor: Tihomil Mastrovic | Client: Museum Documentation Centre

190 (fifth) Kansas Children's Service League Logo | Design Firm: Greteman Group | Creative Director: Sonia Greteman | Designers: Sonia Greteman, James Strange | Client: Kansas Children's Service League

191 Giving Groves Logo | Design Firm: vitrorobertson | Creative Directors: John Vitro, John Robertson | Art Director: Mike Brower | Illustrator: Tracy Sabin | Writer: John Robertson | Client: Giving Groves

Publishing
192 East End Books | Design Firm: Arthur Beckenstein | Art Director: Arthur Beckenstein | Client: East End Books
An independently owned bookstore.

193 Adventure House logo | Design Firm: Drive Communications | Creative Director/Art Director: Michael Graziolo | Designers: Michael Graziolo, Eiji Tsuda | Client: Adventure House
Adventure House publishes pulp genre books and magazines. Along with the corporate mark (the trademark detective fedora), we developed a series of support logos keyed to various genres within the pulp field.

194 (first) Summer Rough Icon | Design Firm: SullivanPerkins | Creative Director: Mark Perkins | Designer/Illustrator: Chuck Johnson | Client: DSVC
Icon for the summer issue of *Rough* magazine.

194 (second) Threshold Editions Logo | Design Firm: Prejean Creative | Creative Director: Kevin Prejean | Designer: Burton Durand | Client: Simon & Schuster
Imprint featuring books of contemporary conservatism.

194 (third) Buchmann | Design Firm: El Paso, Galería de Communicación | Creative Director/Art Director/Designer/Writer: Álvaro Pérez | Client: Buchmann Ediciones
Publisher that launches only pure, exclusive and modern books.

194 (fourth) Le Biarritz Startup Magazine | Design Firm: Stritzel Design Group | Creative Director/Designer: Mark Stritzel | Client: Le biarritz magazine

194 (fifth) Hyperion Books for Children Identity | Design Firm: Miriello Grafico, Inc | Designer: Dennis Garcia | Client: Hyperion
A proposed identity for Hyperion Books.

195 X-Men Logo Concept | Design Firm: Rickabaugh Graphics | Designer: Eric Rickabaugh | Client: Self-Promotion

RealEstate
196 (first) 2 Makes One | Design Firm: CHE Design | Creative Director/Illustrator: Christian Hoyle | Client: Double H Ranch
Logo embraces the past and present of this family-owned farm. The farm has been owned by two brothers, one and a half years apart in age. The older brother was the original owner; he passed away and the farm was taken over by his younger brother. He wanted a logo/brand that showcased the family name but still respected the heritage of his older brother. This was accomplished with the two lowercase "h" making the capital "H."

196 (second) Hidden Rock Ranch | Design Firm: Hirschmann Design | Art Directors: Marc Hirschmann, Mike Hirschmann, Chris Hirschmann | Designer/Illustrator: Karl Hirschmann | Client: Hidden Rock Ranch
Symbol (and cattle brand) for a small ranch near Lawrence, KS.

196 (third) Queen City Capital | Design Firm: A3 Design | Art Director/Account Director/Artists: Alan Altman, Lauren Gualdoni | Client: Queen City Capital

196 (fourth) Savannah Hill | Design Firm: Lanny Sommese | Art Directors: Lanny Sommese, Kristin Sommese | Designers: Lanny Sommese, Jason Dietrick | Typographer: Lanny Sommese | Client: Lauth Development

196 (fifth) The Pinnacle Group Icon | Design Firm: The Bradford Lawton Design Group | Creative Director: Bradford Lawton | Art Director/Designer: Rolando G. Murillo | Client: The Pinnacle Group
Corporate real-estate agency specializing in office relocation.

197 Henritze Logomark | Design Firm: Deep Design | Designer/Illustrator/Design Director: Heath Beeferman | Client: The Henritze Company, LLC

A real-estate development company.

198 Acquire New York Logotype | Design Firm: Poulin + Morris Inc. | Designers: Douglas Morris, Brian Brindisi, AJ Mapes | Client: Acquire New York

Graphic identity and branding for a unique real-estate resource includes a contemporary graphic identity as well as a website, brochures, and stationery. The coordinated materials function as sales and marketing tools for the client as they work to expand their client list in the highly competitive field of NY real-estate.

199 (first) Amore Logo | Design Firm: Tracy Sabin | Creative Director: Craig Fuller | Art Directors: Jerry Sisti, S. Michael Grace | Designer: Jerry Sisti | Illustrator: Tracy Sabin | Client: Barratt American

A housing development featuring Tuscany-inspired architecture.

199 (second) Somerset Partners | Design Firm: Pentagram Design | Art Director: Michael Gericke | Designer: Seong Yang | Client: Somerset Partners

Symbol for a planning and investment real-estate firm specializing in urban developments.

199 (third) Power and Light Condos | Design Firm: Rees Masilionis Turley Architecture | Creative Director: Steve Turley | Art Director: Michael Paxton | Designer/Illustrator: Bryan Lisbona | Client: Alsation Land Company

199 (fourth) AAM | Design Firm: Catapult Strategic Design | Creative Director/Art Director/Designer: Art Lofgreen | Account Director: Dave Duke | Client: AAM

Homeowners' association and management company.

199 (fifth) Settlers Ridge Logo | Design Firm: Tracy Sabin | Art Directors: Danny Zaludek, Paige Cleveland | Illustrator: Tracy Sabin | Client: Kimball Hill Homes

200 (first) Maida Vale Logo | Design Firm: Littleton Advertising and Marketing | Creative Director/Art Director/Designer: Chris Enter | Client: Maida Vale

Maida Vale is a community in Durham, NC featuring distinct European architecture in an upscale environment with homes priced from the $450s. The objective was to showcase the community's prestigious appeal with an elegant font treatment and seal.

200 (second) Jackson Cooksey Logo | Design Firm: Sibley/Peteet Design, Dallas | Creative Director: Don Sibley | Designer: Brandon Kirk | Client: Jackson Cooksey

Identity for commercial real-estate firm in Dallas.

200 (third) Marcia Cegavske Realty | Design Firm: Rogue Element Inc. | Chief Creative Officers/Designers: Allison Manley, Robert Coleman | Artist/Creative Director: Robert Coleman | Art Director: Allison Manley | Client: Marcia Cegavske

Marcia needed a logo to use on all her promotional materials (yet to be designed). She wanted something bold and contemporary, that inferred real-estate. Using her first initial, we designed the rooftops to create the letter "M." The logo is simple enough to work in all sizes and formats, and projects the desired brand.

200 (fourth) Glennwilde Groves Logo | Design Firm: Catapult Strategic Deign | Creative Director/Art Director: Art Lofgreen | Designer: Garren Lofgreen | Account Director: Brad Ghormley | Client: Element Homes

New home subdivision for Element Homes.

200 (fifth) Identity | Design Firm: Brad Simon | Art Director: John Klotnia | Designer: Brad Simon | Client: National Beverage Properties

201 The Austonian | Design Firm: Les Kerr Creative | Creative Director: Danny Nguyen | Art Director/Designer: Les Kerr | Client: Levenson & Hill

Luxury high-rise condominium in downtown Austin, TX.

202 Antler Ranch | Design Firm: RBMM | Designer: Brian Owens | Client: Antler Ranch

Whitetail deer breeding ranch.

203 (first) Torre Tao | Design Firm: Helium Diseno | Art Director: Alejandro Sanchez | Client: Proasa

203 (second) 55 West Wacker Logo | Design Firm: Frank Worldwide | Creative Director: Todd Houser | Art Director: Raymond Adrian | Account Director: Divina Bach | Client: 55 West Wacker

A condo office conversion in the relatively conservative Chicago Central Business District currently offering interested buyers the chance to buy vertical subdivisions with wide-open floorplans for their businesses, or for purely investment purposes.

203 (third) Amsterdam 1 | Design Firm: Helium Diseno | Art Director: Alejandro Sanchez | Client: Picciotto Arquitectos

203 (fourth) 818 Logo | Design Firm: Hornall Anderson Design Works | Creative Director: John Anicker | Art Director: Andrew Wicklund | Designers: John Anicker, Andrew Wicklund, Leo Raymundo, Holly Craven | Client: Schnitzer West

Identity for Seattle professional office building.

203 (fifth) N3 Logo | Design Firm: Concussion, LLC | Art Director: Andrew Yanez | Account Directors: Scott Kirk, Nick Bendian | Client: N3

N3 is a real-estate developer for some of the nation's leading retailers like Starbucks, Wells Fargo, Wachovia and Circuit City.

Recreation

204 Area 251 | Design Firm: Ryan Russell | Art Director/Designer: Ryan Russell/Typographer: Ryan Russell | Client: Area 251 Motocross Facility

205 (top, bottom) Proposed Logo | Design Firm: Gillett + Co | Art Director: Eric Gillett | Designer: Arlo Vance | Client: Porcupine Ridge

Proposed logos for a golf course and clubhouse.

205 (middle) King Pin Bowling Logo | Design Firm: GSD&M | Designer: Tom Kirsch | Client: King Pin Bowling

This logo scored a strike with our agency bowling team.

Religion

206 The Zen | Design Firm: Creation House | Chief Creative Officer/Creative Director/Art Director/Designer: Michael Miller Yu | Illustrator: Henry Yu | Client: The Zen

A health uplifting group comprised of young executives gathers together every Sunday to communicate through music, exercise and meditation. This symbol combines the Chinese word of Buddhism and the English word of Zen (East meets West).

Restaurant

207 Conte's | Design Firm: Louise Fili LTD. | Creative Director/Art Director: Louise Fili | Designers: Louise Fili, Chad Roberts | Client: Conte's

Although this was a new restaurant, the Conte family has been in the seafood business for over half a century. To communicate history, the logo was designed to be a cut-out wooden hanging sign, and then downsized to a die-cut, foil-stamped business card.

208 (first) Food, Friends and Company Logo | Design Firm: Sullivan Perkins | Creative Director: Mark Perkins | Designer/Illustrator: Chuck Johnson | Client: Food, Friends and Company

A holding company for new and developing restaurants.

208 (second) The Gecko Lounge Logo | Design Firm: Peterson Ray & Company | Creative Director/Designer: Miler Hung/Illustrator: Miler Hung | Client: The Gecko Lounge

208 (third) Gajba | Design Firm: Brandoctor | Creative Director: Moe Minkara | Art Director/Designer: Igor Manasteriotti | Illustrator: Davor Rukovanjski | Project Manager: Helena Rosandic | Client: Boris Juric, Gajba

The hygiene aspect plays a major role in nutrition consultation. The observer responds with a positive feeling towards food.

208 (fourth) Summit | Design Firm: Mirko Ilic Corp. | Creative Director/Art Director/Designer: Mirko Ilic | Client: The Broadmoor

Restaurant in CO situated on car-racing track leading to a summit.

208 (fifth) Adobe Café Logo | Design Firm: Sibley/Peteet Design, Austin | Art Director: Rex Peteet | Designer/Illustrator: David Kampa | Client: Adobe Texican Cafe

Logotype and containing shape suggest the punched tin art style so popular in Mexico, and a Tex-Mex blend of block serif woodblock faces conveys an antiquity and informality consistent with the personality of the Cafe. The colors are influenced by the greens to reds of fresh chili peppers roasting on the grill.

209 Margarita Madness Logo | Design Firm: GSD&M | Art Director: David Walker | Designer/Illustrator: Kevin Peake | Client: Chilis

Designed to evoke memories of the early 60s, when all you needed were your friends, sun, and some cool drinks to have a good time.

210, 211 (third) DELADO | Design Firm: Dfraile | Creative Director/Art Director: Eduardo del Fraile | Designers: Eduardo del Fraile, Antonio Marquez | Client: DELADO

Logo applied to an ice-cream parlor. Typography has been designed using the biscuit that used to go together with old ice-cream wafers, delimiting a checkered reticule making the brand.

211 (first) Mermaid Inn logo | Design Firm: Louise Fili LTD. | Creative Director/Art Director: Louise Fili | Designers: Louise Fili, Chad Roberts | Illustrator: Anthony Russo | Client: Mermaid Inn

A casual seafood shack in Manhattan's East Village. The logo reflects the funky, whimsy feel of the shack, and authenticity.

211 (second) Victor's Sea Grill | Design Firm: Sibley/Peteet Design, Dallas | Designer: Craig Skinner | Client: Victor's Sea Grill

211 (fourth) Noir Logo | Design Firm: Jessica Campbell | Creative Director/Designer: Jessica Campbell | Client: Noir Ultra Lounge

Logo created for a members-only ultra-lounge. The mark, like the film genre of the 40s and 50s, explores a darker side of female sexuality. It includes a shape that some may interpret as smoke rising, and alludes to a woman's figure. The logo appears in expected ways (on business cards and letterhead), and serves as the basis for several hallmarks of the establishment. The logo is first presented to patrons on a small sign in the alleyway. This piece marks the private entrance to the lounge and sets the tone. Once inside, members find a space that mimics the curved, undulating lines of the mark, evident in the forms of booths and tables. These elements immerse patrons in a seductive world of mystery.

211 (fifth) Iron Horse | Design Firm: Range, Inc | Creative Director/Designer: John Swieter | Client: Iron Horse Saloon

A bar in North Idaho.

212 (first) Red Burrito | Design Firm: Zeist Design, llc | Creative Directors: Oscar V. Mulder, Richard Scheve | Designer :Toby Sudduth | Client: CKE Restaurants

Red Burrito is the perfect co-brand for Hardee's–Thickburgers and huge burritos under one roof. Zeist created this rustic logo to complement Hardee's while expressing the authentic, California-style bigness of the menu.

212 (second) "Q" BBQ Logomark | Design Firm: Deep Design | Designer/Illustrator/Design Director: Edward Jett | Client: A Sharper Palate

A chain of BBQ restaurants based in Richmond, VA.

212 (third) Lengua de Gaudi | Design Firm: Graphics & Designing Inc. | Creative Director: Takanori Aiba | Art Director: Toshihiro Onimaru | Designer: Touru Yukawa | Client: RC Japan Co., Ltd.

212 (fourth) CoCo. Logo | Design Firm: HZDG | Executive Creative Director: Karen Zuckerman | Creative Director: Tamara Dowd | Art Director: Chris Walker | Account Director: Courtney Dahl | Client: C3fix

212 (fifth) Blacksteer | Design Firm: HKLM | Creative Director: Graham Leigh | Art Director: Gary Harwood | Designer: Soul Modiga | Client: King Pie Holdings

Blacksteer is the oldest chain of steak and rib QSR in South Af-

Credits

rica (started 1962). This new logo represented the rebirth of the legend into the premier African market.

213 Brand Identity for Panini | Design Firm: Lewis Moberly | Creative Director: Mary Lewis | Designers/Illustrators: Hideo Akiba, Fiona Verson-Smith | Design Director: Sonja Frick | Client: Grand Hyatt Dubai

214 Domaine Restaurants Logo | Design Firm: Ramp | Creative Directors: Rachel Elnar, Michael Stinson | Designer: Michael Stinson | Client: Domaine Restaurants
Logo for a husband and wife gourmet restaurant company that specializes in French cuisine.

215 (first) SeaFire Logo | Design Firm: Duffy & Partners | Executive Creative Director: Joe Duffy | Creative Director: Dan Olson | Designer: Joseph Duffy IV | Project Manager: Bridget Schumacher | Client: Atlantis-Paradise Island, Resort
Identity introduces SeaFire, a steakhouse located at The Atlantis Resort on Paradise Island in The Bahamas. It was designed to communicate an inspirational dining experience, combining the grilled rotisserie centerpiece of the cuisine with a setting in one of the most beautiful, exotic marine-themed resorts on the planet.

215 (second) Drum Room | Design Firm: RBMM | Designer: Brian Owens | Client: Drum Room
Restaurant, casual nightclub and lounge located in the historic Hilton President, Kansas City.

215 (third) FEZ Logo | Design Firm: HOOK | Art Director/Illustrator: Brady Waggoner | Project Manager: Jennifer Sousa | Client: Restaurant Development Associates

215 (fourth) ShoreHouse | Design Firm: Louise Fili LTD. | Art Director: Louise Fili | Designer/Illustrator: Chad Roberts | Client: ShoreHouse

215 (fifth) Second Cup Identity | Design Firm: Shikatani Lacroix Brandesign | Creative Director: Jean-Pierre Lacroix | Designer: Kim Yokota | Production Designer: Yakiv Karchev | Hand Lettering: Hon Leong | Client: Second Cup
Corporate identity for retail exterior, packaging, internal communications and corporate collateral.

216 (first) Patti's Place | Design Firm: RBMM | Designer: Yvette Wheeler | Client: Patti's Place
Tea and bakery house.

216 (second) 3rd Base Logo | Design Firm: Dennard, Lacey & Associates | Art Director/Designer/Illustrator: James Lacey | Client: 3rd Base Sports Bar & Grill
Sports bar restaurant featuring provocatively attired waitresses.

216 (third) Pato Zazo Logo | Design Firm: Sibley/Peteet Design, Austin | Creative Director/Art Director: Rex Reteet | Designers: Rex Reteet, David Kampa | Client: El Pato Fresh Mexican Food
Pato, "duck" in Spanish, is the mascot and symbol for this fresh food Mexican restaurant. "Pato," a term of endearment coined by the childhood friends of the owner, stuck with him. The mark and logotype are inspired by the Mola art of South America.

216 (fourth) Nona's Pantry | Design Firm: Gestudia | Art Director/Designer/Illustrator: Francisco G Delgadilo | Client: Nona's Pantry
A small catering start-up company targeting cook-in clients. Logo focuses on the tenderness involved in this catering service.

216 (fifth) Pizza Nova Packaging | Design Firm: Concrete Design Communications Inc. | Art Directors: Diti Katona, John Pylypczak | Designer: Tom Koukodimos | Client: Pizza Nova

217 Noodlin' | Design Firm: Sandstrom Design | Client: Noodlin' Restaurant

Retail
218 Printing Ink's shop | Design Firm: Adventa Lowe | Creative Director: Oleksiy Pasichnyk | Art Director/Designer: Nikolay Kovalenko | Client: Adventa Lowe
Aerial view of a can with printing ink, turning over on its side.

219 (first) Identity | Design Firm: Totem Visual Communications | Creative Director: Colin Byrne | Designer: Aaron Cartlidge | Client: Alan Dalton Goldsmith
Talented goldsmith, handcrafting high quality, bespoke jewelry. Logo reflects artist's individuality. It is based on an ancient alchemy sign for gold, and intertwines the initials "AD." Along with the symbol, the choice of typeface helped create the contemporary, original style Alan wanted. The logo is applied to stationery, signage, window display, jewelry boxes and website.

219 (second) Longs Drugs Private Label Logo | Design Firm: Proteus Design | Art Director: Bill Sterling, Charlie Conn | Designers: Stuart B. Siegal, Peter Farell, Annie Baker, Jason B. Williams, Shawn Broderick | Client: Longs Drugs
Longs Drugs engaged us to help maintain their core customers' perception of its neighborhood feeling, while updating their almost 1,200 store-branded products and creating a private label branding consistency that could compete with larger chains. It was vital to maintain its core values of West Coast heritage and wellness focus, while providing updated graphics to compete with competitive offerings. Longs' strategic initiative created a naming convention for 12 diverse product categories that reinforced the brand's legacy. A bold, clean graphic presentation conveys the neighborhood spirit, while bringing a consistency throughout the brand's offerings.

219 (third) Crossroads Coffeehouse & Music Logo | Design Firm: Peterson Ray & Company | Art Director/Designer: Scott Ray | Client: Crossroads Coffeehouse & Music Company
Logo for coffeehouse and acoustic guitar store.

219 (fourth) West Yellowstone Fly Shop | Design Firm: William Homan Design | Creative Director/Designer: William Homan | Client: West Yellowstone Fly Shop
Retail shop for fly fishing.

219 (fifth) Hill Country Weavers Identity | Design Firm: MBA | Designers: Mark Birkman, Carolyn Pledger | Illustrator: Chris Gall | Client: Hill Country Weavers
Specialty knitting, basketry and weaving boutique.

220 (first) Hello Labels Logo | Design Firm: Concussion, LLC | Art Director: Andrew Yanez | Account Director: Matt Milliron | Client: Hello Labels
Hello Labels is an online retailer of quick-turn labels. Their approach removes the printer-speak and jargon for everyday knuckleheads. They make printers friendlier.

220 (second) Vase | Design Firm: Team Young & Rubicam | Creative Directors: Joseph Francis Bihag, Shahir Ahmed | Art Director/Designer: Joseph Francis Bihag | Client: Art Glass Emporium
A store showcasing exquisite pieces of glass paintings and sculptures created in clear and coloured glass. Logo highlights the colors' effects. The art and colors give the glass its shape and identity.

220 (third) Antiques and Home Furnishings Store | Design Firm: 601 Design, Inc. | Art Director/Designer/Illustrator: Bruce Holdeman | Client: Home on the Range
Antiques and home furnishings store with a western theme.

220 (fourth) KAIHONG PLAZA MARK | Design Firm: 3G (Grand Gleaming Graphics) | Creative Director: Wang Chao-Ying | Art Director/Designer: Hiroyuki Hayashi | Client: KAIHONG PLAZA
A Shanghai department store. Chinese characters for Kaihong are written as `Mçí, and Åg`MÅh was written in the elegant style used by the aristocracy during the Chou Dynasty to express harmony between ancient Chinese culture and the arising culture.

220 (fifth) Bone Bistro Logo | Design Firm: Rick Johnson & Company | Creative Director: Sam Maclay | Designer: Tim McGrath | Writer: Katie DuBerry | Client: Bone Bistro
Promotes Bone Bistro, a high-end dog treat bakery retail store.

221 Hometech Direct Logo | Design Firm: Slow-motion | Art Director/Designer: Jeff Miller | Client: Hometech Direct
A retail store specializing in technology products for the home, such as plasma screens, whole house audio equipment and home computer networking components and services.

Spirits
222 **Platinum** Red Leaf Bottling logo | Design Firm: RBMM | Designer: Christy Gray | Client: Red Leaf Bottling

223 St. Germain Logo | Design Firm: Sandstrom Design | Creative Director/Senior Designer: Steve Sandstrom | Illustrator: Antar Dayal | Project Manager/Print Producer: Prue Searles | Client: Cooper Spirits
Logo for a French, artisanal, elder flower liqueur.

224 Marquis Philips "Roogle" wine range | Design Firm: IKD Design Solutions | Creative Director/Art Director: Ian Kidd | Designers: Ian Kidd, Matthew Remphrey | Illustrator: Robert Marshall | Client: Marquis Philips
A collaboration between award-winning Australian wine makers Sparky and Sarah Maquis and Californian importer Dan Philips led to a branding and packaging brief to launch a new product range in the U.S. We responded with a hybrid image of a kangaroo and eagle illustrated in traditional zoological style. It enjoyed immediate success and became fondly known as the "Roogle".

225 (first) GRAN FRUITS | Design Firm: Graphics & Designing Inc. | Art Director/Designer: Toshihiro Onimaru | Client: Mercian Corporation

225 (second) Underdog Wine Merchants | Design Firm: BlackDog | Art Director: Vicki Kung | Designer/Illustrator: Mark Fox | Client: The Wine Group

225 (third) Tommy's Margarita | Design Firm: Turner Duckworth | Creative Directors: David Turner, Bruce Duckworth | Designer: Brittany Hull | Account Director: Jessica Rogers | Design Director: Shawn Rosenberger | Client: Tommy's Margarita

225 (fourth) Tatsumi Winery | Design Firm: Graphics & Designing Inc. | Executive Creative Director: Takuro Tatsumi | Art Director/Designer: Toshihiro Onimaru | Client: Takus office
Actor Takuro Tatsumi introduces wineries from all over Japan.

225 (fifth) Dortmunder Pilsener Logo | Design Firm: Delikatessen. Agentur für Marken und Design GmbH | Creative Director: Robert Neumann | Designer/Illustrator: Edgar Walthert | Client: Radeberger Gruppe
Alternative proposals for a new beer brand.

226 (first) Dortmunder Pilsener Logo | Design Firm: Delikatessen. Agentur für Marken und Design GmbH | Creative Director: Robert Neumann | Designer/Illustrator: Karsten Kummer | Client: Radeberger Gruppe
The city of Dortmund is the traditional center of beer production in Germany. Radeberger Group, Germany's largest beer producer, wished to launch a new local brand reflecting this tradition. The eagle is a rendition of the eagle in the Dortmund coat of arms, and the watchtower on the red shield is one of the few remaining remnants of the old city wall from the 13th century, a local landmark. The banner reads, "Gemeinsam Stark", literally "Together Strong." The brand was meant to pull the citizens of Dortmund together with a sense of local pride.

226 (second) Miletta Vista | Design Firm: Bailey Lauerman | Creative Director: Carter Weitz | Art Directors: James Strange, Ron Sack | Client: Miletta Vista
Vineyard located in the prairie lands of Nebraska.

226 (third) Santa Rita Hills Seal | Design Firm: Mark Oliver, Inc. | Art Director/Designer: Mark Oliver | Illustrator: Tom Hennessy | Writer: Mark Oliver | Client: Santa Rita Hills Wine Growers Alliance
A group of wineries and vineyards in the Santa Rita Hills appellation. Distinguishes their wines from others of in Santa Barbara County. Seal incorporates the old rancho heritage of the

region, with an illustration of the oak studded rolling hills and valley fog which contribute to the wines' distinctive character.

226 (fourth) Side Job Cellars Logo | Design Firm: Rob Duncan Design, Thermostat | Art Directors/Designers: Rob Duncan, Shawn Rosenberger | Client: Side Job Cellars

Company sells wines produced by people as a hobby or side job.

226 (fifth) Odell Brewing Co. Logo | Design Firm: tbdadvertising | Creative Director: Paul Evers | Designer: David Carlson-Gearbox | Account Supervisor: René Mitchell | Client: Odell Brewing Co.

Branding effort to position Odell as one of the original Colorado craft breweries. The hand-lettering and organic nature of the Aspen leaf, a well-known symbol of the state, convey the spirit of original craft beers and a passionate approach to brewing.

227 Pinot Noir Zealand 2007 Brand | Design Firm: Clemenger Design | Creative Director: Bruce Hamilton | Art Director/Designer: Tim Christie | Illustrator: Grant Reed | Writer: Bruce Hamilton | Client: Pinot Noir New Zealand

Objective–To design a logo for the 2007 Pinot Noir Conference. The previous brand identity reflected an elite event, largely the preserve of an exclusive audience. The organizers wanted to make the conference a more inclusive event and a brand to match.
Solution–'Experience the love of Pinot'. The fact that this single grape can attract wine makers, writers and lovers from all over the planet for three days speaks multitudes about its seductive quality. The logo champions this intrinsic brand truth. The Pinot grapes in the shape of a heart and the curvy, continental typography combine to form a device that embodies the inherent passion for Pinot, and one that is immediately accessible and far-reaching.

Sports

228 Platinum Bagnati Academy Logomark | Design Firm: Deep Design | Creative Director: Fernando Lecca | Designers/Illustrators: Fernando Lecca, Heath Beeferman | Client: Bagnati Academy

Private tennis instruction.

229 Jason Paree Logo or JP Logo | Design Firm: Marc USA | Creative Director: Tony Jaffe | Art Director/Photographer: Dena Mosti | Retoucher: Dave Bernhardt | Client: Jason Paree (Personal Trainer)

230 (first) Logo Design | Design Firm: Synergy Graphix | Art Director: Remo Strada | Client: Piranha Extreme Sports

230 (second) Symbol for Red Devils Soccer Team | Design Firm: Daniel Green Eye-D Design | Designer/Illustrator: Daniel Green | Client: Green Bay East High Soccer Booster Club

Symbol designed for use by both the girls and boys soccer teams on a range of items, including warm-up jackets, t-shirts, and print.

230 (third) Cambiatta Logo | Design Firm: Planet Propaganda | Creative Director: Dana Lytle | Designer: David Taylor | Client: Cambiatta

A new bicycle training company.

230 (fourth) David Beckham Athlete Identity | Design Firm: Ford Weithman Design | Creative Director: Jeff Weithman | Designer: Mark Ford | Illustrator: Clint Gorthy | Client: Adidas

Logo reflects David Beckham's world-famous kick and personality and to position him globally as the Adidas soccer front man.

230 (fifth) Butler College Grizzlies Logo | Design Firm: Greteman Group | Creative Director: Sonia Greteman | Designer: James Strange | Client: Butler College

231 Gunn City Tennis | Design Firm: Toolbox Studios, Inc. | Designer/Illustrator: Brad Savage | Account Executive: Rob Simons | Client: Gunn Automotive

232 Hawaiian Energy Surfboards | Design Firm: Left Side Six | Creative Director/Art Director/Designer/Illustrator: Jim Beaudoin | Client: Lloyd Ishimine (Hawaiian Energy)

Directive: Create a surfboard logo and derive a sub signature surfboard logo for the lead surfboard shaper (Lloyd Ishimine), both reflecting hints of the shaper's Hawaiian and Asian background. Hawaiian Energy is signified by the "Aloha" flower, a Hawaiian way of life, but also illustrated in a way that is reminiscent of Asian graphic qualities. The man holding the surfboard resembles the style of early Hawaiian petroglyph drawings.

233 (first) Seahawks "12" Logo | Design Firm: Hornall Anderson Design Works | Creative Director: Jack Anderson | Art Director: Andrew Wicklund | Designers: Andrew Wicklund, Elmer del Cruz, Peter Anderson, Nathan Young | Client: Seattle Seahawks

Brand developed for the fans of Seattle Seahawks football team.

233 (second) Bayern Munchen | Design Firm: Andreas Zalewski | Designer: Andreas Zalewski | Client: N/A

233 (third) 2 Man Tour | Design Firm: MBA | Creative Director: Mark Brinkman, Mike Coffin | Designers: Mark Brinkman, Caroline Pledger | Client: 2 Man Tour

An amateur golf scramble.

233 (fourth) Corporate Identity Package | Design Firm: Goodby, Silverstein & Partners | Creative Director: Rich Silverstein | Art Director: Rich Silverstein | Designer: Mark Rurka | Illustrator: Michael Schwab | Client: USA Cycling

233 (fifth) Road Sign Series | Design Firm: Carmichael Lynch Thorburn | Creative Director: Bill Thorburn | Designer: Charlie Ross | Client: IMBA(International Mountain Biking Association)

234 Tourism | Treasure Island | Design Firm: Greenlight Designs | Creative Director: Tami Mahnken-Shelly | Senior Designer: Melissa Irwin | Designer: Damien Gilley | Client: Eric Gruendemann (Atomic Tiki)

A dimensional title treatment logo representing an action-packed tv series. Created for use in print presentations and on-air graphics.

235 (first) Brooklyn Botanic Garden Logo | Design Firm: Carbone Smolan |

Creative Directors: Ken Carbone, Leslie Smolan | Designer: Dominick Ricci | Design Director: Carla Miller | Client: Brooklyn Botanic Garden

Moving into the 21st century with a fresh identity was the primary goal for the Brooklyn Botanic Garden. The main challenge was promotion: BBG wanted an identity to draw visitors to Brooklyn and help the garden compete with other well-known institutions in and around NY. The goal became increased awareness among the local audience and more national and international visitors.

235 (second) Kasba Lake Lodge logo | Design Firm: Group One | Designer: Sean Lien | Client: Kasba Lake Lodge

Kasba Lake is located in the template subarctic of Canada's Northwest Territories, just north of the Manitoba-Saskatchewan border. It is Canada's 28th largest lake, spanning 55 by 25 miles. The lake is 150 miles from the nearest road, accessible only by air, and fished exclusively by our guests.

235 (third) Logotype design | Design Firm: Pentagram Design Ltd | Art Director: Justus Oehler | Designers: Norman Palm, Josephine Rank, Uta Tjaden, Christiane Weismueller | Client: Regione Autonoma della Sardegna

Pentagram Berlin created the identity for the Italian region of Sardegna. The design is based on the typeface Eurostile (designed in 1962 by Aldo Novarese). It has been carefully modified.

235 (fourth) Ride the Rockies 2003 Logo | Design Firm: 601 Design, Inc. | Designer: Bruce Holdeman | Client: The Denver Post

Annual 400+mile bike tour through Colorado Rocky Mountains.

235 (fifth) Bend Visitors Bureau Logo | Design Firm: ID Creative Services, LLC | Designer: Shari Chapman | Client: Bend Visitors Bureau

236 Coit Tower, Marina Green, Conservatory of Flowers, Japanese Tea Garden, Union Square | Design Firm: Cronan Design | Designer: Michael Cronan | Illustrator: Michael Cronan | Client: San Francisco Parks Trust

237 Building | Design Firm: Carmichael Lynch Thorburn | Creative Director: Bill Thorburn | Designer: Jesse Kaczmarek | Client: City of Minneapolis

Transportation

238 (first) Alcatraz Ferry | Design Firm: Michael Schwab | Art Director: Tom Escher | Designer/Illustrator: Michael Schwab | Client: Red & White Fleet

238 (second) Golden State Movers | Design Firm: RBMM | Designer: Kevin Bailey | Client: Golden State Movers

Moving company in CA using the state bird (quail) as symbol.

238 (third) MOVESTAR | Design Firm: RBMM | Designer: Brian McAdams | Client: MOVESTAR, Inc.

Moving company owned and operated by off-duty firefighters.

238 (fourth) Oak Cliff Transit Authority | Design Firm: Fusion Advertising | Creative Director: Elena Baca | Designer: Brad Beasley | Client: Oak Cliff Transit Authority

238 (fifth) KLLM Logo | Design Firm:GodwinGroup | Creative Director:Todd Ballard | Art Director/Designer/Illustrator:Bill Porch | Client: KLLM Transport Services

Mark depicts a muscular stallion with a swath of road through its body running hard above the letters "KLLM." The horse symbolizes speed, intelligence, power, loyalty, strength, and devotion. The swath of highway suggests that the quality of the KLLM equipment and the way the company treats its drivers allows them to become one with the road they travel.

239 Zipcar Logo | Design Firm: M Space Design | Designer: Melanie Lowe | Client: Zip Car

Zipcar is an alternative to owning a car. It's a members car-sharing service. Not quite a rental company, but a new environmental transportation. Many of the car fleet are fun models, such as Minis, Bugs and more. The company's personality was described as quirky, fun, simple, smart, friendly and mobile.

Typography

240 Alphabet Soup | Design Firm: Michael Doret | Designer/Design Director/Artist/Typographer: Michael Doret | Client: Alphabet Soup Type Founders

Logo for the digital foundry "Alphabet Soup" to be used on stationery, print and electronic applications.

Writers

241 Brightlines Logo | Design Firm: Mytton Williams | Creative Director: Bob Mytton | Designer: Gary Martyniak | Client: Brightlines Translation

Brightlines offers extensive, end-to-end translation services to help businesses communicate fluently and effectively in an international marketplace. They required a fresh, modern look. The team call themselves transcreators: translators that can write. This provided the symbol's inspiration; we took the "B" of Brightlines and replaced the counters with inverted commas. The colour helps differentiate the company. The logo expresses the ideas of translation, writing and language.

Zoos

242, 243 Oklahoma Trails Logo & Eco-zone I.D.'s | Design Firm: Greteman Group | Creative Director: Sonia Greteman | Designer: James Strange | Client: Oklahoma City Zoo

Logo for new exhibit. In keeping with the region's heritage, Native American themes are prominent. Graphic icons represent major ecological zones of OK, plus the animal primarily identified with each zone.

244 Caldwell Zoo | Design Firm: SullivanPerkins | Creative Director: Prekins Jarrod | Art Director: Rob Wilson | Designer/Illustrator: Jarrod Holt | Client: Caldwell Zoo

DesignFirmDirectory

3 www.whois3.com
8220 LaMirada NE, Suite 500, Albuquerque, NM 87109, United States
Tel 505 293 2333 | Fax 505 293 1198

@ Radical media www.radicalmedia.com
435 Hudson Street, New York, NY 10014, United States
Tel 212 462 1500 | Fax 212 462 1600

3G (Grand Gleaming Graphics) www.gg-graphics.com
4-2 Yocho-machi, Shinjuku-ku, Tokyo 162-0055, Japan
Tel 81 3 3359 9297

601 Design, Inc. www.601design.com
P.O. Box 771202, Steamboat Springs, CO 80477, United States
Tel 970 871 8005 | Fax 970 871 8007

A2/SW/HK www.a2swhk.co.uk
35-40 Charlotte Road, London, England EC2A 3PD, United Kingdom
Tel 44 0 20 7739 4249

A3 Design www.athreedesign.com
7902 Cadmium Court, Charlotte, NC 28215, United States
Tel 704 568 5351

Addis www.addis.com
2515 9th Street, Berkeley, CA 94710, United States
Tel 510 704 7500 | Fax 510 704 7501

Adventa Lowe www.lowe.com.ua
13 Pymoneka, bd 5A, 5th Floor, Kyiv 04050, Ukraine
Tel 38 044 4952860 | Fax 38 044 4952861

Alchemy Studios
1520 Anderson Court, Alexandria, VA 22312, United States
Tel 703 256 5990

Alexander Isley Inc. www.alexanderisley.com
9 Brookside Place, Redding, CT 06896, United States
Tel 203 544 9692 | Fax 203 544 7189

Alterpop www.alterpop.com
1001 Mariposa, #304, San Francisco, CA 94107, United States
Tel 415 558 1515 | Fax 415 558 8422

AMEN www.amencreation.com
400, boulevard de Maisonneuve Ouest, Bureau 700, Montreal,
Quebec H3A 1L4, Canada | Tel 514 874 0000

Andreas Zalewski
Tranvagen 32 515 60, Svaneholm, Sweden
Tel +46 0 733 563835 | Fax +46 0 33 291352

Arthur Beckenstein
58 Oyster Shores Road, East Hamptons, NY 11937, United States
Tel 631 324 4065 | Fax 631 324 4065

B12 www.btwelve.com
10245 E Via Linda Avenue, Suite 208, Scottsdale, AZ 85258, United States
Tel 480 614 9772 | Fax 480 614 9328

Bailey Lauerman www.baileylauerman.com
1248 O Street, Suite 900, Lincoln, NE 68508, United States
Tel 402 475 2800 | Fax 402 475 0428

Bandujo Donker & Brothers www.bandujo.com
22 W 19th Street, 9th Floor, New York, NY 10011, United States
Tel 212 332 4100 | Fax 212 332 6068

Barkley www.barkleyus.com
423 W 8th Street, Kansas City, MO 64105, United States
Tel 816 842 1500 Fax 816 423 6288

BBK Studio www.bbkstudio.com
648 Monroe Avenue NW, Suite 212,Grand Rapids, MI 49503, United States
Tel 616 459 4444

Bernhardt Fudyma Design Group www.bfdg.com
133 E 36th Street, New York, NY 10016, United States
Tel 212 889 9337 | Fax 212 889 8007

Beth Singer Design www.bethsingerdesign.com
1408 N Filmore Street, Suite 6, Arlington, VA 22201, United States
Tel 703 469 1900 | Fax 703 525 7399

Big-Giant www.big-giant.com
1631 NW Thurman Street, #150, Portland, OR 97209, United States
Tel 503 221 1079 | Fax 503 721 0212

BlackDog www.blackdog.com
855 Folson Street, #931, San Francisco, CA 94107, United States
Tel 415 990 6112

Blinn Design www.blinndesign.com
957 15th Street, Santa Monica, CA 90403, United States
Tel 310 435 1799 | Fax 310 393 6090

Brad Simon www.optodesign.com
214 Sullivan Street, New York, NY 10012, United States
Tel 212 254 4470 | Fax 212 254 5266

Braley Design www.braleydesign.com
415 Albermarle Road, #5C, Brooklyn, NY 11218, United States
Tel 415 706 2700

Brand Plant
Pionerstabe 31, Duesseldorf, NRW 40215, Germany
Tel 49 0 211 34 02 99 | Fax 49 0 211 15 93 380

Brandoctor www.brandoctor.com
Zavrtnica 17, Zagreb, Croatia
Tel 385 1 6192 597 | Fax 385 1 6192 597

Brinkley Design www.brinkleydesign.com
1930 Abbot Street, Suite 401, Charlotte, NC 28203, United States
Tel 704 372 8666 | Fax 704 372 2956

Buzzsaw Studios, Inc. www.buzzsawstudios.com
920 NW Bond, Suite 203, Bend, OR 97701, United States
Tel 541 382 1019

Café Design www.cafecsoport.hu
Vaci ut 141, Budapest 1138, Hungary
Tel 36 1 450 5060 | Fax 36 1 450 5099

Calagraphic Design www.ronaldjcala2.com
523 Stahr Road, Elkins Park, PA 19027, United States
Tel 215 782 1361

Carbone Smolan www.carbonesmolan.com
22 W19th Street, 10th Floor, New York, NY 10022, United States
Tel 212 807 0011 | Fax 212 807 0870

Carlson Marketing Worldwide www.carlsonmarketing.com
1405 Xenium Lane N, MS 8272, Plymouth, MN 55441, United States
Tel 763 212 8318

Carmichael Lynch Thorburn www.clynch.com
800 Hennepin Avenue, Minneapolis, MN 55403, United States
Tel 612 334 6045 | Fax 612 334 6032

Cass Design Co. www.cassdesignco.com
P.O. Box 210043, Nashville, TN 37221, United States
Tel 615 646 8517

Catapult Strategic Design www.catapultu.com
4251 E Thomas Road, Phoenix, AZ 85108, United States
Tel 602 381 0304 | Fax 602 381 0323

CHE Design www.christianhoyle.com
1910 Cap Rock Drive, Richardson, TX 75080, United States
Tel 469 232 8804

Chris Corneal
26A Kresge Art Center, East Lansing, MI 48824, United States
Tel 517 432 5299 | Fax 517 432 3938

Clemenger Design www.clemenger.com.au
8 Kent Terrace, Wellington 6011, New Zealand
Tel 64 4 802 3362 | Fax 64 4 802 3362

Concrete Design Communications Inc. www.concrete.ca
2 Silver Avenue, Toronto, Ontario M6R 3A2, Canada
Tel 416 534 9960 | Fax 416 534 2184

Concussion, LLC www.concussion.net
707 W Vickery Blvd., Suite 103, Fort Worth, Texas 76104, United States
Tel 817 336 6824 | Fax 817 336 6823

Craig-Teerlink Design
422 Day Street, San Francisco, CA 94131, United States
Tel 415 821 9591 | Fax 415 821 9591

Crave Design Agency www.cda-florida.com
3100 NW Boca Raton Blvd., Suite 109, Boca Raton, FL 33431, United States Tel
561 417 0780 | Fax 561 417 0490

Creation House www.creationhouse.com.hk
47-78 High Street, 6/7 Flat 8, Hang Sing Mansion, Sai Ying Poon, Hong Hong
Tel 852 9093 8703 | Fax 852 2838 1375

Cronan Design www.cronan.com
3090 Buena Vista Way, Berkeley, CA 94708, United States
Tel 415 720 3264

Daniel Green Eye-D Design
202 E Mission Road, Green Bay, WI 54301, United States
Tel 920 435 5151

DarbyDarby Creative www.DarbyDarbyCreative.com
2376 7th Avenue, New York, NY 10030, United States
Tel 646 489 1256 | Fax 212 283 3850

Deadline Advertising www.dead-line.com
12424 Wilshire Blvd., Suite 850, Los Angeles, CA 90025, United States
Tel 310 442 8100 | Fax 310 442 8104

Deep Design www.deepdesign.com
3060 Peachtree Road, Suite 510, Atlanta, GA 30305, United States
Tel 404 266 7500 | Fax 404 266 8902

Deka Design Studio
Garas utca 6, Budapest 1026, Hungary
Tel 36 1472 0229 | Fax 36 1472 0230

Delikatessen. Agentur für Marken und Design GmbH
www.delikatessen-hamburg.com | Grosse Brunnenstr. 63a, Hamburg 22763,
Germany | Tel 49 0 40/35 08 06 14 | Fax 49 040/35 08 06 10

Dennard, Lacey & Associates www.dennardlacey.com
5050 Quorum Drive, Suite 300, Dallas, TX 75254, United States
Tel 972 233 4030 | Fax 972 392 7550

Design Raymann BNO www.designraymann.nl
Peter van Anrooylan 23 Dieren, 6952 CW, Netherlands
Tel 31 313 413192 | Fax 31 313 450463

Dfraile www.dfraile.com
Saavedra Fajardo, 7, 2c, Murcia 30001, Spain
Tel 34 968 21 18 24 | Fax 34 968 21 80 87

Digital Flannel www.digitalflannel.com
P.O. Box 358, Woodstock, VT 05091, United States
Tel 802 457 3838 | Fax 802 457 6121

Douthit Design Group www.douthitdesign.com
1819 Kane Street, Houston, TX 77007, United States
Tel 713 526 2712 | Fax 713 520 7978

Dream Empire www.vinko.co.uk
53 Newry Street, Rathfriland, County Down, BT34 5PY, United Kingdom
Tel +44 79 22 44 5005

Drive Communications www.drivecom.com
133 W 19th Street, Fifth Floor, New York, NY 10011, United States
Tel 212 989 5103 | Fax 212 989 6307

Duffy & Partners www.duffy.com
710 2nd Street S, Suite 602, Minneapolis, MN 55401, United States
Tel 612 548 2333 | Fax 612 548 2334

EAT Advertising & Design www.eatinc.com
5206 NW Bluff Lane, Parkville, MO 64152, United States
Tel 816 505 2950 | Fax 816 505 2925

El Paso, Galería de Comunicación www.elpasocomunicacion.com
Sagunto #13 - Local Madrid, Madrid 28010, Spain
Tel 34 915 942 248 | Fax 34 914 478 016

Elixir Design www.elixirdesign.com
2134 Van Ness Avenue, San Francisco, CA 94109, United States
Tel 415 834 0300 | Fax 415 834 0101

Envelope
306-1562 W 5th Avenue, Vancouver, BC V6J5H9, Canada
Tel 904 779 7069

Evia Ltd. www.evia.fi
Lonnrotinkatu 28, Helsinki, 00180 Finland
Tel 35 09 12551

Ferreira Design Company www.ferreiradesign.com
335 Stevens Creek Court, Alpharetta, GA 30005, United States
Tel 678 297 1903

Finished Art Inc. www.finishedart.com
708 Antone Street, Atlanta, GA 30318, United States
Tel 404 355 7902 | Fax 404 352 3846

Fleishman-Hillard Creative www.fleishman.com
200 N. Broadway, St Louis, MO 43102, United States
Tel 314 982 9149

Ford Weithman Design
431 NW Flanders Street Suite 304, Portland, OR 97209, United States
Tel 503 222 0296 | Fax 503 222 0289

Frank Worldwide www.frankworldwide.com
4040 NE Second Avenue, Office 401, Miami, FL 33137, United States
Tel 305 576 1119 | Fax 305 576 1120

Frost Design www.frostdesign.com.au
Level 1, 15 Foster Street, Surry Hills, NSW, Australia
Tel 61 2 9280 4233 | Fax 61 2 9280 4266

Fujiwaki Design
Yamada bldg, 4f, 2-4-10 Utsubo Honmachi, Nishi-ku, Osaka, Japan
Tel 06 6479 8777 | Fax 06 6479 8778

Fusion Advertising www.fusionista.com
614 North Bishop Avenue, Suite 3, Dallas, TX 75208, United States
Tel 214 946 7404

Garfinkel Design www.garfinkeldesign.com
115 Cedar Springs Drive, Athens, GA 30605, United States
Tel 706 549 6887

Gee + Chung Design www.geechungdesign.com
38 Bryant Street, Suite 100, SanFrancisco, CA 94105, United States
Tel 415 543 1192 | Fax 415 543 6088

Gestudia
1612 Dolores Street, San Francisco, CA 94110, United States
Tel 415 641 5343

Gillett + Co
2795 East Valley View Avenue, Salt Lake City, UT 84117, United States
Tel 801 424 0581 | Fax 801 424 0582

Ginette Caron
Piazza Sant'Ambrogio, 29 Milano, 20123, Italy
Tel 39 02 8646 1063 | Fax 39 02 8646 1063

Giotto Design www.giottodesign.net
Calle Juan Gonzalez N35-135 e Ignacio, San Maria Of. 606 Edif. Metropoli,
Quito, Pichincha, ECUADOR | Tel 59 32246 1075 | Fax 59 32246 1075

Go Welsh! www.gowelsh.com
987 Mill Mar Road, Lancaster, PA 17601, United States
Tel 717 898 9000 | Fax 717 898 9010

GodwinGroup www.godwin.com
188 East Capitol Street, Suite 800, Jackson, MS 39201, United States
Tel 601 360 9511

Goodby, Silverstein & Partners www.goodbysilverstein.com
720 California St, San Francisco, CA 94108, United States
Tel 415 392 0669 | Fax 415 955 6291

Gouthier Design: a brand collective www.gouthier.com
245 W 29 Street, Suite 1304, New York, NY 10001, United States
Tel 212 244 7430 | Fax 212 937 3613

Grady Campbell, Inc. www.gradycampbell.com
900 N. Franklin Avenue, Suite 310, Chicago, IL 60610, United States
Tel 312 642 6511 | Fax 312 642 6511

Grafico de Poost www.poost.nl
P. O. Box 6118 Eindhoven, 5600, HC, Netherlands
Tel 31 0 402464217 | Fax 31 0402457464

Graphic Content www.graphiccontent.com
600 N. Bishop Ave. Suite 200, Dallas, TX 75208, United States
Tel 214 948 6969 | Fax 214 948 6950

Graphics & Designing Inc. www.gandd.co.jp
3-3-1 Shinokanedai, Minato-ku, Tokyo, JAPAN 108-0071
Tel +81 3 3449 0651 | Fax +81 3 3449 0653

Greenlight Designs www.greenlightdesigns.net
11206 Weddington Street, Second FloorN. Hollywood, CA 91601, United States
Tel 818 509 0787 | Fax 818 509 0750

Greteman Group www.gretemangroup.com
1425 E. Douglas, Suite 200, Wichita, KS 67211, United States
Tel 316 263 1004 | Fax 316 263 1060

Group One www.group-1.com
100 N. 6th Street, Suite 800A, Minneapolis, MN 55403, United States
Tel 612 335 7711 | Fax 612 334 8102

GROUP T DESIGN www.grouptdesign.com
2001 S Street NW, Suite 300 Washington DC 20009, United States
Tel 202 213 5453 | Fax 202 370 6403

GSD&M www.gsdm.com
828 West 6th Street, Austin, TX 78703, United States
Tel 512 242 4622 | Fax 512 242 7622

H&K Global Connections Inc. www.hkgc.jp/www.hkgc.jp/en(english)
2-2-13-523, Hotarugaike, Minamimachi, Toyonaka, Osaka, Japan
Tel +81 (0)6 6841 7351 | Fax +81(0)6 6841 7351

Hambly & Woolley Inc. www.hamblywoolley.com
43 Bathurst Street, Suite 400, Toronto, Ontario M5V 2P2, Canada
Tel 416 504 2742 | Fax 416 504 2745

Helium Diseno www.heliumdiseno.com
Moliere 13 piso 2, Col. Chapultepec Polanco, DF 11560, Mexico
Tel 52 55 52720910

Hiebing www.hiebing.com
315 Wisconsin Avenue, Madison, WI 53703, United States
Tel 608 256 6357

Hirschmann Design www.hirschmanndesign.com
729 Walnut Street, D1, Boulder, CO 80302, United States
Tel 303 449 7363 | Fax 303 449 7345

HKLM www.hklm.co.za
Building B, No 4 Kikuyu Road, Sunninghill, Johannesburg, Gauteng 2157,
South Africa | Tel 27 11 461 6600 | Fax 27 11 461 6606

HOOK www.hookusa.com
409 King Street, Floor 4, Charleston, SC 29403, United States
Tel 843 853 5532 | Fax 843 805 7058

Hornall Anderson Design Works www.hadw.com
1008 Western Avenue, Suite 600, Seattle, WA 98104, United States
Tel 206 467 5800 | Fax 206 467 6411

Hotsauce www.hotsauceny.com
165 Perry Street, 2a, New York, NY 10014, United States
Tel 917 776 7823

Huber Creative, LLC www.hubercreative.com
1823 N. 6th Street, Sheboygan, WI 53081, United States
Tel 920 423 4262

HZDG www.hzdg.com
725 Rockville Pike, Studio 3, Rockville, MD 20852, United States
Tel 301 294 6302 | Fax 301 294 6305

ID Creative Services, LLC www.sharichapman.com
1620 SW Taylor Street, Portland, OR 97210, United States
Tel 503 548 6313 | Fax 503 223 2719

iHua Design www.ihuadesign.com
532 Aileen Street, Oakland, CA 94609, United States
Tel 510 658 2997 | Fax 215 359 0892

IKD Design Solutions www.ikdesign.com.au
173 Fullarton Road, Dulwich, SA 5065, Australia
Tel 61 8 8332 0000 | Fax 61 8 8364 0726

Initio Advertising www.initioadvertising.com
212 Third Avenue N, Minneapolis, MN 55401, United States
Tel 612 339 7195 | Fax 612 333 0632

Interbrand www.interbrand.com
1000 Sansome Street,, Suite 101, San Francisco, CA 94111, United States
Tel 415 593 2200 | Fax 415 593 2250

Intralink Film Graphic Design www.intralinkfilm.com
155 North La Peer Drive, Los Angeles, CA 90048, United States
Tel 310 271 5671

Irving (formerly Roberts & Co) www.irvingdesigns.com
31 Oval Road, London NW1 7EA, United Kingdom
Tel 44 207 267 4477

Jan Sabach www.web.mac.com/jansabach
Corneliusstrasse 7 Munich, 80469, Germany
Tel 49 173 580 6590

Jessica Campbell
410 N. Michigan Avenue, 9th Floor, Chicago, IL 60611, United States
Tel 312 595 2620

Joe Miller's company www.joemillersco.com
3080 Olcott St, Ste 105a, Santa Clara, CA 95054, United States
Tel 408 988 2924 | Fax 408 727 9941

John Michael Pugsley Design Inc. www.jmpdesign.com
1834 12th Street #4, Manhattan Beach, CA 90266, United States
Tel 424 247 8266

John Nordyke
49 Craigmoor Road, West Hartford, CT 06107, United States
Tel 860 233 8874

Judson Design Associates www.judsondesign.com
2407 Norfolk, Houston, TX 77098, United States
Tel 713 520 1096 | Fax 713 520 6836

JWT Canada-Sauce Design www.jwtcanada.ca
160 Bloor Street East, Toronto, ON M4W 3P7, Canada
Tel 416 926 7300 | Fax 416 926 7408

k birnholz www.kbirnholz.com
Herengracht 572, Amsterdam, NL 1017ch, Netherlands
Tel 31 20 6209 353 | Fax 31 20 638 6194

Kara King
2502 Live Oak, Apt.119, Dallas, TX 75204, United States
Tel 214 533 0606

Kate Resnick Design
P.O. Box 3273, Falls Church, VA 22043, United States
Tel 202 487 1414

Keith Harris Design
Markgrafenstrasse 17, Konstanz 78467, Germany
Tel 49 07531 958939 | Fax 49 07531 958939

Kitemath www.kitemath.com
1317 N. Hoyne Avenue, Chicago, IL 60622, United States
Tel 773 252 9908 | Fax 773 326 2449

Lam Design Group
4812 South 30th Street, Apt. B2, Arlington, VA 22206, United States
Tel 703 625 7319

Lanny Sommese
100 Rose Drive, Port Matilda, PA 16870, United States
Tel 814 353 1951

DesignFirmDirectory

Left Side Six www.leftsidesix.com
3003 Westcott Street, Falls Church, VA 22042, United States
Tel 703 508 6434 | Fax 703 873 4108

Les Kerr Creative www.leskerr.net
3315 Willow Ridge Circle, Carrollton, TX 75007, United States
Tel 972 236 3599

Lewis Moberly www.lewismoberly.com
33 Gresse Street, London, United Kingdom
Tel 44 0 207 580 9252 | Fax 44 0 207 255 1671

Lienhart Design www.lienhartdesign.com
939 W. Huron Street,, Suite 310, Chicago, IL 60305, United States
Tel 312 738 2200 | Fax 312 738 2100

Lippincott Mercer www.lippincottmercer.com
499 Park Avenue, New York, NY 10022, United States
Tel 212 521 0037 | Fax 212 754 2591

Liska + Associates www.liska.com
515 North State Street, 23rd Floor, Chicago, IL 60610, United States
Tel 312 644 4400 | Fax 312 644 9650

Littleton Advertising and Marketing www.littletonadvertising.com
2840 Plaza Place, Suite 360, Raleigh, NC 27612, United States
Tel 919 861 7016 | Fax 919 510 5285

Live!design Ltd. www.livedesign.fi
Kuninkaankartanonkatu 6 as. 10 turku, 20810, Finland
Tel 358 50 5820395

Louise Fili LTD.
156 Fifth Avenue, #925, New York, NY 10010, United States
Tel 212 989 9153 | Fax 212 989 0884

M Space Design www.mspacedesign.net
333A Harvard Street, Cambridge, MA 02139, United States
Tel 617 547 5503

Mad Dog Graphx www.thedogpack.com
1443 West Nothern Lights Blvd, Suite U, Anchorage, AK 99503, United States
Tel 907 276 5062 | Fax 907 279 5722

Marc USA www.marcusa.com
4 Station Square, Suite 5, Pittsburgh, PA 15219, United States
Tel 412 562 2000

Mark Oliver, Inc. www.markoliverinc.com
1984 Old Mission Drive, Suite A 15, Solvang, CA 93463, United States
Tel 805 686 5166 | Fax 805 686 5224

Matsumoto Incorporated www.matsumotoinc.com
127 West 26th Street, 9th Floor, New York, NY 10001, United States
Tel 212 807 0248 | Fax 212 807 1527

MBA www.your-mba.com
Tel 512 971 7820 | Fax 512 899 1695

McCann Erickson Russia
11, bolshoi karetnyi pereulok Moscow, Russian Federation, Russia
Tel 7 495 933 05 00 | Fax 7 495 933 05 01

MCM Design Studio www.mcmds.com
520 Lincoln Street, Walla Walla, WA 99362, United States
Tel 509 529 4001

Meta4 Design
311 West Superior, Suite 504, Chicago IL, United States
Tel 312 337 4674

Method www.method.com
972 Mission Street, 2nd Floor, San Fransisco, Ca 94103, United States
Tel 415 901 6300 | Fax 415 901 6310

Michael Doret www.michaeldoret.com
6545 Cahuenga Terrace, Hollywood, CA 90068, United States
Tel 323 467 1900

Michael Schwab www.michaelschwab.com
108 Tamalpais Avenue, San Anselmo, CA 94960, United States
Tel 415 257 5792 | Fax 415 257 5793

Mine www.minesf.com
190 Putnam Street, San Francisco, CA 94110, United States
Tel 415 647 6463 | Fax 415 647 6468

MiresBall www.miresball.com
2345 Ketner Blvd., San Diego, CA 92101, United States
Tel 619 234 6631 | Fax 619 234 1807

Miriello Grafico, Inc www.miriellografico.com
1660 Logan Avenue, San Diego, CA 92113, United States
Tel 619 234 1124 | Fax 619 234 1960

Mirko Ilic Corp. www.mirkoilic.com
207 East 32nd Street, New York, NY 10016, United States
Tel 212 481 9737

Mono www.mono-1.com
2902 Garfield Avenue S., Mpls, MN 55408, United States
Tel 612 822 4135 / 612 822 4136

Muller + Company www.mullerco.com
4739 Belleview, Kansas City, MO 64112, United States
Tel 816 531 1992 | Fax 816 531 6692

Murillo Design www.murillodesign.com
6933 Border Brook Dr., #312, San Antonio, TX 78238, United States
Tel 210 247 2717 | Fax 210 832 0007

Mytton Williams www.myttonwilliams.co.uk
15 Street, James's Parade, Bath, BA1 1UL, United Kingdom
Tel 44 0 1225 442634 | Fax 44 0 1225 442639

Naughtyfish Design www.naughtyfish.com.au
Level 3, 306B, Rushcutters Bay, NSW, 2011, Australia
Tel 02 9357 5911 | Fax 02 9029 4062

Nicholas M. Agin www.nickagin.com
10 Hanover Square 20Q, New York, NY 10005, United States
Tel 614 439 3021

Nicholson Kovac, Inc. www.nicholsonkovac.com
600 Broadway, Kansas City, MO 64105, United States
Tel 816 842 8881 | Fax 816 842 6340

Ó! www.oid.is
Armuli 11, Reykjavik, 108, Iceland
Tel 354 562 3300

Ogilvy www.ogilvy.com
115 N Duke Street, Durham, NC 27701, United States
Tel 919 281 0623 | Fax 919 281 0605

Okan Usta www.okanusta.net
81 Belair Road, Staten Island, New York, NY 10305, United States
Tel 917 599 6513

Origin Design www.origindesign.com
20 East Greenway Plaza, suite 301, Houston, Texas, 77046, United States
Tel 713 520 9544

Oxide Design Co. www.oxidedesign.com
4013 Farnam Street, Omaha, NE 68131, United States
Tel 402 344 0168 | Fax 402 344 0169

P&H Creative Group www.pandh.com
420 North 5th Street, Suite 475, Minneapolis, MN 55401, United States
Tel 612 338 7511 | Fax 612 338 7507

Paul Black Design www.paulblackdesign.com
1400 Turtle Creek Blvd., Suite 140, Dallas, TX 75207, United States
Tel 214 537 9780 | Fax 214 744 1411

Pentagram Design www.pentagram.com
204 Fifth Avenue, New York, NY 10010, United States
Tel 202 683 7000 | Fax 212 532 0181

Pentagram Design, Berlin www.pentagram.de
Leibnizstrasse 60, Berlin 10629, Germany
Tel +49 302787610 | Fax +49 302786110

Pentagram SF www.pentagram.com
387 Tehama Street, San Francisco, CA 94103, United States
Tel 415 896 0499 | Fax 415 541 9106

Peterson Ray & Company www.peterson.com
311 N Market Street, Suite 311, Dallas, TX 75202, United States
Tel 214 954 0522 | Fax 214 954 1161

pfw design www.pfwdesign.net
550 Prospect Street, #15, New Haven CT 06511, United States
Tel 917 204 0856

Planet Propaganda www.planetpropaganda.com
605 Williamson Street, Madison, WI 53703, United States
Tel 608 256 0000 | Fax 608 256 1975

Pollard Design
8841 SW 52nd Avenue, Portland, OR 97219, United States
Tel 503 246 7251 | Fax 503 246 5257

Poulin + Morris Inc. www.poulinmorris.com
286 Spring Street, New York, NY 10013, United States
Tel 212 675 1332 | Fax 212 675 3027

Prejean Creative www.prejeancreative.com
305 La Rue France, Suite 200, Lafayette, LA 70508, United States
Tel 337 593 9051 | Fax 337 593 9053

Proteus Design www.proteusdesign.com
77 North Washington Street, Boston, MA 02114, United States
Tel 617 263 2211 | Fax 617 263 2210

Puma www.puma.com
One Design Center Place, Suite 800, Boston, MA 02210, United States
Tel 617 488 1031 | Fax 617 488 2970

Ramp www.rampcreative.com
411 S. Main Street, Suite 615, Los Angeles, CA 90013, United States
Tel 213 623 7267

Range, Inc. www.rangeus.com
105 Turtle Creek Road, Dallas, TX 75207, United States
Tel 214 744 0555 | Fax 214 744 0577

RBMM www.rbmm.com
7007 Twin Hills, Suite 200, Dallas, TX 75231, United States
Tel 214 987 6500 | Fax 214 987 3662

Rees Masilionis Turley Architecture www.architecturermt.com
908 Broadway, Kansas City, MO 64105, United States
Tel 816 842 1292 | Fax 816 842 1878

Rick Johnson & Company www.rjc.com
1120 Pennsylvania, NE, Albuquerque, NM 87110, United States
Tel 505 266 1100

Rickabaugh Graphics www.rickabaughgraphics.com
384W. Johnstown Road, Gahanna, OH 43230, United States
Tel 614 337 2229 | Fax 614 337 2197

Rob Duncan Design
2 Townsend Street, Apt 3-304, San Francisco, CA 94107, United States
Tel 415 706 7869

Robertson Design www.robertsondesign.com
219 Ward Circle, Suite 4, Brentwood, TN 37027, United States
Tel 615 373 4590

Rogue Element Inc. www.rogue-element.com
4043 N. Ravenswood Avenue, Suite 202, Chicago, IL 60613, United States
Tel 773 880 9525 | Fax 773 880 9526

Rule29 www.rule29.com
303 West State Street, Geneva, IL 60134, United States
Tel 630 262 1009 | Fax 630 262 1163

Ryan Russell
2515 Shawn Circle, State College, PA 16801, United States
Tel 814 880 6377

Salt Industries
5938 Shady Grove Circle, Raleigh, NC 27609, United States
Tel 919 874 0043 | Fax 919 874 0043

SamataMason www.samatamason.com
101 S. First Street, Dundee, IL 60118, United States
Tel 847 428 8600 | Fax 847 428 6564

Sandstrom Design www.sandstromdesign.com
808 SW 3rd Avenue, Ste. 610, Portland, OR 97204, United States
Tel 503 248 9466 | Fax 503 227 5035

Savannah College of Art and Design www.scad.edu
SCAD Keys Hall, Savannah, GA 31401, United States
Tel 912 525 5110 | Fax 912 525 5992

Scofield Design + Communications www.scofieldesign.com
P.O. Box 966, Fishers, IN 46037, United States
Tel 317 259 7520

SERVE www.servemarketing.org
223 North Water Street, Suite 250, Milwaukee, WI 53202, United States
Tel 414 289 0882 | Fax 414 289 0883

Sheaff Dorman Purins www.sheaff.com
186 Crescent Road, Needham, MA 02494, United States
Tel 781 449 0602 | Fax 781 455 8945

Shikatani Lacroix Brandesign www.sld.com
387 Richmond Street, East, Toronto, ON, Canada
Tel 416 367 1999 | Fax 416 367 5451

Shin Matsunaga
98-4, Yarai-choo, Shinjuku-ku, Tokyo 162-0805, Japan
Tel 81 3 5225 0777 | Fax 81 3 3266 5600

Shinnoske Sugisaki www.shinn.jp
2-1-8-602 Tsuriganecho Chuoku, Osaka 540-0035, Japan
Tel 81 6 6943 9077 | Fax 81 6 6943 9078

Sibley/Peteet Design, Austin www.spdaustin.com
522 East 6th Street, Austin, TX 78701, United States
Tel 512 473 2333 | Fax 512 473 2431

Sibley/Peteet Design, Dallas www.spddallas.com
3232 McKinney Avenue, Suite 1200, Dallas, TX 75204, United States
Tel 214 969 1050 | Fax 214 969 7585

Slow-motion
5925 Kentwood Avenue, Kansas City, MO 64110, United States
Tel 816 333 0243

Spela Draslar
Maroitova 12 Ljubijana, 1113 Slovenia, Slovenia
Tel 386 31 879 711

Squires & Company www.squirescompany.com
2913 Canton Street, Dallas, TX 75226, United States
Tel 214 939 9194 | Fax 214 939 3454

Stand Advertising www.standadvertising.com
2351 North Forest Road, suite 102, Buffalo, NY 14068, United States
Tel 716 210 1065 | Fax 716 210 1069

Stockland Martel www.stocklandmartel.com
5 Union Square West, New York, NY 10003, United States
Tel 212 727 1400 | Fax 212 727 9459

STORY www.storyco.tv
401 W. Superior Street, Chicago, IL 60610, United States
Tel 312 642 3173 | Fax 312 642 3149

Stritzel Design Group
503 N. Oakland Avenue, Pasadena, CA 91101, United States
Tel 626 564 9284 | Fax 626 564 9284

Strømme Throndsen Design www.stdesign.no
Holtegata 22, Oslo, Norway 0355, Norway
Tel 47 22963900 | Fax 47 22963901

Studio International www.studio-international.com
Buconjiceva 43, Zagreb, 10000, Croatia
Tel 385 1 3760171 | Fax 385 1 3760172

Sugarlab www.sugarlab.ca
5485 St-Urbain, Montreal, Quebec, H2T 2W8, Canada
Tel 514 773 0367

Sukle Advertising & Design www.sukle.com
2430 W. 32nd Avenue, Denver, CO 80211, United States
Tel 303 964 9100

SullivanPerkins www.sullivanperkins.com
2811 Mckinney Avenue, Suite 320, Dallas, TX 75204, United States
Tel 214 922 9080 | Fax 214 922 0044

Supon Creative www.suponcreative.com
2240 Decatur Place, NW Washington, DC 20008, United States
Tel 202 667 4644

Sussman/Prejza & Company, Inc. www.sussmanprejza.com
3525 Eastham Drive, Culver City, CA 90232, United States
Tel 310 836 3939 | Fax 310 836 3980

Synergy Graphix www.synergygraphix.com
183 Madison Avenue, Suite 415, New York, NY 10017, United States
Tel 212 968 7567

Tactical Magic www.tacticalmagic.com
1460 Madison Avenue, Memphis, TN 38104, United States
Tel 901 722 3001 | Fax 901 722 2144

TAXI Canada Inc., Toronto www.taxi.ca
495 Wellington Street West, Suite 102, Toronto, Ontario, M5V 1E9, Canada
Tel 416 979 7001 | Fax 416 979 7626

TAXI Canada Inc., Montreal www.taxi.ca
1435 rue St-Alexandre, Bureau 620, Montreal, Quebec, H3A 2G4, Canada
Tel 514 842 8294 | Fax 514 789 3930

tbdadvertising www.tbdagency.com
856 NW Bond Street, #2, Bend, OR 97701, United States
Tel 541 388 7558 | Fax 541 388 7532

Team Young & Rubicam www.teamyr.com
1st Floor, Century Plaza Building, Jumiera Beach Road, Bur Dubai, Dubai 14129, United Arab Emirates | Tel 9714 3445444 | Fax 9714 3496636

The Bradford Lawton Design Group www.bradfordlawton.com
1020 Townsend, San Antonio, TX 78209, United States
Tel 210 832 0555 | Fax 210 832 0007

The Decoder Ring Design Concern www.thedecoderring.com
410 Congress Avenue, Austin, TX 78701, United States
Tel 512 236 1610 | Fax 512 597 1848

The Design Studio of Steven Lee www.stevenleedesign.com
135 South Park Street, San Francisco, CA 94107, United States
Tel 415 546 1701

Tim Frame Design www.timframe.com
P.O. Box 3 Cedarville, Ohio 45314, United States
Tel 614 598 0113 | Fax 614 388 5616

TODA www.toda.net
250 West Broadway, New York, NY 10013, United States
Tel 212 343 2414 | Fax 212 343 1474

Together Design www.togetherdesign.co.uk
106 Cleveland Street, London, UK,W1T 6NX, United Kingdom
Tel 0044 0 20 7387 7755

TOKY Branding+Design www.toky.com
3139 Olive Street, Louis, Missouri 63103, United States
Tel 314 534 2000 | Fax 314 534 2001

Tompertdesign www.tompertdesign.com
514 High Street, Atelier, Palo Alto, CA 94301, United States
Tel 650 323 0365 | Fax 650 323 0366

Toolbox Studios, Inc. www.toolboxstudios.com
454 Soledad, Suite 100, San Antonio, TX 78205, United States
Tel 210 225 8269 | Fax 210 225 8200

Totem Visual Communications www.totem.ie
The Brewery Fairlane, Dungarvan, County Waterford, Ireland
Tel 353 058 24832 | Fax 353 58 24814

Tracy Sabin www.tracy.sabin.com
7333 Seafarer Place, Carlsbad, CA 92011, United States
Tel 760 431 0439 | Fax 760 431 0439

TURF www.turfnewyork.com
180 Varick Street, 1622, New York, NY 10014, United States
Tel 212 941 8220 | Fax 212 941 8381

Turner Duckworth www.turnerduckworth.com
831 Motgomery Street, San Francisco, CA 94133, United States
Tel 415 675 7777 | Fax 415 675 7778

Ty Wilkins www.tywilkins.com
201 S St. Francis Street, 402, Wichita, KS 67202, United States
Tel 918 284 0462

UNIT design collective www.unitcollective.com
997 Steiner Street, San Francisco, CA 94117, United States
Tel 415 710 1395 | Fax 503 210 1395

Ventress Design Group www.ventress.com
3310 Aspen Grove Drive, Suite 303, Franklin, TN 37067, United States
Tel 615 727 0155 | Fax 615 727 0159

vitrorobertson www.vitrorobertson.com
625 Broadway, Fourth Floor, San Diego, CA 92101, United States
Tel 619 234 0408 | Fax 619 234 4015

VIVA DESIGN! Studio www.viva-design.com
Apt. 7, 15/2 Vanda Vasylevskaya Street, Kiev 4116, Ukraine
Tel 38044 489 19 54 | Fax 38044 489 19 54

Volt Positive www.voltdc.com
1505-400 Slater Street, Ottawa, Ontario, K1R 7S7, Canada
Tel 613 262 7161

Wallace Church, Inc. www.wallacechurch.com
330 E. 48th Street, NewYork, NY 10013, United States
Tel 212 755 2903

Wall-to-Wall Studios, Inc. www.walltowall.com
40 24th Street, 2nd Floor, Pittsburgh, PA 15222, United States
Tel 412 232 0880 | Fax 412 232 0906

Wells Communications Consulting
24 Stormy View Road, Ithaca, NY 14853, United States
Tel 607 257 8318 | Fax 607 257 8318

Weymouth Design www.weymouthdesign.com
332 Congress Street, Boston, MA 02210, United States
Tel 617 542 2647 | Fax 617 451 6233

William Homan Design www.williamhomandesign.com
111 Marquette Avenue S, #1411, Minneapolis, MN, United States
Tel 612 702 9105

Wink www.wink-mpls.com
126 North Third Street, Mineapolis, MN 55401, United States
Tel 612 455 2642 | Fax 612 455 2645

Woodpile Studios www.woodpilestudios.com
1520 Nightshade Court, Vienna, VA 22182, United States
Tel 703 757 2372 | Fax 703 757 2379

Wray Ward Laseter www.wrayward.com
521 E. Morehead Steet, Suite 500, Charlotte, NC 28202, United States
Tel 704 926 1332 | Fax 704 375 5971

Young & Laramore www.youngandlaramore.com
407 North Fulton Street, Indianapolis, IN 46202, United States
Tel 317 264 8000 | Fax 317 264 8001

Z Squared Design www.zsquaredesign.com
699 Arguello Blvd., #302, San Francisco, CA 94118, United States
Tel 415 551 2229 | Fax 415 551 2228

Zeist Design, LLC www.zeistdesign.com
39 Mira Loma Drive, San Francisco, CA 94127, United States
Tel 415 305 6229

Zync Communications Inc. www.zync.ca
282 Richmond Street East, Suite 200, Toronto, Ontario, M5A 1P4, Canada
Tel 416 322 2865 | Fax 416 322 2864

CreativeDirectors

Designers

Designers continue next page

Designers

ExecutiveCreativeDirectors

ProjectManagers

Artists

Illustrators

Photographers

Typographers

Authors/Writers/Copywriters/Editors

DesignFirms

Design Firms continue next page

DesignFirms

Clients

Clients

GraphisTitles

PosterAnnual2007

Summer 2007
Hardcover: 256 pages
200 plus color illustrations

Trim: 8.5 x 11.75"
ISBN: 1-932026-40-1
US $70

GraphisPosterAnnual2007 features the finest Poster designs of the last year, selected from thousands of international entries. These award winning Posters, produced for a variety of corporate and social causes, illustrate the power and potential of this forceful visual medium. This year's edition includes interviews with Japanese Designer **Shin Matsunaga, Marksteen Adamson** of Britain's ASHA and Swiss Poster Curator **Felix Studinka**.

DesignAnnual2008

Spring 2007
Hardcover: 256 pages
300 plus color illustrations

Trim: 8.5 x 11.75"
ISBN: 1-932026-43-6
US $70

GraphisDesignAnnual2008 is the definitive Design exhibition, featuring the year's most outstanding design work from around the globe in a variety of disciplines. Featured categories include Books, Branding, Interactive, Letterhead, Typography and much more! All winners have earned the new Graphis Gold and/or Platinum Awards for excellence. Case studies of Platinum winners complete the latest book from this popular series.

AdvertisingAnnual2008

Fall 2007
Hardcover: 256 pages
300 plus color illustrations

Trim: 8.5 x 11.75"
ISBN: 1-932026-44-4
US $70

GraphisAdvertisingAnnual2008 showcases over 300 single ads and campaigns, from trade categories as varied as Automotive, Film, Financial Services, Music, Software and Travel. All have earned the new Graphis Gold Award for excellence, and a few outstanding entries have earned the Graphis Platinum Award. This year's edition includes case studies of a few Platinum-winning Advertisements. This is a must-have for anyone in the industry.

Brochures6

Fall 2007
Hardcover: 256 pages
300 plus color illustrations

Trim: 8.5 x 11.75"
ISBN: 1-932026-48-7
US $70

GraphisBrochures6 demonstrates the potency of the brochure medium with close ups, reproductions of covers and inside spreads from the award winners. Each brochure has earned a Graphis Gold and/or Platinum Award for excellence. Case studies of a few, carefully selected Platinum winning artists and their work complete the book. The book is completed with an index of firms, creative contributors and clients.

Available at www.graphis.com

GraphisTitles

Annual Reports '07/'08

December 2007 *Trim: 8.5 x 11.75"*
Hardcover: 240 pages *ISBN: 1-932026-41-X*
200 plus color illustrations *US $70*

GraphisAnnualReports'07/'08 celebrates the year's best ARs, selected by an elite panel of judges chaired by Deanna Kuhlmann-Leavitt. The book presents covers, editorial and financial spreads, detailed credits, and Q&As with the winners. Design legend Steve Frykholm is honored with an interview and feature portfolio, and each featured AR has earned a Graphis Gold or Platinum Award for outstanding design.

Letterhead7

December 2007 *Trim: 8.5 x 11.75"*
Hardcover: 256 pages *ISBN:1-932026-43-6*
300 plus color illustrations *US $70*

Letterhead7 features interviews with Platinum winners from KNARF, The Moderns, Guy Villa Design, Teikna, Voicebox Creative, Graphics + Designing Inc. and Catapult Strategic Design. Marrying art and function, the solutions in this book represent the best in international letterhead design from the last five years. Beautifully reproduced, each included design has earned a Graphis Gold or Platinum Award for excellence.

Available at www.graphis.com

Graphis Standing Orders (50% off):
Get 50% off the list price on new Graphis books when you sign up for a Standing Order on any of our periodical books (annuals or bi-annuals).
A Standing Order is a subscription to Graphis books with a 2 year commitment. Secure your copy of the latest Graphis titles - with our best deal - today online at www.graphis.com. Click on Annuals, add your selections to your Standing Order list, and save 50%.

Check out our new website!! www.graphis.com

Graphis THE BEST IN ASIA & OCEANIA

Advertising

Graphis THE BEST IN EUROPE & AFRICA

Photography

Graphis THE BEST IN THE AMERICAS

Design&Art

/